THE NATIONAL GALLE

J

100 Great Paintings

THE NATIONAL GALLERY, LONDON

100 Great Paintings: Duccio to Picasso

European Paintings from the
14th to the 20th Century
Illustrated in Colour

Dillian Gordon

Sponsored by Coutts & Co.
and
Published by Order of the Trustees
Publications Department
National Gallery,
London

Designed by Tom Carter.

Colour photography by National Gallery Photographic Section.

Colour origination by Masterlith Ltd., 36 Lewis Road, Mitcham, Surrey.

Printed and bound in Great Britain by Staples Printers Kettering Limited, The George Press, Trafalgar Road, Kettering, Northamptonshire.

Distributed by
William Collins Sons & Co Ltd
London . Glasgow . Sydney . Auckland
Toronto . Johannesburg

ISBN 0 00 217066 3

£6.95 net

Cover illustrations
Front: detail from Jean-Baptiste CHARDIN: *The Young Schoolmistress* (*see* page 189)
Back: detail from Jan van EYCK: *The Arnolfini Marriage* (*see* page 65)

Foreword

This book is concerned with illustrating one of the best investments ever made by a British government. In 1824, when the reigning monarch was George IV, an enlightened patron of the arts, and the Prime Minister the Earl of Liverpool, the government decided to purchase 38 paintings from the Angerstein collection and with them create a National Gallery, for the total sum of £60,000. To put that amount in perspective it is worth noting that at the same date the government allocated, for 'repairs' at Windsor Castle, no less than £300,000.

It must have been an extraordinary period. The Emperor of Austria had just repaid a large part of his country's debt to Great Britain, and *The Annual Register* summed up 1824 by stating: 'The prosperous state of the revenue during the present year rendered the office of Chancellor of the Exchequer comparatively easy'.

Over the years since then the National Gallery has continued to benefit from sustained state support, allowing major purchases to go on being made. It has also benefited, since its earliest days, from generous private support, chiefly in the form of gifts and bequests of paintings. Today it has matured into being one of the finest and most famous public collections of European paintings in the world. The Collection is still, fortunately, not vast in number but is of perhaps unparalleled choiceness and balance in its representation of all the major schools of painting.

From quite early on, the Gallery benefited too from bequests of money; for guidance over those, the Trustees turned in 1864 to our near neighbours, Messrs. Coutts. Thus began an association between the two institutions that has happily continued up to the present day. With this publication the Gallery's bankers have become also our sponsors, and we are deeply grateful for, as well as proud of, the fresh association that has brought about this publication.

One hundred paintings have been selected by Dillian Gordon to stand for the richness and range of the Collection, achieving a balance that skilfully reflects its character. Her deft comments sharpen appreciation of the familiar and also, on occasion, call attention to the fine but less familiar; the thought and imagination she has brought to her daunting yet enjoyable task shine through these pages. Distilled here is the essence of the Gallery, and the result can serve as an introduction to Western painting almost as much as to the Collection.

Publication of this book by the National Gallery gives some indication of how we see our role today: not merely as an institution holding, acquiring and displaying great paintings but as being bound to foster wider understanding and deeper appreciation of them. Lend us your eyes, we beg the public, while in turn we – in increasingly varied ways – try to enhance the pleasure that comes from stretching the imagination by looking long and seriously at paintings.

Michael Levey
Director

Preface

'It is a great pleasure to write the word, but I am not sure that there is not a certain impudence in pretending to add anything to it. . . There is nothing new to be said. . . but the old is better than any novelty. . . I write these lines with the full consciousness of having no information whatever to offer. I do not pretend to enlighten the reader; I pretend only to give a fillip to his memory; and I hold any writer sufficiently justified who is himself in love with his theme'.

Henry James' preface to the chapter on Venice in his *Italian Hours* is as appropriate an introduction as one might wish for a book on some of the masterpieces in the Collection of the National Gallery.

To write on so many masterpieces would not have been possible without recourse to the scholarship of previous writers, or to the authors of the text catalogues published by the National Gallery. I have gleaned unashamedly. I have benefited greatly from conversations with my colleagues, and am grateful above all to those who have checked my text and made invaluable suggestions.

The Director, Sir Michael Levey, has not only helped with the task of selecting one hundred pictures from a Collection of over two thousand, but has nurtured the manuscript with an unflagging care and improved it with trenchant criticism, for both of which I am deeply grateful.

Dillian Gordon

Introduction

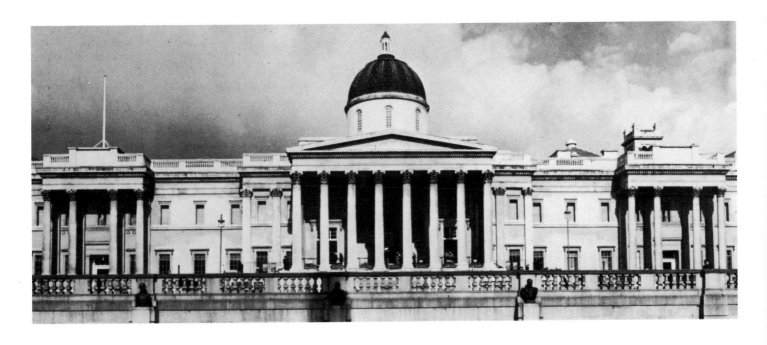

The Formation of the Collection

The Early Years

There are those for whom the National Gallery represents an object of unfulfilled intentions. 'How often my soul visits the National Gallery, and how seldom I go there myself', wrote Logan Pearsall-Smith in his *Afterthoughts* of 1931. For the two and a half million people who do visit the Gallery every year there is a collection of more than two thousand European paintings dating from the 13th to the 20th centuries and among them some of the world's masterpieces. Yet just over 160 years ago this Collection did not exist. Although only founded in 1824, a collection of more than a thousand paintings had been formed by the end of the 19th century which vied with the best in Europe.

The idea of setting up a National Gallery was in the air in 1822. France, Austria and Spain already had national collections based on the wealth of their royal collections, and England felt

The south façade of the National Gallery, seen from Trafalgar Square.

it was time to remedy her defect by creating a National Gallery in this country. Constable gloomily lamented that it would be 'an end of the art in poor old England, and she will become, in all that relates to painting, as much a nonentity as every other country that has one. The reason is plain, the manufacturers of pictures are then made the intention of perfection.' Others were more optimistic. Sir Robert Peel, for example, felt that the National Gallery would 'contribute to the cultivation of the arts'. Eventually, on 2nd April 1824, the House of Commons voted £60,000 for the purchase of the collection of the late John Julius Angerstein, a Russian emigré banker, and the Government bought thirty-eight pictures which formed the nucleus of the present Collection.

The beginning of the National Gallery was a modest and almost impromptu affair. Only a

month after the Commons' decision, Angerstein's house, 100 Pall Mall, was opened to the public as the National Gallery. The Angerstein collection, which was varied in range, had been formed partly with the help of the painter Sir Thomas Lawrence, and included what are now some of the Gallery's most famous paintings: Raphael's portrait of *Pope Julius II* (*see* p.55); one of Claude's most famous sea pictures, *The Embarkation of the Queen of Sheba* (*see* p.111) and Hogarth's satirical series *Marriage à la Mode* (*see* p.171).

The staff of the National Gallery in Pall Mall was small. In charge of the Collection was a Keeper, Mr William Seguier, under the supervision of 'six gentlemen', the equivalent of today's Board of Trustees: the Prime Minister of the day, Lord Liverpool, Lords Ripon, Aberdeen and Farnborough, Sir Thomas Lawrence, President of the Royal Academy, and the collector, Sir George Beaumont.

In 1826 Sir George Beaumont, who had promised his collection to the nation if a suitable building could be found, donated sixteen pictures which included Canaletto's Venetian view picture known as *The Stonemason's Yard* (*see* p.185), a large landscape by Rubens showing the painter's own country mansion, the *Château de Steen,* and four pictures by the 17th-century French classical landscape painter, Claude.

The Reverend William Holwell Carr had also promised his collection with the same provision. When he died in 1831, the first major bequest of paintings brought to the National Gallery several masterpieces, including a small altarpiece by Tintoretto with *St. George and the Dragon* (*see* p.91) and Rembrandt's informal study of his mistress bathing (*see* p.159).

The collection grew rapidly, if somewhat haphazardly, through purchases as well as donations and bequests. The first picture to be bought was *The Madonna of the Basket* by Correggio (*see* p.95), purchased in 1825 for £3,800, a comparatively high price for such a tiny though charming picture. The following year other major purchases included Titian's mythological painting of *Bacchus and Ariadne* (*see* p.85), acquired from the jeweller, Mr Thomas Hamlet. The first Raphael to be bought for the

collection, *St. Catherine of Alexandria,* simply arrived in 1839 without any warning to the Trustees, having been purchased by the Chancellor of the Exchequer. Both these pictures were extolled in Thackeray's novel, *The Newcomes,* where the National Gallery, less than thirty years after its inception, is favourably compared to the Louvre:

'What a grand thing it is to think of half a mile of pictures at the Louvre! Not but what there are a score under the old pepper-boxes in Trafalgar Square as fine as the best here [in Paris]. I don't care for any Raphael here as much as our own St. Catherine. There is nothing more grand. Could the pyramids of Egypt or the Colossus of Rhodes be greater than our Sebastian? And for our Bacchus and Ariadne, you cannot beat the best you know'.

Already by 1828, the house at Pall Mall was much too small for the ever-growing collection, and the site of the Royal Mews on the north side of Trafalgar Square was chosen for a new building. The architect, William Wilkins, modelled his design upon the demolished Mews with its long, low façade and tripartite division, giving priority to the provision of top-lit rooms. When the building was opened in 1838, the paintings were hung in five rooms along the west wing, and the east wing was occupied by the Royal Academy until it moved to Burlington House in 1869. Since then the building has been added to piecemeal in order to accommodate an ever-expanding collection. The most recent addition was the Northern Extension, opened by Her Majesty the Queen in 1975.

The nature of the Gallery's acquisitions has always attracted public interest. In the 1840s there was some disquiet regarding the narrow range of the pictures bought by the Trustees. But the occasional inspired purchase was made. Jan van Eyck's *Arnolfini Marriage* (*see* p.65), which had supposedly been acquired by a British soldier after the Battle of Waterloo, was bought for the Gallery in 1842 for the sum of £630. However, the predilection for 17th-century Italian painting,

100 *Pall Mall, where the National Gallery was first opened to the public in* 1824.

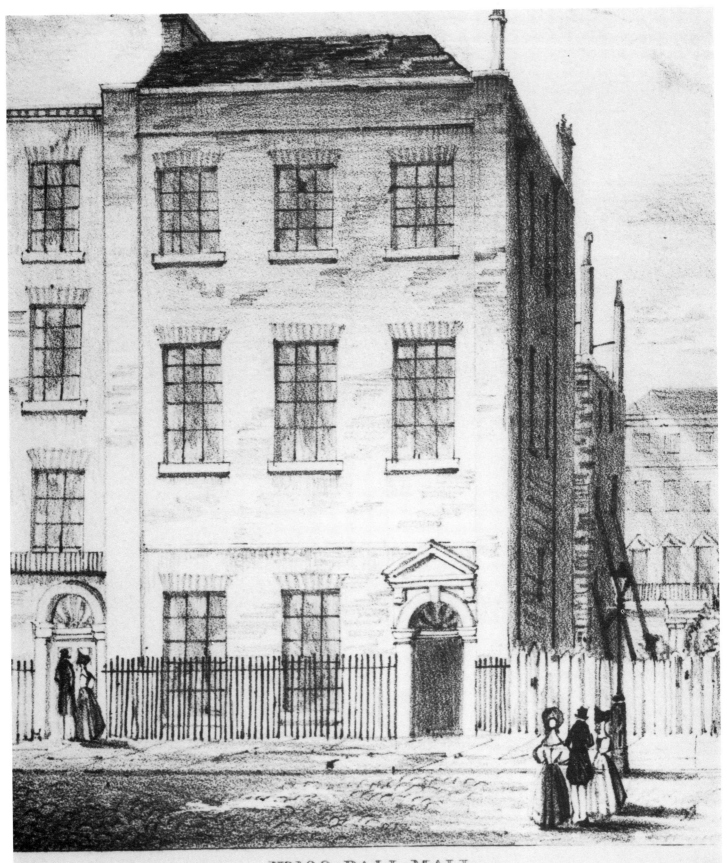

N.º 100, PALL MALL,
or the National Gallery of England.

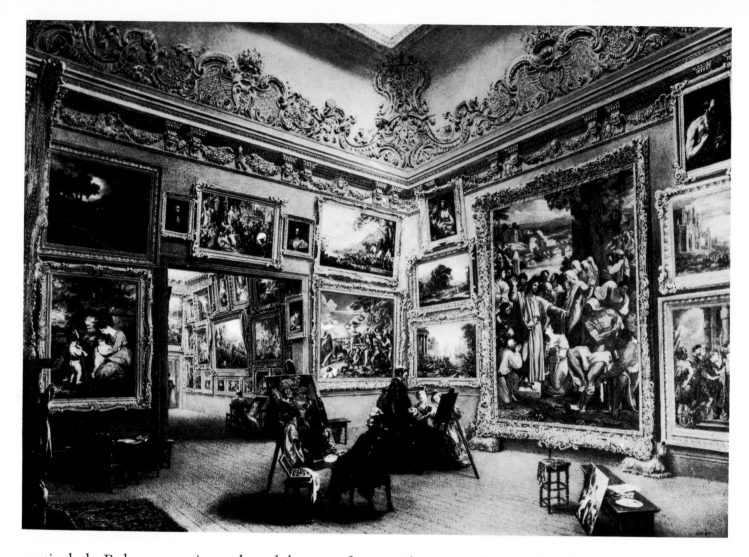

The interior of 100 *Pall Mall. Watercolour by F. Mac-Kenzie (c.1787–1854). Victoria and Albert Museum.*

particularly Bolognese artists, coloured the taste of English collectors and Ruskin's letter to *The Times* in 1847 lamented the fact that the Gallery had 'no Perugino. . ., no Angelico, no Fra Bartolomeo, no Albertinelli, no Ghirlandajo, no Verrocchio, no Lorenzo di Credi' and pleaded that the purchase fund should 'no longer be played with like pebbles in London auction rooms'. He scornfully suggested that good pictures only found their way through the 'preposterous portico' of the National Gallery 'through chance or oversight'.

A Committee of the House of Commons in 1836 had recommended that pictures by Raphael and painters before him should be sought for the Collection, but to little avail. For there were those like Sir Robert Peel, one of the Trustees, whose own sympathies and collecting were mainly devoted to 17th-century Dutch and Flemish painting: 'I think we should not collect

curiosities'. In that very year 1836, Waagen, the German connoisseur, whose advice had been sought, was recommending: 'If the National Gallery is to be a complete historical collection, of course it must commence from the time of Giotto; but I should not think it advisable to commence in that way; I should think the preferable way would be to commence with the very best masters, those who had brought it to the greatest state of perfection, and then go up to the source as well as come down to the present time. I do not think the public would take that interest if we were to commence with Cimabue and Giotto, but we might commence with Raphael and the other great masters of that period'.

The possible reaction of the 19th-century public to Italian 'primitives' may be found in one of

Henry James' novels. The young heroine of *What Maisie Knew* visits the National Gallery with her stepfather during one of their rambles through London in search of 'combined amusement and instruction', but chiefly to take refuge from the rain: 'Maisie sat beside him staring rather sightlessly at a roomful of pictures which he had mystified her much by speaking of with a bored sigh as a "silly superstition". They represented, with patches of gold and cataracts of purple, with stiff saints and angular angels, with ugly Madonnas and uglier babies, strange prayers and protestations. . . It presently appeared however, that his reference was merely to the affectation of admiring such ridiculous works.'

Although the late 18th and the 19th centuries saw a revival of interest in early Italian paintings, the first Italian 'primitives' did not enter the collection of the National Gallery until 1848, and then not as a purchase, but as a gift: two *Groups of Saints* by Lorenzo Monaco, thought then to be by one of Giotto's pupils, Taddeo Gaddi, were presented by the collector, Mr W. Coningham.

The First Director

It was mainly, however, under Sir Charles Eastlake, the first Director (1855–65), that the Gallery began to acquire early Italian and Italian Renaissance paintings, among the main strengths of the present collection. Eastlake had been Keeper of the Gallery during the years 1844–47 and during that time made notable acquisitions, including Bellini's magnificent portrait of *Doge Leonardo Loredan* (see p.79) bought for only 600 guineas. He had resigned in 1847 after a number of mishaps including the failure to persuade the Trustees to buy Michelangelo's *Madonna and Child with Angels* (eventually bought in 1870), the unfortunate purchase of a false Holbein, and public criticism of the cleaning of pictures. During Eastlake's directorship, however, some of the Gallery's most important works came into the collection. Perhaps, in retrospect, the most sensational of his purchases was Piero della Francesca's *Baptism* (see p.33) which he bought for only £241, a price to be compared with £1,000 paid for Gainsborough's portrait of the actress Mrs Siddons, the following year.

Some of Eastlake's successes can be credited to the Government's more systematic approach to the National Gallery, long overdue. The scandal which had broken over numerous controversial issues had resulted in a Select Committee of Inquiry in 1853. As a result of this, various improvements had been made, including a fixed annual purchase grant at the disposal of the Trustees on the advice of a properly qualified Director and the appointment of a travelling agent to scour collections abroad. It was also recommended that the scope of purchases be wider and more methodical: 'What Chaucer and Spenser are to Shakespeare and Milton, Giotto and Masaccio are to the great masters of the Florentine School'. Eastlake had not only the support of the Government, he had also the enlightened guidance of his wife, as well as the friendship of Lady Callcott, a society lady who had spent her honeymoon in Italy writing a monograph on Giotto's frescoes in the Arena Chapel at Padua. Furthermore, the then Keeper, the painter Thomas Uwins, who died in 1857, was of the opinion that the works of Giotto, Cimabue and their contemporaries 'would be sufficient to inoculate any country with good taste'. The list of Eastlake's purchases, some made during his travels in Italy, makes heady reading: Mantegna's altarpiece of the *Virgin with the Magdalen and John the Baptist,* Veronese's *Adoration of the Magi,* a *Virgin and Child* by Bellini, Perugino's triptych with the *Virgin adoring the Child,* the Pollaiuolo *Martyrdom of St. Sebastian* (see p.43), and Veronese's *Family of Darius before Alexander* (see p.93). Eastlake bought numerous early Italian paintings, such as the triptych with the *Virgin and Child with Saints* by Duccio, and Renaissance pictures including Uccello's *Battle of San Romano* (see p.37), both from the Lombardi-Baldi collection in Florence. He also built up the Early Netherlandish collection, buying Rogier van der Weyden's *Mary Magdalen Reading* (see p.69), and Bouts' *Entombment,* an early example of painting on cloth. Among the major gifts made to the Gallery during Eastlake's directorship were twenty pictures presented by Queen Victoria in fulfillment of Prince Albert's wishes, including the *St. Peter and St. Dorothy* (see p.113), and Crivelli's altarpiece with *The Annunciation* (see p.77) given by Lord Taunton.

Eastlake's taste was as distinguished as it was wide-ranging and his purchase of English pictures included Reynolds' *Captain Orme* (*See* p. 173). His indefatigable zeal in travelling abroad himself, searching for masterpieces, was further rewarded when he acquired the rare *Allegory* by Bronzino (*see* p.61), as well as Andrea del Sarto's *Portrait of a Young Man* (*see* p.59) and Moroni's *Tailor* (*see* p.103). It was while travelling in Italy that Eastlake was taken seriously ill; he died in Pisa on 24th December 1865.

From 1866 to the Present

To succeed Eastlake must have been a hard task indeed. William Boxall R.A. who became the next Director (1866–74) was, like Eastlake, a painter. Under him the Gallery in no way lost its impetus. His purchases included a rare easel picture by Michelangelo, *The Entombment* (*see* p.57). But he also built up the 17th-century Dutch and Flemish collection, adding notable pictures from the Peel Collection, such as Hobbema's *Avenue at Middelharnis* (*see* p.169), de Hoogh's *A Woman and her Maid in a Courtyard* and Rubens' portrait of his sister-in-law, known also as *Le Chapeau de Paille* (*see* p.127).

When Boxall resigned he was succeeded by Frederick William Burton (1874–94), also a painter. And again the list of acquisitions made under him includes some of the Collection's masterpieces: Piero della Francesca's unfinished painting of *The Nativity* (*see* p.35) and Botticelli's *Venus and Mars* (*see* p.45) were both bought in 1874. A rare altarpiece by Leonardo, *The Virgin of the Rocks* (*see* p. 49), was bought in 1880. Only a few fragments from Duccio's enormous altarpiece of the *Maestà* for Siena Cathedral have found their way outside Siena, and the National Gallery owns three, of which *The Annunciation* (*see* p.21) and *Christ healing the Blind Man* were bought in Florence by Burton in 1883. One of Raphael's major early works, the centre panel of the altarpiece known as *The Ansidei Madonna* (*see* p. 53), and Van Dyck's equestrian portrait of *Charles I* (*see* p.131) were bought from the Duke of Marlborough in 1884. Members of Parliament assured the Prime Minister, Mr Gladstone, that with these two purchases the level of the entire collection was raised at a single stroke.

Constable's *Hay Wain* (*see* p.181), which had initially met with such lack of enthusiasm from the English, was presented to the Gallery by Henry Vaughan in 1886, and Holbein's full-length double-portrait known as *The Ambassadors* (*see* p.119) was purchased in 1890.

Burton was succeeded by yet another painter, later P.R.A., Edward John Poynter (1894–1904). Amongst other works, he bought Mantegna's *Agony in the Garden* (*see* p.75), Antonello's *St. Jerome* (*see* p.73), Pisanello's *Vision of St. Eustace* (*see* p.31) in his first year of office, and later Zurbarán's *St. Margaret* (*see* p.141) and Titian's *Portrait of a Man* (*see* p.83).

Poynter had no immediate successor and when in 1905 the Gallery had no Director, Velàzquez's *Rokeby Venus* (*see* p.137) was nearly lost to the Nation since no one had realised it was for sale until it was on the verge of being auctioned. Fortunately, the recently founded National Art-Collections Fund came to the rescue and the picture was acquired.

Twentieth-century Directors continued to make the acquisition of masterpieces one of their prime objectives. Undeflected from this course by world events, Sir Charles Holroyd (1906–16) made an outstanding acquisition, Masaccio's *Virgin and Child* (*see* p.25), purchased during World War I at a time when much of the Collection was stored for safety in the London Underground.

By the beginning of the 20th century the Gallery still lacked more recent paintings by foreign painters. Two important bequests restored the equilibrium. In 1917 a major collector of French 19th-century pictures, Sir Hugh Lane, bequeathed a number of major French Impressionist works including Renoir's *Les Parapluies* (*see* p.205). After the death of Sir Hugh Lane in the Lusitania, a second, unwitnessed, codicil to his Will was discovered which re-allocated the collection to Ireland. Today, although all the Lane pictures are vested in the National Gallery Trustees, the majority are on loan to the Municipal Gallery of Modern Art, Dublin. In 1924 Sir Samuel Courtauld bequeathed a large sum of money solely for the purchase of 19th-century French paintings.

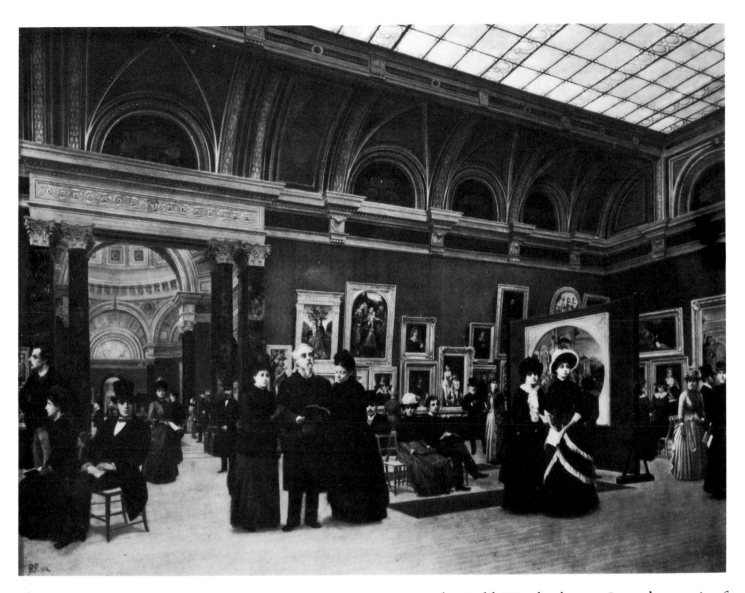

Room 32 in the National Gallery painted in 1886 by G. Gabrielli.

The Second World War presented a more serious threat to the Collection than had the First World War. It was to the then Director, Kenneth Clark (later Lord Clark) that Sir Winston Churchill wrote his famous injunction: 'Bury them in the bowels of the earth, but not a picture shall leave this island', and the pictures were stored for safety in slate quarries in Wales. It was also during this time that a member of the Keeper staff, later to become Director, Martin Davies, began working on the text catalogues, whose scrupulous scholarship has been a model for catalogue compilers ever since.

The Gallery's positive acquisition policy never slackens even in times of recession. Just before the Second World War broke out Ingres' portrait of *Madame Moitessier* (*see* p.195), still in the glorious original frame which picks up the floral motif of her dress, was bought. Several organisations have proved ready to help when the Gallery's annual purchase grant cannot quite stretch as far as is needed. In 1962 the National Art-Collections Fund organised the Appeal for, and presented, an exceptionally rare work, the Leonardo Cartoon (*see* p.51) and the purchase of Titian's *Death of Actaeon* (*see* p.89) was only possible after a public appeal in 1972. More recently, the newly-established National Heritage Memorial Fund has contributed towards the cost of Claude's *Enchanted Castle*, a picture with a particular 'heritage' interest since it inspired some famous lines in Keats' *Ode to a Nightingale*. Pre-eminent works purchased by private treaty sale are exempt from

taxes and it was such an arrangement which enabled the Gallery to acquire recently the Claude and also the second of only two paintings by Altdorfer in this country, *Christ taking leave of His Mother* (*see* p.117), again with help from the National Art-Collections Fund. Occasionally, the Gallery will venture into the auction rooms and thus recently purchased a spectacular example of early Rubens, his *Samson and Delilah* (*see* p.123).

The Care of the Collection

Crucial to the role of the Gallery is not only the acquisition but also the preservation of paintings, the responsibility of the Gallery's Conservation and Scientific Departments.

The Conservation and Scientific Departments

The question of cleaning and conservation of paintings was, in the 19th century, the subject of heated controversy. There was then no permanent conservation staff. In the 1840s the Keeper is said to have cleaned pictures with his handkerchief, washed them with water, dried, oiled and varnished them. The pictures acquired a dingy layer of yellowing varnish and grime which people began to associate with Old Masters. A more professional and thorough approach to cleaning was undertaken when Eastlake was Keeper in 1846, but raised a public outcry. Ruskin's letter to *The Times* the following year was urgently 'desirous that a stop may be put to the dangerous process of cleaning lately begun at our National Gallery'. The Select Committee of Inquiry set up in 1853 investigated the question and thereafter cleaning was carried out by professional private restorers. Yet it was not until after the Second World War, in 1946, that a Conservation Department was established. Today the cleaning and restoration of pictures is systematically undertaken and scientifically controlled by a team of trained restorers who keep a photographic and written record of every picture in the Collection.

The work of the Conservation Department is aided by that of the Scientific Department, established in 1934. The work of this department involves the identification of pigments, and of the wood or canvas support of paintings. Microscopy is used to analyse the layer structure of paintings with samples smaller than the size of a pin-head taken from the edges or damaged areas of paintings. Gas-chromatography is used for the identification of paint media; for example, much valuable information has been discovered about the use of egg or oil to bind pigments in 15th-century paintings. The results reached by the Scientific Department go to help the work of restorer and art-historian alike.

'Cleaning the Pictures in the National Gallery', by John Leech, Punch, *Almanac for* 1847.

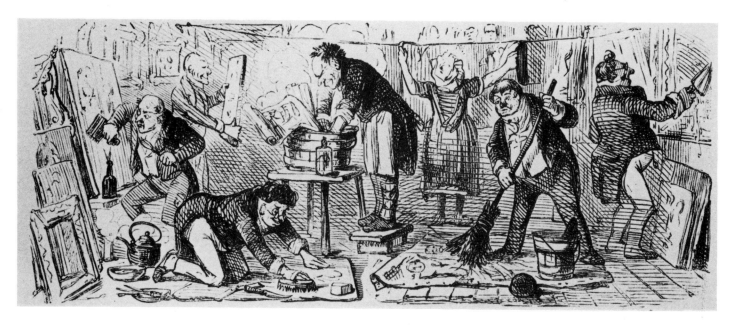

Another major function of the Scientific Department is the monitoring of conditions in the Gallery. During the Second World War, when the pictures were in the quarries in Wales, it was discovered that the near-perfect conditions lessened the inevitable deterioration. This gave strong impetus to the introduction of air-conditioning into the Gallery. In Ruskin's time, the overcrowded 'melancholy and miserable rooms' of the Gallery had open fires, and the pictures suffered from the dirty environment. Ruskin recommended glazing, and indeed until fairly recently most of the pictures were protected by glass. In Ronald Firbank's *Vainglory* (1915) Mrs Shamefoot comes to powder her nose in the reflection of Leonardo's *Virgin of the Rocks* on her way to the Savoy. Today air-conditioning makes glass an unnecessary barrier. The Scientific Department also monitors the light levels in the Gallery and has a special computer-based machine for measuring colour change in pictures over a long period of time.

In Ruskin's day pictures were tiered high, one above the other, partly for reasons of fashion, partly for reasons of space. Today the paintings are almost all hung at eye level, which Ruskin himself recommended as best for the purposes of study and enjoyment. The Collection is arranged according to School, and chronologically.

The Administration of the Gallery

Each School of painting is the responsibility of a member of the Keeper staff whose work involves consulting with the Scientific and Conservation Departments over paintings in their care. Their work also involves doing research on those pictures, the revision of the text catalogues, the mounting of exhibitions, the answering of enquiries, and so on. The Keeper staff of six is answerable to the Director. The ultimate responsibility, however, lies with the Board of ten Trustees appointed by the Prime Minister to serve for a term of seven years and who meet regularly to discuss the affairs of the Gallery.

In addition there exists a labyrinthine staff structure whose daily activity is entirely directed toward the well-being of the two thousand pictures displayed on the walls of the National Gallery and the associated needs of the public. A Framing Shop restores frames and makes new ones to ensure that each picture is appropriately displayed. A Photographic Department takes black-and-white, colour and X-ray photographs for the purposes of research, documentation and reproduction. The Publications Department produces post-cards, books, catalogues, a *Technical Bulletin* and posters, disseminating visual information on the Collection. Recently an Education Department was established to cater for children of all ages; it organises daily public lectures, courses for teachers, and produces audio-visual programmes. A Press Office liaises between the Gallery and the media. A book and photographic Library cover reference material for the Collection. A Warder staff of about two hundred keeps the Collection under constant supervision.

The National Gallery and the Tate Gallery

The National Gallery houses European paintings from the 13th–20th centuries with a representative selection of British pictures, while the Tate Gallery houses the major holding of the nation's British pictures and modern painting from approximately the end of the 19th century.

The Tate Gallery was founded by Sir Henry Tate in 1897 and first administered by the National Gallery. Sir Henry presented his own collection of British pictures, and to it were added some of the British pictures from Trafalgar Square. In 1954 the Tate Gallery was made independent and some more of the British and modern works from the National Gallery were transferred there.

THE NATIONAL GALLERY, LONDON

100 Great Paintings
in Colour

Note: Measurements throughout are given in metres.

DUCCIO di Buoninsegna

The Annunciation

active 1278; died 1319

Panel, 0.43 × 0.44

Together with his contemporary, Giotto, Duccio was one of the leading painters in central Italy responsible for a revival in the art of painting at the beginning of the 14th century. While Giotto worked chiefly in Florence, Duccio ran a large workshop in the rival town of Siena.

One of the most important and influential works to be produced by Duccio and his assistants was an enormous altarpiece for the high altar of Siena Cathedral, commissioned in 1308 and carried in triumph to the Cathedral in 1311. The altarpiece was painted on both sides: on the front was a *Maestà*, or Virgin and Child enthroned with saints and angels; on the back were over thirty narrative scenes showing the Passion of Christ. The huge structure rested on a predella, or step, painted with small scenes of the Infancy of Christ on the front – opening with the *Annunciation* – and with the Ministry of Christ (of which the National Gallery owns *Christ healing the Blind Man* and *The Transfiguration*) on the back. In 1506 the altarpiece was taken down and eventually sawn up. Most of it remains in the Museo dell' Opera del Duomo in Siena.

The Annunciation is described in St. Luke's Gospel (1,26). The Angel Gabriel has come to announce that the Virgin is to bear the Son of God. Startled at the appearance of the heavenly being, she draws back. In her hand she holds a book inscribed with the relevant prophecy from Isaiah (VII,14): *Ecce virgo concipiet et pariet filium et vocabitur* (Behold a Virgin shall conceive and bear a son and his name shall be called Emmanuel). The vase of lilies symbolises her purity; the tiny white dove represents the Holy Spirit.

Early Italian artists normally painted on poplar panels and tempered their pigments with egg. The technical restraints were such that the painter had to wait for each brushstroke to dry before applying the next one, so the delicate brushstrokes are still visible. The angel's blue robe and lilac cloak are modelled in graduated tones which develop from deep shadow to a fine mesh of white highlights.

Vasari, the 16th-century biographer, despised Duccio for continuing to paint in the *'Maniera Greca'* or the Greek style. Here the Virgin's dress is indeed still modelled with the gold striations found in Byzantine icons; but her lapis blue robe with its dainty gold edging is incipiently naturalistic.

Although medieval Italian painters had only a very approximate idea of perspective, Duccio has here unfolded the pale grey and pink architecture around the figures in order to create a sense of three-dimensional space. However, while Florentine painters tended to concentrate on monumental forms set within illusionistic space, Sienese painters were primarily interested in decorative effects, using glowing jewel-like colours and flowing elegant lines. Over a century later Sienese painters like Sassetta (*see* p.27) and Giovanni di Paolo (*see* p.29) were still painting in a style reminiscent of that of Duccio.

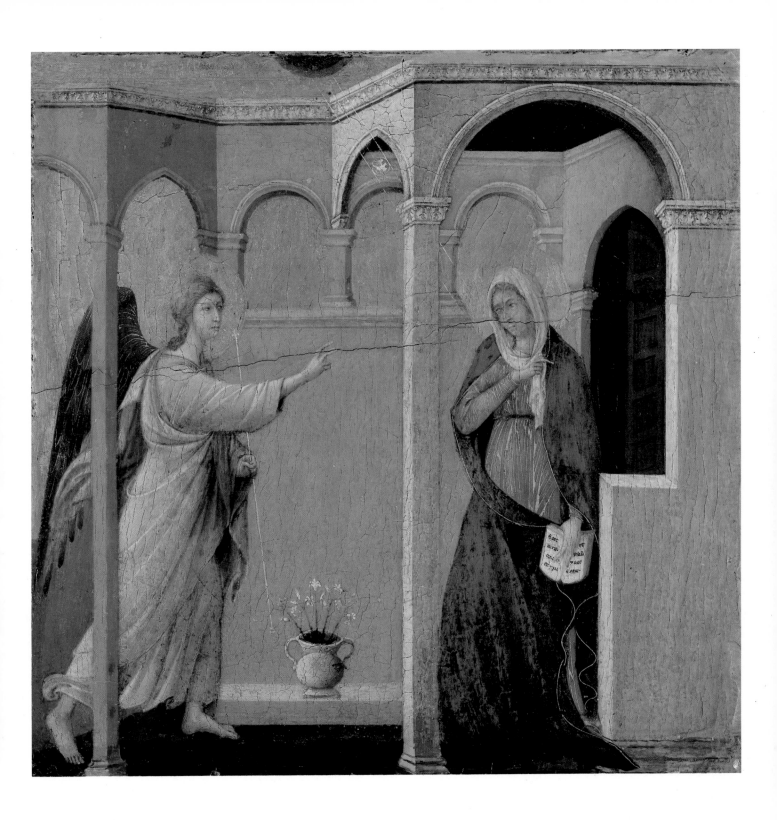

French School

*c.*1395

Oak panels, each 0.457 × 0.292

The Wilton Diptych

It would be easy to mistake the Wilton Diptych for an illustration to a medieval poem. The chivalrous knight and the courtly lady; the magical transition of a mortal from this arid world to the flower-sprinkled meadow of a faery realm beyond; a white hart; a golden ring and an arrow: all these have the magical properties of the Celtic world of myth and legend. However, although tinged with fairy tale, the Wilton Diptych is rooted in history.

The kneeling king is Richard II (reigned 1377–99). He is being presented to the Virgin and Child by John the Baptist, one of his favourite saints, since he acceded to the throne of England on the vigil of the feast of that saint. With him are also St. Edmund of East Anglia holding the arrow shot by a Dane which killed him in 869, and St. Edward the Confessor, King of England (1042–1066), holding the ring he is supposed to have given to St. John the Evangelist, mistaking him for a pilgrim. The crowns worn by the three figures turn the scene into an *Adoration of the Magi,* thereby equating Richard with one of the Three Wise Men: Richard's birthday was on the feast of the Epiphany. His personal badge was a white hart with golden antlers and appears in several forms: it is painted on the outside of the diptych; it is punched into the gold leaf of his robe, and worn by each of the eleven angels who seem to be welcoming him to join them as the twelfth angel. Even St. John the Baptist's hair shirt is not the

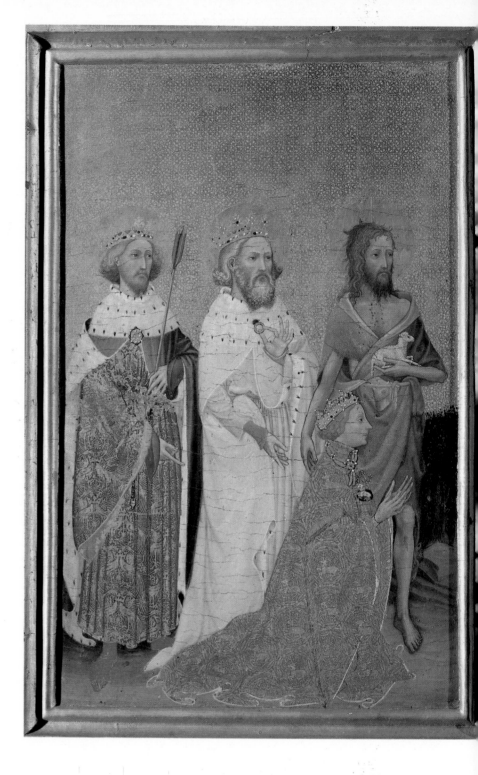

traditional camel, but a deer-skin. The broom cods around the king's neck refer to Geoffrey Plantagenet (*genet* is the French for broom), founder of the royal house.

Because so little English medieval art survives, there is little comparative material, and the artist who painted the Wilton Diptych remains unknown. It has been related to early Sienese painting and to French manuscript illumination. The most interesting connection of its style is with Bohemian

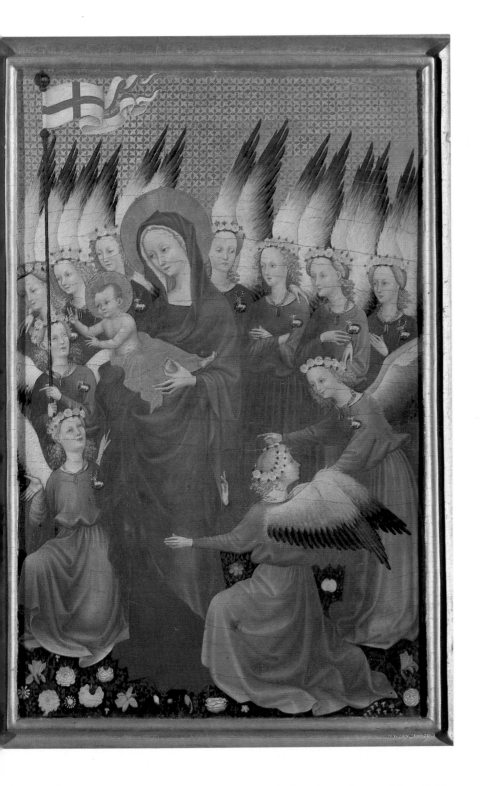

manuscript illumination, in view of the fact that Richard II married Ann of Bohemia in 1383. It is possible that she brought with her from Prague artists or works of art.

The Wilton Diptych is so-called because it came from Wilton House in Wiltshire. It was once owned by Charles I who acquired it from a certain Lady Jennings in exchange for a portrait of the king by the 17th-century Dutch painter, Jan Lievens.

Tommaso di Giovanni, called MASACCIO

The Virgin and Child

1401–1427/9

Panel, 1.355 × 0.73

Very little work by the Florentine painter, Masaccio, survives. Yet it is clear from his frescoes in the Brancacci chapel in Santa Maria del Carmine, Florence, and from his few surviving altarpieces, that he was one of the most important painters working in that city at the beginning of the Renaissance, during the first part of the 15th century.

This work is the centre panel of an altarpiece painted by Masaccio in 1426 for a chapel in the church of Santa Maria del Carmine in Pisa. Other surviving smaller fragments include standing saints in Berlin, *St. Paul* in Pisa, *St. Andrew* in the Getty Museum, California, a predella with *Adoration of the Magi* in Berlin, and a *Crucifixion* in Naples.

Strictly speaking, the term Renaissance refers to the rebirth of classical culture during the 15th century. Masaccio was the first painter to develop the monumental approach which Giotto had brought to Florence over a century earlier. Here the green under-modelling of the faces, the gold background, and elaborate punching of the haloes are vestiges of the world of the early Italian painters. However, the classical throne, which incorporates columns of the Corinthian, Ionic and Composite Orders, is symptomatic of the revival of interest in a classical idiom, current in the work of Ghiberti, Brunelleschi and contemporary Renaissance architects. The study of architecture and sculpture contributed to the ability to render the illusion of three-dimensional space. The bulky monumentality of the Virgin's lapis lazuli robe shows that Masaccio studied classical sculpture. During the Renaissance the laws of perspective were discovered: the Virgin's halo is still a flat disc, but the Child's halo, seen in perspective, forms an ellipse. Equally characteristic of the Renaissance is the nascent humanity in the interpretation of the Virgin and Child. No longer are they iconic formalised figures, but individualised portraits of a reflective mother aware of the fact that the fat baby on her knee, sucking his fingers, is eventually to suffer death on the Cross.

The Child eating grapes pre-figures the Passion, and, in fact, the *Crucifixion* panel was placed directly above the Virgin and Child. The vertical symbolism runs from the Crucifixion down to the throne steps whose pattern is based on classical sarcophagi, and therefore may allude to the tomb in which the body will be laid.

The density of meaning is reinforced by the density of structure. The pyramid of figures is drawn together, not only by the unifying light streaming from a single source but also by the harmony of colours built up of red and blue mixed in varying degrees.

Stefano di Giovanni, called SASSETTA

1392(?)–1450

Panel, 0.87 × 0.525

St. Francis gives his Cloak to a poor Knight

Concurrent with the new naturalism of Renaissance painting at the beginning of the 15th century was the so-called International Gothic style. Painters like the Sienese Sassetta were aware of the new developments in scientific knowledge which were beginning to affect how painters looked at the world, but chose to continue painting in a highly decorative way, fusing a dream world of imagination with closely observed reality.

Typical of this transitional style is the double-sided altarpiece Sassetta completed in 1444 for the church of San Francesco in the small town of San Sepolcro. The design derived originally from Duccio's *Maestà* (*see* p.21): on the front were the Virgin and Child enthroned with saints; on the back was a standing St. Francis in Glory, with small narrative scenes from his life on either side, which had alternately a gold-leaf background and a naturalistic blue sky. The National Gallery owns all but one of the eight scenes. This one depicts the future saint who, about to set out for the wars in Apulia, is giving his cloak to a poor, barefoot knight. That evening an angel in a dream shows him a palace with banners marked with Christ's Cross, symbolising the Franciscan Order he was later to found. In the background a pale yellow dawn is breaking over the hill town of Assisi, St. Francis' native town.

San Sepolcro is not far from Assisi and the story of his life would have been a familiar one to its inhabitants, perhaps in the form of the *Fioretti*. We know of Ser Lapo, the friend of the Merchant of Prato (*d.*1410), that: 'on winter nights he read aloud to the children, by the fireside, the stories in San Francesco's *Fioretti,* borrowing them from Margherita, who kept them shut away in her chest . . . For the little boys delighted in them in the evenings'.

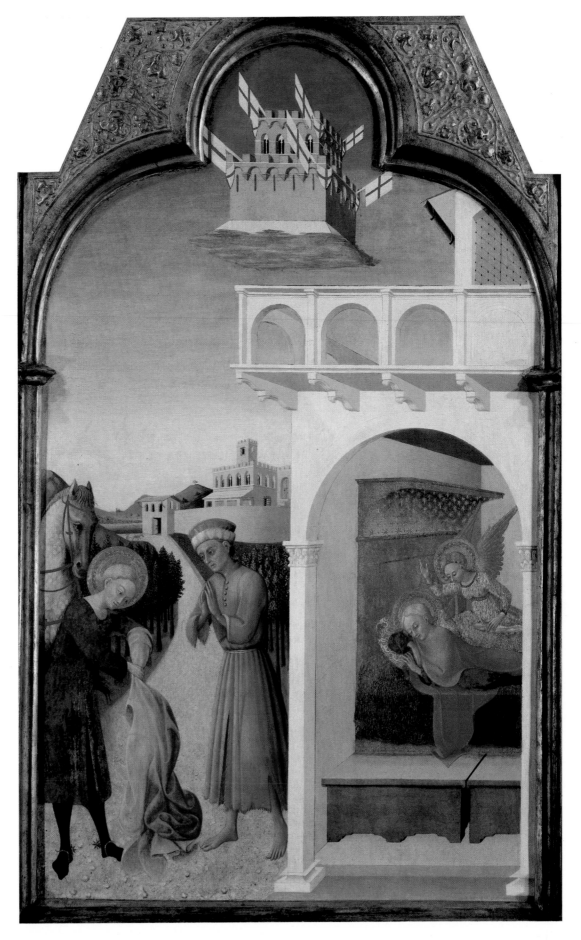

Italian School

GIOVANNI DI PAOLO
active 1420, died 1482

Panel, 0.31 × 0.385

St. John the Baptist retiring to the Desert

Like Duccio's *Annunciation* (*see* p.21), this is a predella panel. It originally supported a large altarpiece dedicated to St. John the Baptist and painted in about 1454.

Other panels from the same predella in the National Gallery also have scenes from the saint's life: *The Birth of John the Baptist; The Baptism of Christ; The Head of St. John the Baptist brought to Herod*. The narrative scenes derive closely from the bronze relief panels of *The Baptism* by Ghiberti and *The Head of St. John brought to Herod* by Donatello, which arrived in Siena in the autumn of 1427 to form part of the Font for the Baptistry.

However, although he was interested in the creation of an illusionistic three-dimensional space as demonstrated by two of Florence's outstanding Renaissance sculptors, Giovanni di Paolo clung to the tenacious medievalism of the International Gothic style. Like Sassetta (*see* p.27), the other leading Sienese painter in the early 15th century, he was interested primarily in decorative effects. The simultaneous narrative showing St. John both leaving home, and going into the wilderness, is as old-fashioned and as unrealistic as is the use of only two basic colours, pink and green. The rules of proportion, scale, and perspective are disregarded. Yet the roses painted in the borders on either side are studied in loving observation of the natural world, and are painted with an awareness that the altarpiece would be set up high on an altar and viewed from below.

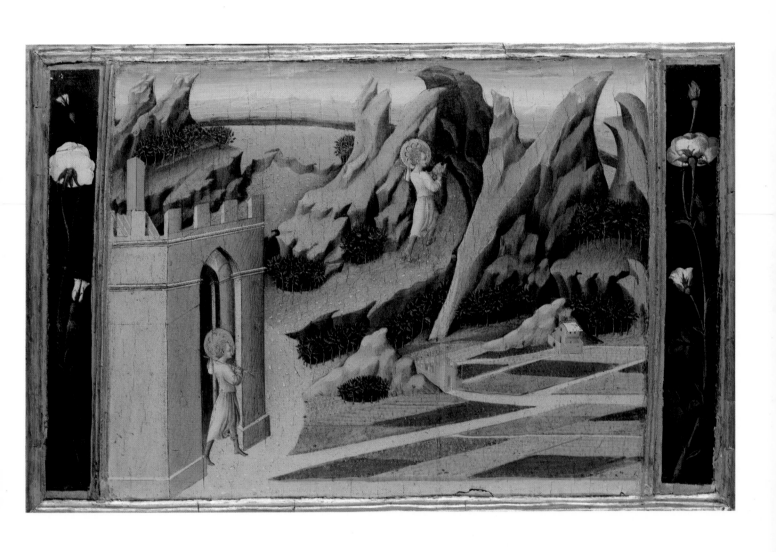

PISANELLO
living 1395, died 1455(?)

Panel, 0.545 × 0.655

The Vision of St. Eustace

An insatiable scientific curiosity about the natural world, combined with a love of rich decorative effects, characterises the work of Pisanello, one of the most imaginative of the International Gothic painters. He made several drawings of animals and birds from life, and has here used the story of the vision of St. Eustace as a pretext for including studies of a bear, herons, swans and sundry species of bird, as well as the horse, hounds, and deer necessary to the narrative. The story of St. Eustace relates how, when he was out hunting, he met a stag with a Crucifix between its antlers and was converted to Christianity. Although the individual animals and birds are convincingly studied from life, they are arranged over the whole of the picture surface, regardless of scale or perspective. They seem to have wandered in from the margins of a Gothic illuminated manuscript.

The scroll has, as far as is known, never had any lettering, although it may have been intended to receive the artist's signature.

Pisanello worked chiefly in Verona, for the d'Este family in Ferrara, for the Gonzaga family in Mantua, and for Alfonso V at the Neapolitan court. As well as being a painter, he was skilled at casting medallions and the head of St. Eustace here seen in profile is closely related to his medallion portraits of such people as Lionello d'Este and Sigismondo Malatesta.

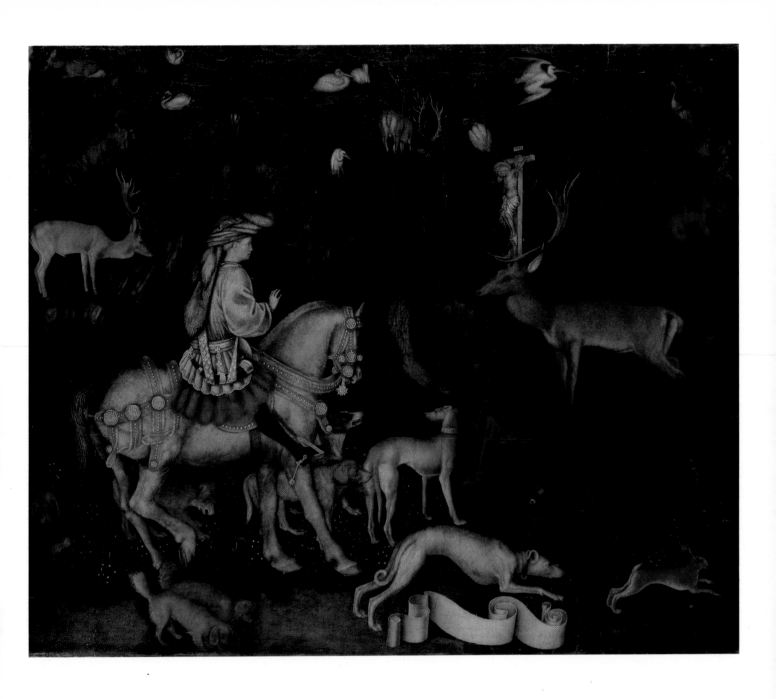

PIERO DELLA FRANCESCA *The Baptism of Christ*
active 1439, died 1492

Panel, 1.67 × 1.16

> A painter of the Umbrian school
> Designed upon a gesso ground
> The nimbus of the Baptized God
> The wilderness is cracked and browned.
>
> But through the water pale and thin
> Still shine the unoffending feet
> And there above the painter set
> The Father and the Paraclete.

(from *Mr Eliot's Sunday Morning Service*)

T. S. Eliot, when he wrote those lines, was perhaps thinking of this picture, painted about 1450, one of the most famous in the Collection.

Piero was born in San Sepolcro (where he would, incidentally, have seen Sassetta's altarpiece: *see* p.27). The naturalistic landscape background is recognisably the countryside around San Sepolcro, and painted with the same familiarity with which Constable was to depict the Suffolk landscape associated with his boyhood. The reflection of the hills, actually impossible, is a brilliant device to extend the depth of the pictorial space.

Piero wrote two mathematical treatises, and applied his knowledge of mathematics in his paintings. Part of the sense of calm in this scene derives from the lucid composition: Christ's pale body is placed precisely in the centre. On one side stand three angels, hand in hand, dressed in robes of red, blue, white and pink. Although the fluting of their classical robes is occasionally broken by a diagonal fold, there is no sense of movement. Even the figure undressing in preparation for baptism is immobile. It seems that John the Baptist will forever pour water over Christ's head from the perfectly shaped bowl.

In spirit the picture belongs to the Renaissance; in technique it is still rooted in the Middle Ages, since the pigments are tempered with egg, not with oil.

The painting was bought with great foresight by the first Director of the National Gallery, Sir Charles Eastlake, in 1861, at a time when Piero della Francesca was not yet a famous name.

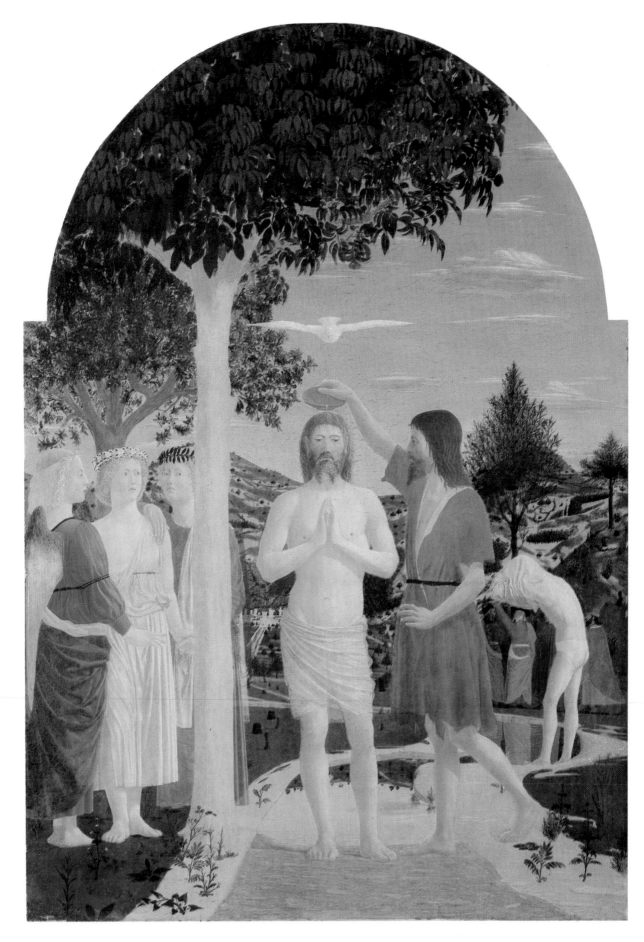

PIERO DELLA FRANCESCA *The Nativity*
active 1439, died 1492

Panel, 1.245 × 1.23

The Nativity is painted with a mixture of pigments tempered with egg and pigments tempered with oil. Possibly Piero learnt the technique of oil painting from the Flemish painters who like him were patronised by Duke Federico da Montefeltro at the court of Urbino. Similarly, the Child lying naked on the ground may reflect the influence of Flemish paintings, such as the Portinari altarpiece by Hugo van der Goes (now in the Uffizi in Florence), which arrived in Florence on 28 May 1483. Piero has elaborated this motif by placing the Child on the Virgin's robe which she has spread out over the ground. As one of his last works, of perhaps the 1480s, it is interesting to compare it with *The Baptism* (*see* p.33), an early work. The landscape is similar, but also reflects the influence of early Netherlandish landscape painting in the way in which the horizon dissolves in mists. The angels wear similar robes to those in *The Baptism,* but the front trio is bonded together more closely by the sensitive way in which Piero moves through different shades of blue. The under-modelling is no longer the pale green of *The Baptism,* but a more realistic russet for flesh tones.

The picture has suffered from over-cleaning long ago, but may also be unfinished. Like Michelangelo's *Entombment* (*see* p.57), it offers the opportunity to study the painter's technique. The underdrawing shows through clearly in places, particularly in the drawing of Joseph and the shepherds. It may be that the painting remained unfinished because Piero went blind in his old age. As late as the 17th century it was still in the possession of his heirs in San Sepolcro.

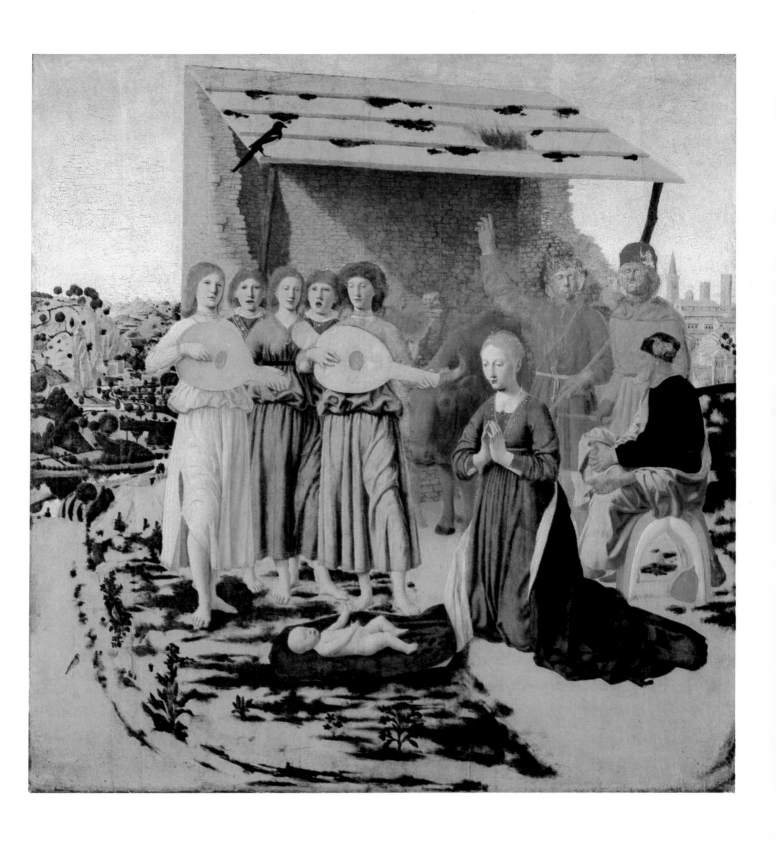

Paolo UCCELLO *The Battle of San Romano*

c. 1397–1475

Panel, 1.82 × 3.20

Paolo Uccello, Paul the Bird, was so called because he loved birds, and kept his house full of pictures of birds, as well as of cats and dogs. And he loved perspective. The 16th-century biographer, Vasari, grumbled that Uccello would have been the most captivating and imaginative painter to have lived since Giotto, 'if only he had spent as much time on human figures and animals as he spent, and wasted, on the finer points of perspective'. Here the broken lances arranged artificially on the ground lead toward a single vanishing point, and show Uccello, like the other contemporary Florentine painters, preoccupied with the possibilities of linear perspective.

However, rather than creating the illusion of three-dimensional space, the scene divides into two restricted sections: a narrow stage-like terrain bordered by foliage and a backdrop of landscape with tiny figures totally out of proportion to the main figures. The merry-go-round horses are constructed of flat geometric shapes, in white, brown, grey and black, trimmed with pretty harnesses of pale blue and real gold. The effect is wonderfully decorative – a tapestry of frozen action. And intentionally so, since the panel hung in the Palazzo Medici in Florence, together with two similar battle-scenes, now in the Uffizi in Florence and in the Louvre in Paris, all three painted about 1450.

For the Medici it represented a fanfare of political propaganda, since although the series was described in 1492 as depicting the *Rout of San Romano*, what took place in 1432 was actually a minor skirmish between the forces of Florence and Siena. Incongruously emerging from lush greenery hung with glowing ripe oranges and full-blown pink and white roses, ride the sinister Florentine knights in armour, painted with transparent glazes on silver leaf, with closed visors protecting their anonymity. They are led by Nicholas of Tolentino, singled out on his white horse, bravely unvisored, and wearing an ornate cap. A fresh-faced youth behind him is seen in the pure profile of a classical medallion. There is no sign of blood, only the crimson seeds of a splitting pomegranate. A knight bearing the Medici triple plume charges ferociously on. But, strange to relate, it seems that in this particular scene only one Sienese soldier has stayed to tackle the onslaught of a dozen or so Florentines. The rest can be seen scampering home in the distance.

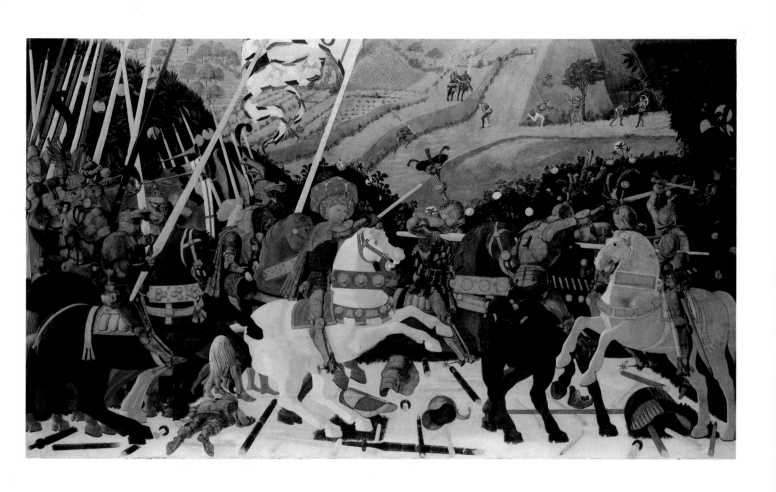

Follower of
Andrea del VERROCCHIO

Tobias and the Angel

c. 1435–1488

Panel, 0.84 × 0.66

Ignorant of the fact that his travelling companion was the Archangel Raphael, Tobias was journeying to collect money owed to his dying father, Tobit, so that the family would not be left in want. On the way, Tobias was bathing in the River Tigris when a huge fish leapt from the water and would have devoured him if Raphael had not helped him to catch and gut it. The story comes from the apocryphal Book of Tobit.

The painter shows the young Tobias, dressed in 15th-century Florentine fashionable costume, returning home to his blind father; he carries the fish he has caught in the river which winds away into the background, and a scroll with the Italian word *Ricord* – a record of the list of debts collected. Half timid, half trusting, he places his arm through Raphael's and the angel's wing curves protectively around his shoulder. Raphael holds a small container with the fish's gall with which he will cure Tobit's blindness. Not until that moment will he reveal that he is an angel.

The painter has deliberately contrasted the stolid step of the mortal Tobias with the light, airy, springing step of Raphael, but his cloak billowing out in the breeze echoes the grace of the angel's wings, which in turn pick up the blue, red and black of the boy's costume, creating a decorative and consequently emotional bond between the two. Although some passages may have been painted by a pupil, the breezy, elegant sense of movement may be due to Verrocchio's own design, and the beautiful, sensitive face of the child was surely painted by the master himself.

The painting dates from about 1467. Representations of Raphael and Tobias were extremely popular in Florence during the last quarter of the 15th century. It may be that Tobias' face is the portrait of the son of a Florentine merchant, who was being sent abroad as an apprentice. It was fashionable on such occasions to commission a painting of Tobias with Raphael, thus commending the child to the protection of a guardian angel.

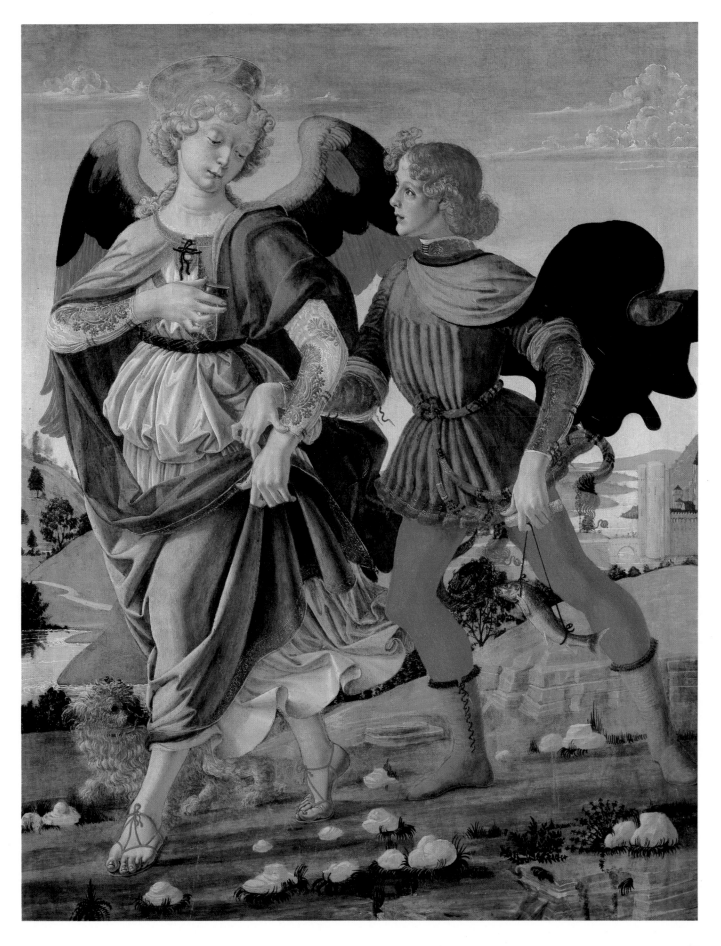

Fra Filippo LIPPI

The Annunciation

*c.*1406(?)–1469

Panel, 0.685 × 1.52

Fra Filippo Lippi, a Carmelite friar at Santa Maria del Carmine in Florence, enjoyed the patronage of the Medici family. His painting of *The Annunciation* came originally from the Palazzo Riccardi, which used to belong to the Medici family, and has the Medici device of three feathers within a ring painted in grisaille on the stone parapet. It may be that the theme of *The Annunciation* was chosen because of the expected birth of a child, perhaps the future Lorenzo the Magnificent, who was born in 1449. It was probably painted to hang over a doorway together with a similar panel with *Seven Saints,* now also in the National Gallery.

In this deceptively simple composition Lippi has achieved a synthesis of form and content. The arum lilies carried by Gabriel, symbol of the Virgin's purity, have become part of the garden's ornamentation, as well as decorating the head of her bed. The walled garden (*hortus conclusus*) provides not only a naturalistic setting, but also another symbol of the Virgin's purity. The Dove symbolises the Holy Spirit and flies straight from the hand of God towards the Virgin's womb in a flutter of haste, trailing a spiral of golden glittering movement. In keeping with the arched top, both the angel and the Virgin bow their heads in respectful greeting, but she, abashed, drops her gaze, while the angel looks steadfastly at her. As if to emphasise his supernatural being, Gabriel seems to hover above the garden of clover without making the slightest indentation or crushing any of the delicate leaves.

The outline of the Virgin's face mingles with the punched rings of the halo. Lippi avoids this mistake in the angel's face where the simplicity of pure profile is unsullied. Lippi was outstanding even among his contemporary Florentine painters for the effectiveness of his line.

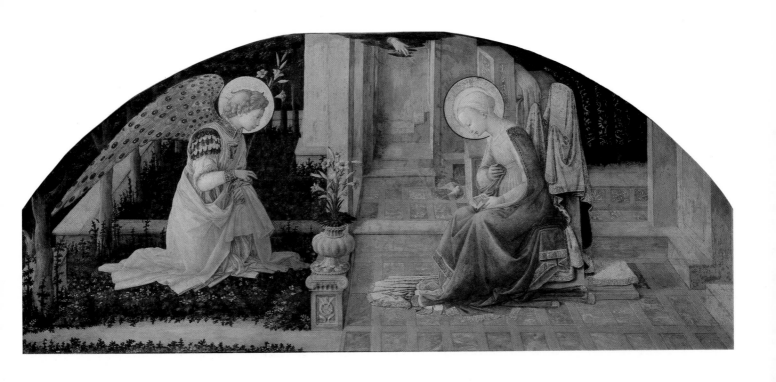

Antonio and Piero del POLLAIUOLO

c. 1441 to not later than 1496

Panel, 2.915 × 2.025

The Martyrdom of St. Sebastian

This altarpiece was painted for the Oratory of San Sebastiano attached to the church of the Santissima Annunziata in Florence, and was commissioned by the Pucci family, probably in 1475. The suffering of St. Sebastian, a Roman soldier martyred by arrows in the 3rd century during the reign of the Emperor Diocletian, became a popular subject in Italian painting during the 15th century, both because St. Sebastian was invoked as a protector against the plague (popularly seen as arrows of wrath inflicted by God), and because it offered an opportunity for the depiction of human anatomy.

The Martyrdom of St. Sebastian synthesises several of the main characteristics of Florentine Renaissance painting of the second half of the 15th century. The ruin of a classical triumphal arch not only sets the scene near Rome, but also, counter-balanced by a solid rock overgrown with flourishing greenery, symbolises the crumbling decay of the pagan world in the face of Christianity. The geometric formation of the figures in a pyramid, and the symmetry of the poses reflect the current interest in mathematical treatises. The figures of six ferocious archers wounding the patiently resigned saint are variations on only two poses, seen from different angles. As well as painters, the Pollaiuolo brothers were also sculptors, and were manifestly interested in the possibilities of three-dimensional forms seen from different viewpoints.

Stretching away in the background is a flat landscape with a winding river very similar to the landscape backgrounds of Early Netherlandish paintings. As the landscape recedes, not only do the forms diminish in size, but they grow paler in tone and less precisely defined. This device known as aerial perspective, and the use of oil technique, clearly reflect the influence of Early Netherlandish painting.

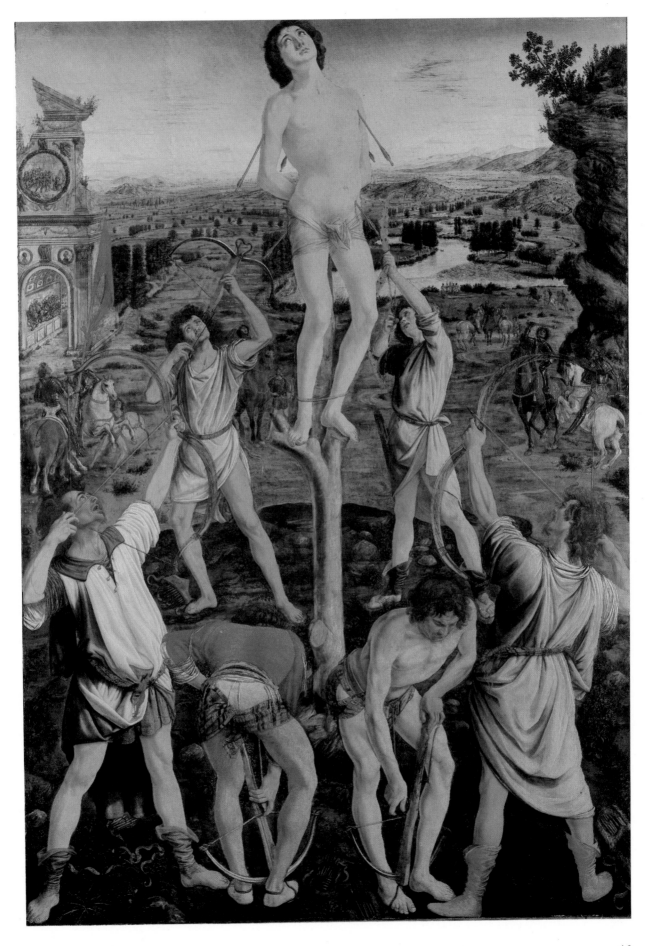

Sandro BOTTICELLI

Venus and Mars

c. 1445–1510

Panel, 0.69 × 1.735

The erotic imagery of Botticelli's *Venus and Mars*, painted in about 1485, suggests that this may have been commissioned to decorate a bedroom, perhaps to celebrate a marriage. It possibly came from one of the palaces belonging to the Florentine family of Vespucci, since the wasps buzzing around Mars' ear could be a pun on that family's name (the Italian for wasps is *vespe*). Venus, Goddess of Love, lies languidly wakeful on a cushion, fully-clothed in sinuous folds of virginal white, an enigmatic expression on her perfectly shaped face, while playful satyrs try to rouse the God of War from his sleep.

Paradoxically, it is Mars who is naked, but he slumbers on oblivious. However, the inference is that Venus will triumph since she dominates the picture: the sea in the background is a reference to her birth from the waves, as is the conch one satyr is blowing mercilessly in Mars' ear; and myrtle, growing thickly behind both Mars and Venus, is one of Venus' attributes.

During the Middle Ages most art was commissioned for religious purposes, and the majority of surviving paintings are altarpieces. During the Renaissance, paintings came to be commissioned for more secular purposes, sometimes even for furniture such as *cassone* (marriage chests) or bedroom decoration. A consequent broadening of subject-matter, coupled with an increased interest in classical authors, meant that the depiction of mythological scenes became more frequent. The precise literary source of Botticelli's *Venus and Mars* is not known, although there is some connection with a text describing the Marriage of Alexander and Roxana by the classical poet, Lucian.

Botticelli was the pupil of Fra Filippo Lippi, and also worked with the Pollaiuolo brothers. From them he learnt a style which depends on line rather than on colour, but perhaps not until the 19th century, with Ingres, did any painter achieve such expressive purity of line as had Botticelli.

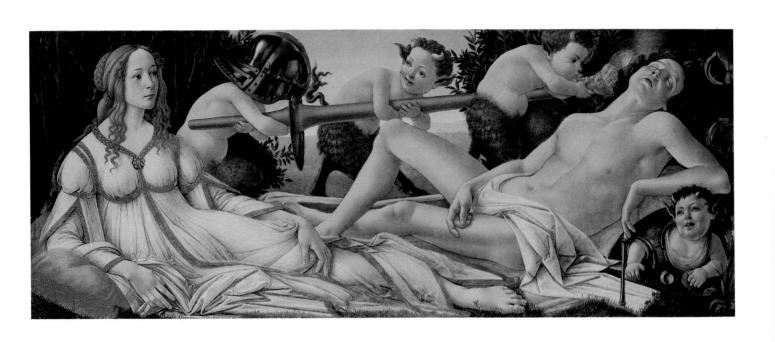

Sandro BOTTICELLI

*c.*1445–1510

Canvas, 1.085 × 0.75

Mystic Nativity

The Greek inscription at the top reads: 'I Sandro painted this picture at the end of the year 1500(?) in the troubles of Italy in the half time after the time according to the 11th chapter of St. John in the second woe of the Apocalypse in the loosing of the devil for three and a half years then he will be chained in the 12th chapter and we shall see clearly (?) as in this picture'.

Actually, we do not see clearly, and the meaning of this picture, the only signed and dated work by Botticelli, remains obscure. It appears to be a personal prayer for peace, profusely symbolised by the olive branches held by all the figures except the Holy Family. Even the three Magi adoring the Child on the left are crowned not with gold but with olive branches, as are the shepherds kneeling on the right. The angels dancing in an exhilarating ring also carry olive branches and scrolls with inscriptions which include a quotation from the Gospel according to St. Luke: 'Glory to God in the highest, and on earth Peace, Good Will to all men'. Three angels, perhaps the three archangels, embrace three secular figures in the foreground. Five tiny devils are slipping away as unobtrusively as they possibly can.

Florence was a troubled city at the end of the 15th century, and Botticelli appears to have been expressing a nostalgia for the Middle Ages by painting in a deliberately anachronistic way. As if he would reverse time, he has reversed the laws of perspective: the Virgin, the figure furthest away, is the largest, and the figures diminish in size the nearer they are. The creator of the sophisticated and elaborately complex compositions of *The Primavera* or *The Birth of Venus* here divides the surface into three simple horizontal layers. He uses colour purely for pattern. Moreover, he chooses the very colours favoured by medieval painters, particularly the Sienese: the ring of angels, whose garments billow softly with the rhythm of their dance, is interwoven in a pattern of pink, olive green and white. Their robes are tinged with gold which emanates from the golden disc of heaven which has parted the natural sky and creates a mysterious glow in the forest clearing behind.

Botticelli was himself to become a focus for nostalgia when he came to be admired by several of the Pre-Raphaelites.

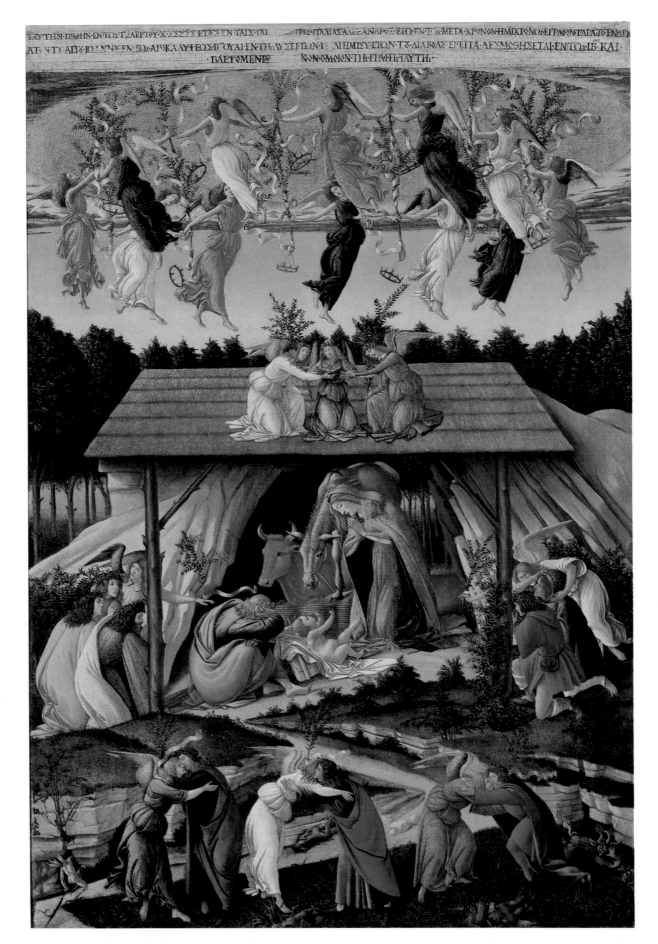

LEONARDO da Vinci
1452–1519
Panel, 1.895 × 1.20

The Virgin of the Rocks

Leonardo trained in Verrocchio's studio, and Vasari relates how when the master saw Leonardo's contribution of the face of the angel to *The Baptism of Christ* (now in the Uffizi, Florence), he laid down his brushes and never painted again, knowing that he would never surpass his pupil. By the time Leonardo came to paint *The Virgin of the Rocks*, he was at the height of his powers.

The Virgin of the Rocks was originally the altarpiece of the chapel of the Confraternity dedicated to the Immaculate Conception in the church of San Francesco Grande, Milan. The two wings, each with an angel playing a musical instrument (also in the National Gallery), were painted by his pupils, the brothers Evangelista and Giovanni Ambrogio Preda. Another version of *The Virgin of the Rocks,* also by Leonardo, is in the Louvre in Paris. The exact relationship of these two paintings is still unclear, but it seems that the altarpiece commissioned by the Confraternity in 1483 was the Louvre version, and that Leonardo was commissioned to make a copy, the National Gallery version. In the event the copy seems to have remained *in situ,* and the first version to have been sent to France.

The figures are arranged in a pyramidal composition, locked in a silent communion which excludes the spectator. The Virgin places one arm protectively over the infant John the Baptist; the other hovers over the Christ Child, who blesses St. John, and is himself held gently by the angel.

Leonardo drew ceaselessly. With his pencil he investigated the external world of plants and rocks, the forms of hair and drapery, with such a restless energy as if he would discover the secret of the life-force itself. The sense of drawing and structure which underlies the painted surface is of prime importance, and the actual paint layer is so secondary as to have been left unfinished in places. Indeed, this altarpiece is more like a drawing than a painting. Apart from the graceful golden lining and the subdued blues of the Virgin's robe, and the more translucent blues of the sky and pools, the picture is devoid of colour. The almost monochromatic forms are modelled with a soft *sfumato* (from the Italian, meaning 'smoked'): in his notebooks, Leonardo wrote that light and shade should blend 'without lines or borders, in the manner of smoke'.

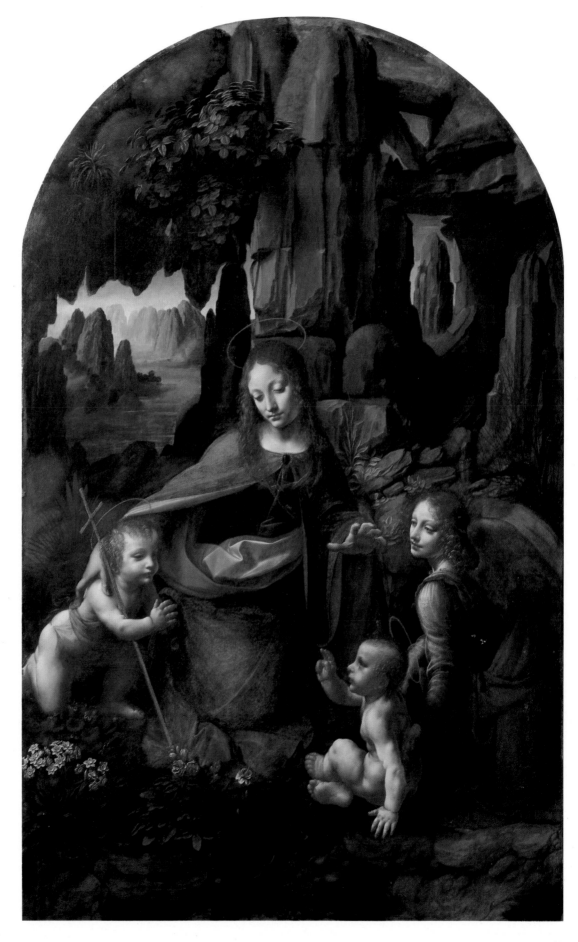

LEONARDO da Vinci

1452–1519

Chalk on paper,
mounted on canvas, 1.415 × 1.04

Cartoon: The Virgin and Child with St. Anne and St. John the Baptist

The word cartoon derives from the Italian *cartone* meaning a large sheet of paper. A painter of frescoes and large-scale panel-paintings would normally make a small sketch for a picture and then scale it up to the size required. The outlines were pricked through on to the gesso and pounced: that is, charcoal was dusted through the holes, leaving an outline for painting when the paper was removed.

This large-scale drawing, dating from the mid-1490s, is in black chalk heightened with white, on several sheets of reddish-buff paper stuck together and now attached to a canvas. It has never been pricked, which indicates that it was never used for a painting. Leonardo was above all else a draughtsman, and the highly finished state of some areas of the drawing suggests that he regarded it as complete in itself.

The figures, harmoniously intertwined, combine two traditional themes. The subject of the Virgin and Child sitting in the lap of the Virgin's mother had already been painted by Masaccio in an altarpiece for Sant' Ambrogio in Florence (now in the Uffizi), while the representation of the Virgin and Child with St. John the Baptist was popular during the Renaissance, particularly in the city of Florence which was dedicated to St. John the Baptist. From the dense mass of lines where Leonardo has ceaselessly experimented and changed his mind, and the softness of the modelling, emerge figures which combine the sweetness of Raphael with the monumentality of Michelangelo, but the forms are imbued with a veiled mysticism that is uniquely Leonardo's.

Through his many drawings and notebooks much is known about Leonardo's life and ideas, and his discoveries in anatomy and aeronautics. Yet the essence of his genius as an artist remains always elusive.

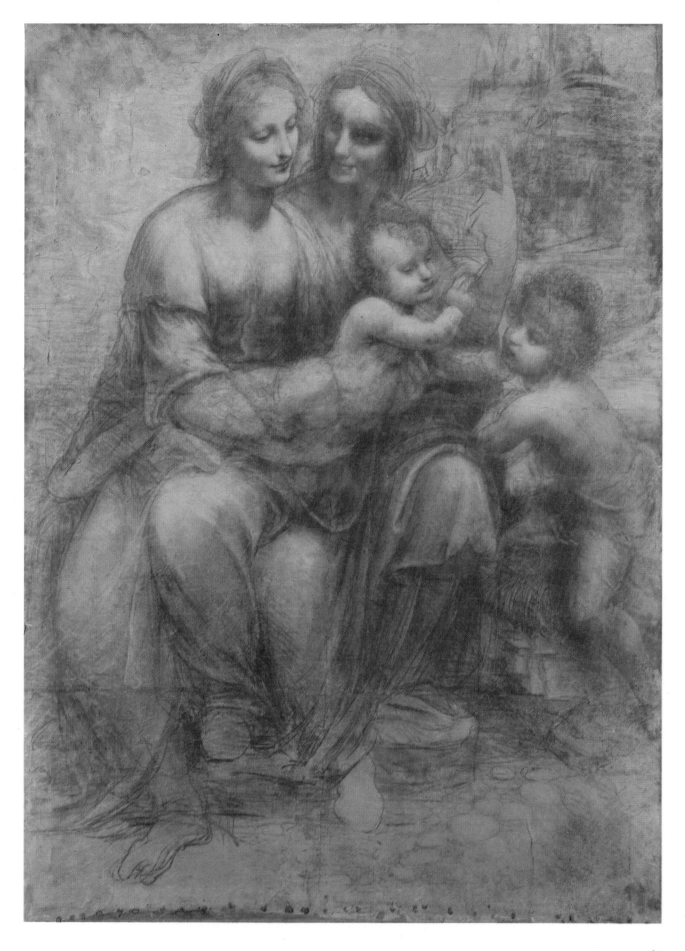

51

RAPHAEL

The Ansidei Madonna

1483–1520

Panel, 2.388 × 1.562

It was from Leonardo that Raphael learned to convey a psychological introspection in the features of his sitters, as here in the altarpiece known as *The Ansidei Madonna.* He probably painted it in 1505, when he was emerging from the tutelage of Perugino, and had possibly seen some of Leonardo's work in Florence.

Not only stylistically and psychologically does Raphael appear here as a mature artist. The relationship of the altarpiece to its setting has been carefully thought out. It was commissioned by Bernardino Ansidei for the family chapel in the church of San Fiorenzo in Perugia. The chapel was dedicated to St. Nicholas of Bari, hence the presence of the Bishop saint with three golden balls at his feet, symbolising the dowry he provided for three impoverished girls. St. John the Baptist, on the other side, looks towards the main altar of the church, above which would have been a Crucifix. Thus an implicit link is made between the suffering Christ and the small Child who perches contentedly on the Virgin's knee and still needs her steadying hand on his shoulder, while she points out the letters of a devotional book to him. The altarpiece was originally supported by a predella with three scenes dedicated to each of the main protagonists: *St. John the Baptist preaching* (on loan to the National Gallery); *The Marriage of the Virgin,* and *St. Nicholas saving the lives of seafarers;* both the latter panels are now lost.

Each figure is a serene and compact unity in itself; not one overlaps another, and each is absorbed in isolated inward contemplation. Yet all are linked by a harmony of proportion in their relationship to the cool grey classical architecture. The vaulted niche is emphatically designed to be seen from a low point below the altar and as a continuation of the real or ideal architecture of the church. Raphael has brilliantly combined an indoor and outdoor setting by piercing the back wall to open into a view over blue Umbrian hills dissolving into mist under a limpid blue sky.

Essentially this altarpiece has all the elements one associates with the High Renaissance. Only one remnant of medieval painting remains: the strands of the Child's hair are highlighted with gold.

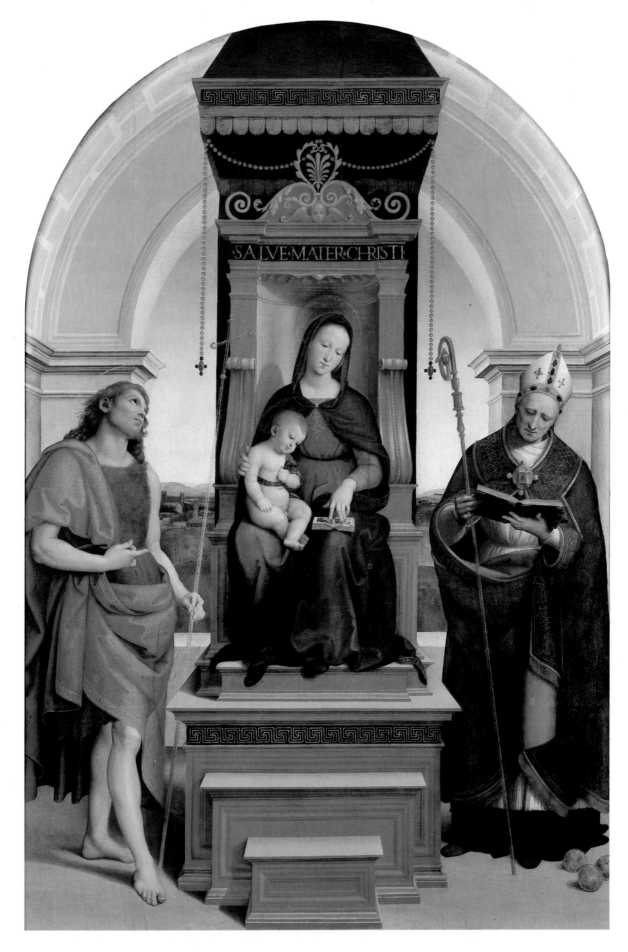

Italian School

RAPHAEL
1483–1520

Panel, 1.08 × 0.87

Pope Julius II

In 1508 Raphael went to Rome, and by 1509 he was working on the frescoes in the Vatican *Stanze* for Pope Julius II. About a year before the Pope died at the age of 70, Raphael painted this compassionate portrait of his patron. For over a century no Pope had been bearded. But in June 1511, Julius appeared in Rome wearing a beard as a token of mourning for having lost sovereignty over the city of Bologna; by March 1512 he had shaved it off, a fact that enables this portrait to be dated precisely between those dates. In September 1513, after the Pope's death, the portrait was put up in Santa Maria del Popolo in Rome, the church of the della Rovere, the Pope's family. According to Vasari, the likeness was so convincing that all who saw it were intimidated. Indeed, Raphael's mastery of the technique of oil painting enabled him to attain the sort of realism Bellini had achieved a few years earlier in his portrait of *Doge Loredan (see* p.79).

The sitter is shown three-quarter length, and at an angle, turning away from the spectator in inner sorrow. The sensitive, bejewelled fingers of one hand tighten nervously on the arm-rest of the chair while the other hand clutches a white kerchief. Behind the earnest, brooding eyes, sunken jaw, and sagging bulbous cheeks is sensed the substructure of a skull. The vertical line of the corner of the green wall behind implicitly confirms the change in plane from the pinkish wrinkled forehead, which catches the light, to the temples darkened with shadow.

The pattern of the wall-fabric with the papal crossed keys and tiara, and the gleaming acorns, punning emblems of the della Rovere family (the Italian for oak is *rovere*), are the sole indications of the status of this old man, the spiritual head of Christendom. There is a monumental simplicity in the use of only three main colours divided into broad areas of white, red and green. With fluid brushstrokes Raphael has studied the soft runnels of the white linen robe, the tremulous delicacy of the gold and red tassels, the few wisps of ermine caught in the scarlet buttonholes, and the reflection of the scarlet cap in the right-hand acorn top to the chair.

The portrait was to be enormously influential not only on subsequent papal portraits, but on the development of portraiture in general. Rembrandt, in particular, used the three-quarter pose for many of his sitters, and his portrait of *Margaretha de Geer (see* p.161) seems closely derived from Raphael's *Julius II*.

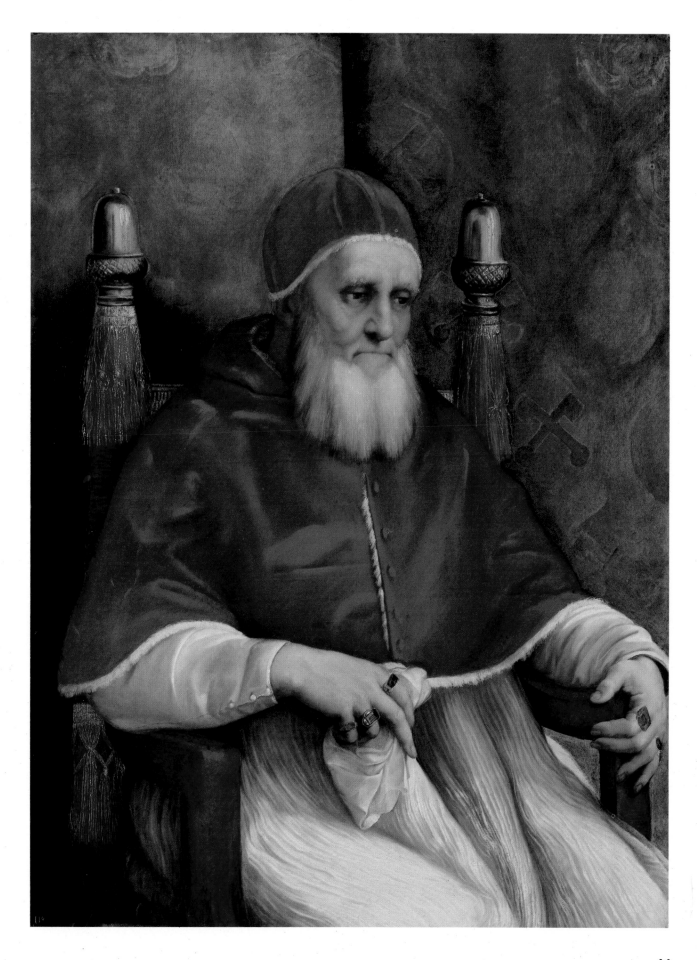

MICHELANGELO Buonarroti *The Entombment*

1475–1564

Panel, 1.61 × 1.49

It is only too easy when walking around a collection of paintings to forget the close-knit nature of all the visual arts – of painting, sculpture, and architecture, particularly in the Renaissance. Michelangelo was not only a painter, but also architect and sculptor, and even poet. His pre-eminence as a sculptor and fresco-painter is very much in evidence in *The Entombment,* a rare example of an easel-painting by him, which may have been destined for the free-standing tomb he was designing for Julius II. The tomb was never finished. Nor was this painting. In it his technique can be studied from the initial blocking in of the general design, with a minimal amount of underdrawing, to the highly finished figure of Christ which resembles polished marble. In fact the *Pietà* was a subject often carved by Michelangelo in marble. The syncopated rhythm of the figures who unfold across the composition from right to left comes from the brush of an artist used to painting large-scale narrative scenes in frescoes: olive greens, pinks and oranges are interwoven in isolated blocks of virtually monochromatic colour. Looped together by the shroud which supports Christ's inert slumping body, they have the compact unity of having been hewn from a single piece of stone. As in Michelangelo's sculpture, the forms seem to be inherent, waiting to be discovered by the artist, by adding colour, rather than by chipping away stone.

Intensely powerful, remote and impassive, these superhuman god-like figures – presumably Joseph of Arimathaea, the three Marys and an androgynous figure, perhaps originally St. John the Evangelist – carry the helpless dead Son of God towards the tomb in the background. The emphasis is on the human form. There is no interest in landscape, and the scene has been idealised to the point of abstraction. There is no sign of the Cross or the hill of Golgotha in the distance; Christ's body is immaculate, untouched by wounds or blood. It is, in fact, only through an iconographic association with such pictures as *The Entombment* by Rogier van der Weyden (now in the Uffizi, Florence), which Michelangelo may have seen in the Medici collection, that the subject-matter is identifiable.

Michelangelo's response to classical sculpture was profound, and in this instance it is possible to identify a specific prototype. On 14 January 1506 a Roman digging in a vineyard discovered the *Laocoön,* a classical antique statue of a priest and his two sons, struggling in agony as they are strangled to death by writhing snakes. It is generally accepted that the intertwined figures of *The Entombment* were inspired by the *Laocoön,* and that it was probably painted about 1507.

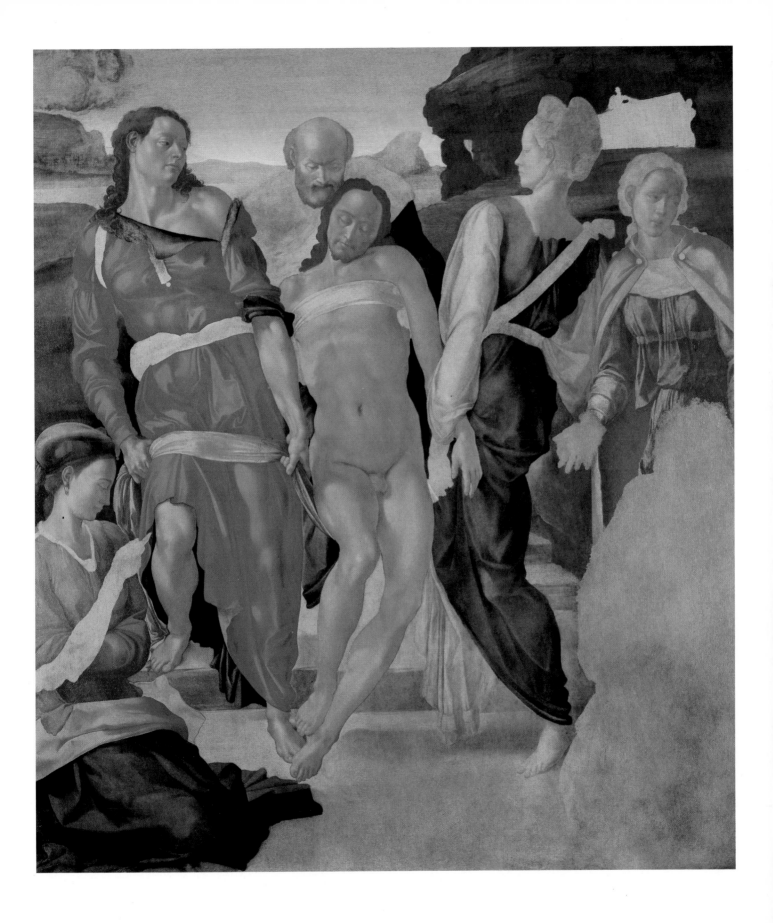

Andrea d'Agnolo, called DEL SARTO

1486–1530

Portrait of a Young Man

Canvas, 0.72 × 0.57 Signed, top left, with the artist's monogram.

> 'You turn your face
> But does it bring your heart?'

In Robert Browning's dramatic monologue, sub-titled *The Faultless Painter,* Andrea del Sarto is addressing his fickle wife, as she models for him, and not this young man in a black three-cornered hat. Yet the two lines capture one of the essences of portrait painting, the moment when spectator and sitter are locked in confrontation and communication, and when the sitter's face must convey a synthesis of character, of living, of being. Here the sombre brown eyes, set mouth, and pronounced but solemn dimple turn inquiringly as if to put that very same question in Browning's poem back at us. The earnest young man holds an indistinguishable grey object, perhaps a piece of clay or marble, or a book, which has led to suggestions that he may be a sculptor or writer. Otherwise the painting is bare of clues as to the identity, status, foibles, or interests of the sitter.

The background is a plain, stern grey. The bulk of the triangular blue-grey sleeve, almost chiselled out of fabric and echoing the shape of his hat, is thrust forbiddingly forward, placing a barrier between him and the spectator, in a way very similar to Titian's *Portrait of a Man* with a blue sleeve (*see* p.83). The brilliant white light which catches in the rivulets of the shirt across his shoulder seems to come from an invisible window on the left through which the Florentine daylight is streaming in. The portrait probably dates from about 1517. The starkly simple areas of charcoal black, pale grape-purple and hard stone-grey, around one glaring patch of white, are reminiscent of Raphael's use of colour in the portrait of *Julius II* painted a few years earlier (*see* p.55).

Like Leonardo, Andrea del Sarto attracted the attention of Francis I, but soon returned to Florence after a brief visit to France in 1518/19.

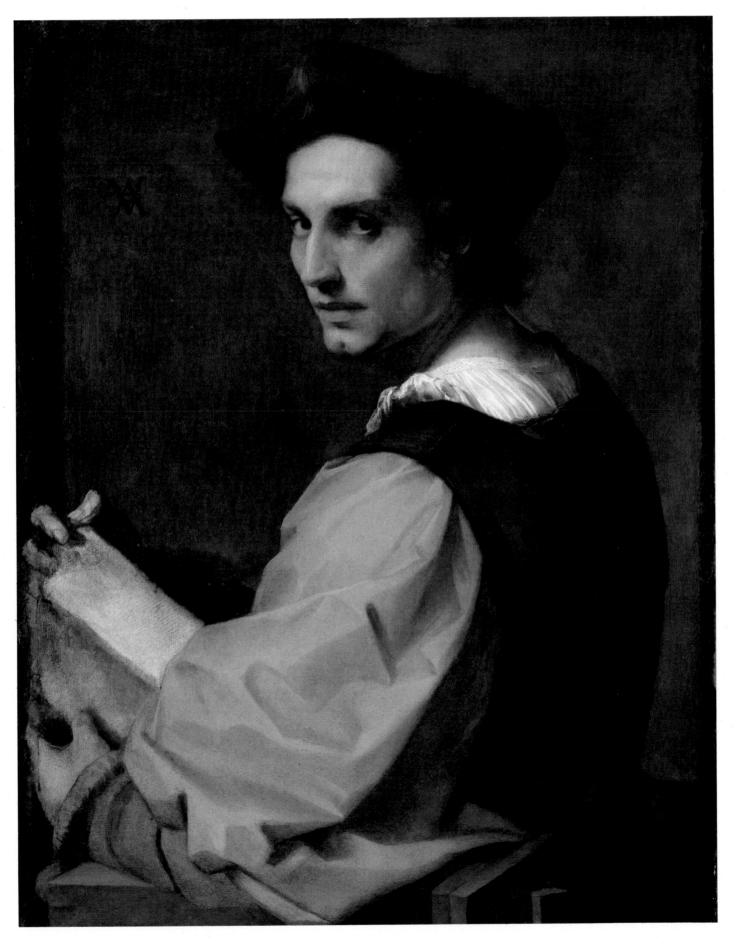

Agnolo di Cosimo, called BRONZINO

An Allegory with Venus and Cupid

1503–1572

Panel, 1.46 × 1.16

Central to Bronzino's allegory is Venus, Goddess of Love, holding in her hand the golden apple which she won from Paris as a prize for her beauty. In the corners are her attributes: doves, and a bush of myrtle. She is disarming Cupid by drawing his arrow from his quiver as he embraces her, and is about to thrust his own arrow through his wing, thereby destroying all his powers.

Envy, a sexless withered creature, tears at its own hair, screaming with rage at their loving relationship, and in the background lurks Pleasure, a monster with a human face but a reptile's body. In one hand she alluringly holds the honeycomb which signifies the delights of love, and in the other her tail, with the sting of pain. A laughing child, about to throw rose petals at the loving couple, has an anklet of bells for dancing, while one foot is pierced by a thorn. At Venus' feet lie masks, perhaps of comedy and tragedy. In the top left-hand corner a mask may symbolise Fraud. Time, a winged old man with an hour-glass whose sands are running out, hovers over the group with a brilliant blue cloak. Is it that Love will always be a mixture of exquisite Pain and Pleasure, dogged by Envy and Fraud, which Time will reveal? Or is it that human life, Love and Beauty, threatened as they constantly are by Envy and Deceit, will eventually all be annihilated by Time and, implicitly, Death?

Bronzino's elaborately distorted forms, the highly finished figures painted an unnatural white as if of polished marble, perhaps influenced by Michelangelo, and the unreality of the brilliantly hard enamel-like colours, represent a sophisticated defiance of the naturalism which Renaissance painters had been striving towards and achieved. By about 1550, when this picture may have been painted, painters had mastered the art of painting in oil to such a degree that they could now afford to be deliberately artificial and non-naturalistic.

Bronzino was in effect Court Painter to Duke Cosimo de' Medici, and this painting may have been sent by the Florentine ruler as a gift to the pleasure-loving Francis I of France.

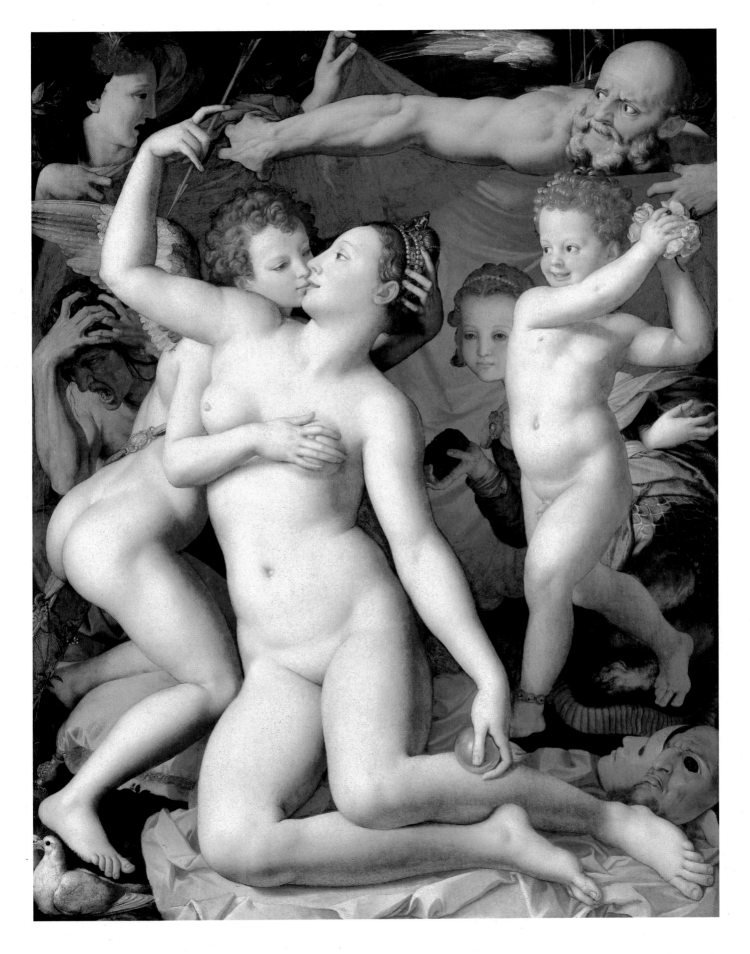

Jan VAN EYCK

A Man in a Turban

active 1422, died 1441

Oak panel, 0.333 × 0.258 Inscribed: AVC.IXH.XAN.JOH̄ES.DE.EYCK.ME

FECIT.ANO.M.CCCC.33.21OCTOBRIS.

Jan van Eyck, the major Early Netherlandish painter of the 15th century, was credited by Vasari with having been the inventor of the technique of oil-painting, although it is now recognised that he was not the inventor but one of the earliest and most brilliant exponents of a developing technique. The translucent quality of oil as a binding medium for pigments enabled the painter to achieve realistic effects which were not possible with the more opaque egg tempera where every brush stroke showed. So perfect was van Eyck's technique that his pictures have survived in immaculate condition.

This early picture, possibly a self-portrait, dated 1433, is inscribed at the top with the words which translated run: 'As I can', the first part of a Flemish proverb. The pun on his own name gives the inscription a second meaning of 'As Eyck can'. Read like this, the picture appears to be a boast or perhaps a riposte to a similar picture by another painter, such as the portrait of a man in a red turban attributed to the Master of Flémalle, also in the National Gallery. However, the second part of the proverb runs: 'But not as I would'. Such humility might seem to be strange coming from a man who had been appointed Court Painter to Philip the Good, Duke of Burgundy, in 1425, and was greatly admired by his patron.

The picture concentrates on the face, framed only by the elaborately balanced folds and tucks of the red turban and a tightly drawn fur-collared jacket. The spare, almost mean face, with its greying stubble, thin lips and cold shrewd eyes with sagging wrinkled pouches, is observed with honest psychological – as well as visual – realism. Flattery is absent. This searching scrutiny, characteristic of Early Netherlandish painting, is very different from the idealising portraits of contemporary painters in Renaissance Italy, such as Domenico Veneziano.

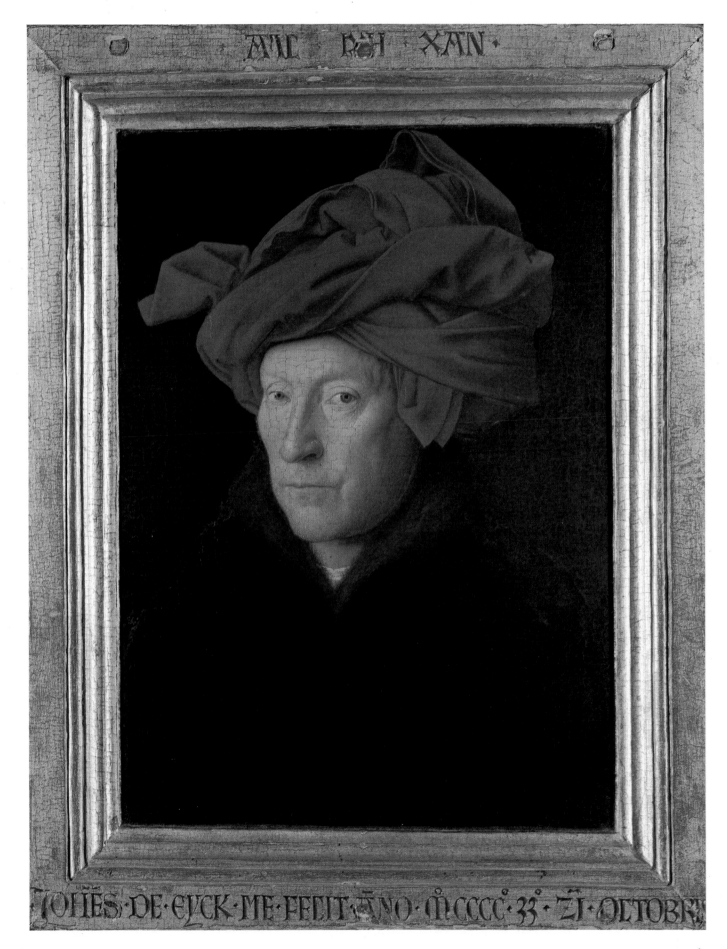

Jan VAN EYCK

active 1422, died 1441

The Arnolfini Marriage

Oak panel, 0.818 × 0.597. Signed: *Johannes de Eyck fuit hic 1434*

From about 1430 onward until he died, Jan van Eyck worked mainly in Bruges. An Italian merchant, Giovanni Arnolfini, living in Bruges, was married to the daughter of a Lucchese silk merchant, Giovanna Cenami, and this is thought to be their marriage portrait.

On the face of it, the subject-matter appears to be straightforward – a couple in a bedroom surrounded by household objects. But how many middle-class housewives would tolerate graffiti on their walls? At first sight the only aspect not perfectly consistent with an everyday interior is the Latin inscription: *Johannes de Eyck fuit hic 1434* (Jan van Eyck was here in 1434). The terminology and use of a flourishing notarial script indicate that Jan van Eyck was there in a double capacity: as painter recording the event, and as a legal witness; and, in fact, the famous mirror reflects two figures. We are prompted to look for religious symbolism, so that the everyday objects take on an added meaning. The single apple on the window sill symbolises the Fall of Man, redeemed by the Passion of Christ shown in the small scenes which encircle the mirror; beside the mirror hangs a rosary. The single candle burning in the candelabrum signifies the presence of God, and the couple have removed their pattens because they are in effect on holy ground. It becomes apparent that what is being shown is the actual marriage, the swearing of solemn vows. And the two main virtues of marriage, fertility and fidelity, are being invoked. The green of the bride's robe, and the dog are both symbols of fidelity. Carved on the bed-head is a wood statue of St. Margaret, patron saint of childbirth (*see* p.141).

Jan van Eyck's meticulous technique enabled him to convey objects with unprecedented and convincing realism. With the brilliant device of the mirror, the space in the painting extends to incorporate the actual space in which we, the spectators, stand, fusing the pictorial and real world.

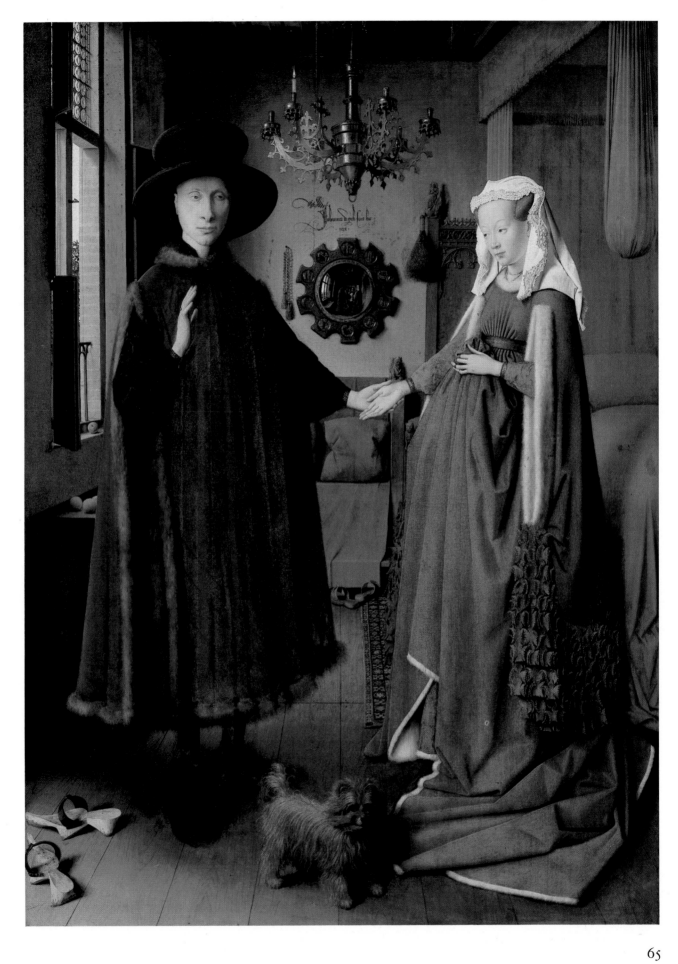

Robert CAMPIN *The Virgin and Child before a Firescreen*
1378/9–1444
Oak panel, 0.635 × 0.49

It became a feature of Early Netherlandish painting – which was to last into the 17th century – that everyday objects were invested with symbolism, first religious and eventually secular. This painting of the Virgin and Child, of about 1434–8, attributed to Robert Campin, a contemporary of van Eyck, is a typical example. The plaited cane firescreen also serves as a halo behind the loosening plaits of the Virgin's hair, and a tiny flicker of flame is a reference to Pentecost when the Virgin and disciples received the Holy Spirit. The lions carved on the bench refer to the throne of Solomon, also associated with the *sedes sapientiae,* or the seat of wisdom, of the Virgin. The triangular stool may be a reference to the Trinity. The naked Child will eventually be sacrificed in order to redeem the sins of Man. The chalice and elaborately carved cabinet are additions, and thought to be a 19th-century restorer's fancy.

Every detail has been carefully observed, and the ponderous folds of the Virgin's robe, perhaps influenced by the work of the northern sculptor, Claus Sluter (*d.* 1405/6), convey a sense of solid three-dimensional space. But, however convincing the technique may be, realism has been subordinated to symbolism. There is a touch of maternal neglect in the fact that Mary wears a fur-lined robe, and a fire burns in the hearth, while the cheerily naked Child is exposed to the cold northern air from the open window. Through it we glimpse a town with the townspeople setting about their daily tasks, such as the mending of a roof.

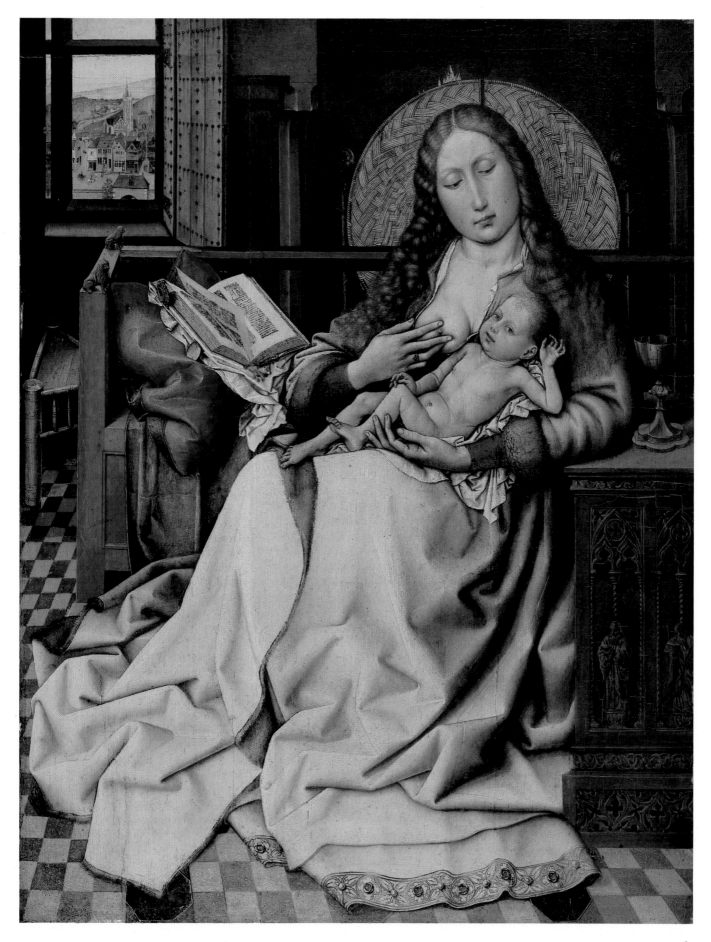

Rogier van der WEYDEN

*c.*1399–1464

Panel, 0.61 × 0.54

The Magdalen reading

The saint seated reading a devotional book is identifiable as Mary Magdalen by the jar beside her, a reference to the ointment with which she anointed Christ's feet. The panel is tantalising because it is a fragment of a lost altarpiece. When this picture was cleaned in 1956, it was discovered that the Magdalen was not a solitary figure, but that the plain background behind was overpainted, and concealed the fragmentary figure of St. Joseph, holding a rosary, standing behind her, and another, in red, kneeling to the left. This confirmed that the panel was once part of a much larger altarpiece. It has been reconstructed with the help of a drawing in the National Museum at Stockholm, and a fragmentary panel with the head of St. Joseph in the Calouste Gulbenkian Foundation in Lisbon. Originally, Mary Magdalen was in the bottom right-hand corner of a larger composition which included the Virgin and Child at the centre.

Rogier was one of the leading painters in the Netherlands during the middle of the 15th century, active mainly in Tournai. His style is more expressive and less analytical than that of van Eyck, but his technique is no less realistic. The very nails in the floorboards are painstakingly rendered.

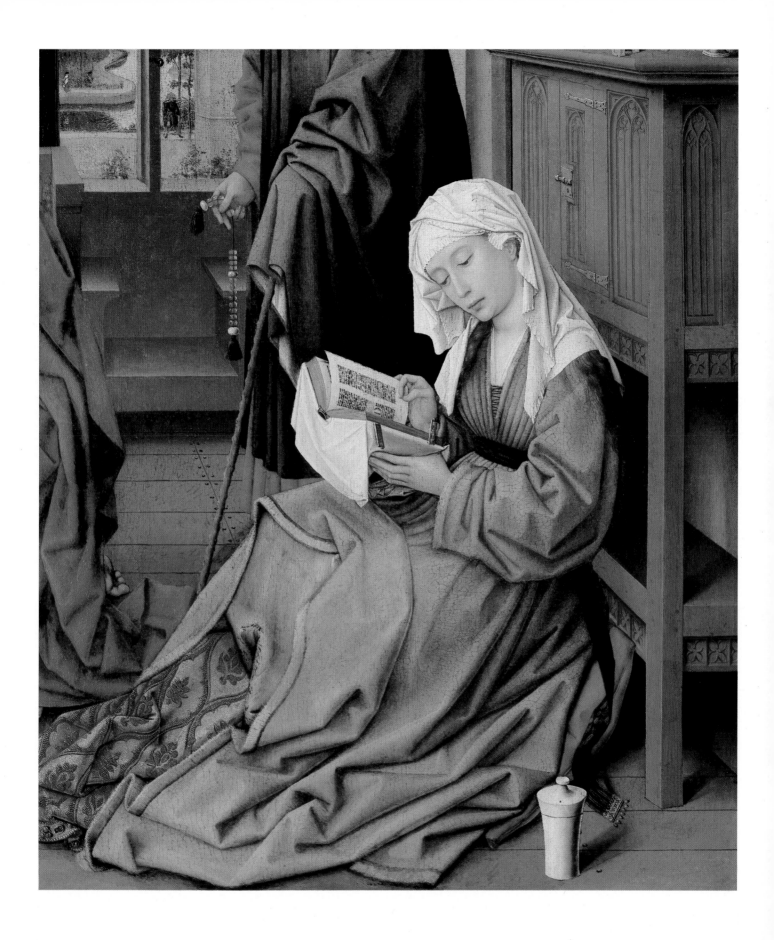

Hans MEMLINC
active 1465, died 1494

Oak panel, centre: 0.705 × 0.705; wings: 0.705 × 0.305

The Donne Triptych

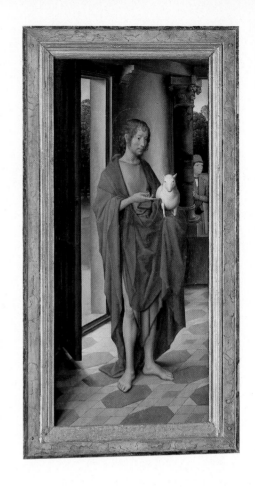

Hans Memlinc was perhaps a pupil of Rogier van der Weyden and worked mainly in Bruges where he may have painted this triptych for an Englishman, Sir John Donne. Donne was in Bruges in 1468 for the marriage of Margaret of York, Edward IV's sister, to the Duke of Burgundy, Charles the Bold. This may explain why Sir John and his wife, kneeling in the foreground, wear the Yorkist collar of roses with King Edward IV's pendant, the lion of March. It is known that Donne visited Flanders again in 1477.

The kneeling donors are identifiable by their coat-of-arms which decorates two of the capitals and the stained glass window in the right wing. Behind Lady Donne kneels one of their daughters. Sir John is being presented to the Virgin and Child by St. Catherine, carrying the sword with which she was beheaded. The Child's gesture is somewhat ambiguous, either blessing Sir John, or reaching for the pear held up by the angel, or both. St. Barbara carries her attribute, the tower in which she was imprisoned by her father. The tower almost blends with the neat Flemish landscape in the background where men carrying a sack of flour to a mill, swans and a huntsman are shown in minute detail. The patron saints of the donor stand in the wings of the triptych: St. John the Baptist on the left, St. John the Evangelist on the right. Normally the wings of a triptych were treated as completely separate entities. But here they have been cleverly integrated with the central panel by the columns of the portico and receding tiled floor which includes the two saints in the same space as the figures in the central panel. Half-hidden by one of the columns is a figure watching the scene, perhaps a self-portrait of the artist whose name saint would also have been John.

The Virgin and Child looking together at a devotional book seems to have been primarily a northern motif, and such a Flemish picture may have been the inspiration behind Raphael's *'Ansidei Madonna'* (see p.53).

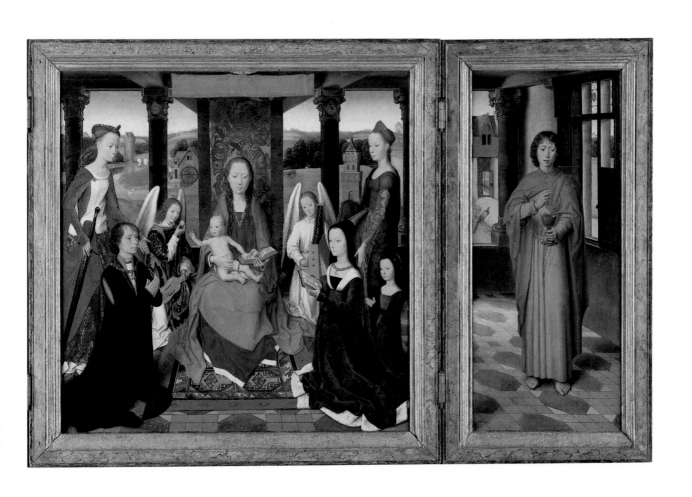

ANTONELLO da Messina

active 1456, died 1479

Lime panel, 0.46 × 0.365

St. Jerome in his Study

The Sicilian painter, Antonello da Messina, is generally credited with having introduced the technique of oil painting into Venice. During a visit to Naples, sometime before 1456, he probably came into contact with works by Jan van Eyck and Rogier van der Weyden. His painting of *St. Jerome in his Study* may derive from a St. Jerome by van Eyck which formed one wing of a triptych in Naples. Indeed, so close is the picture to the work of Early Netherlandish painters that, during the 16th century, it was attributed by some to van Eyck and by some to Memlinc. Similar to Early Netherlandish paintings is the attention to detail in the still-life of the ceramic pots, the brass bowl, the setting of the composition on a spacious receding tiled floor, and the view through a window to a scene beyond, totally unconnected with the main one. The friars strolling by a stream and figures in a rowing boat are far removed from the world of scholarship and learning of St. Jerome.

The saint, who is represented as a cardinal, is surrounded by nearly thirty volumes with markers or propped open at a particular page. St. Jerome wrote a number of influential commentaries, translated texts from Greek and Hebrew, and produced the standard Latin text of the Bible, later known as the Vulgate. He is also shown wearing a hairshirt, a sign of penance. He spent five years living in a desert as a hermit during which time he befriended a lion.

The picture was in a Venetian collection in 1529, and Antonello da Messina was definitely painting in Venice in 1475. However, whether this picture was painted in Venice or Naples has not yet been resolved.

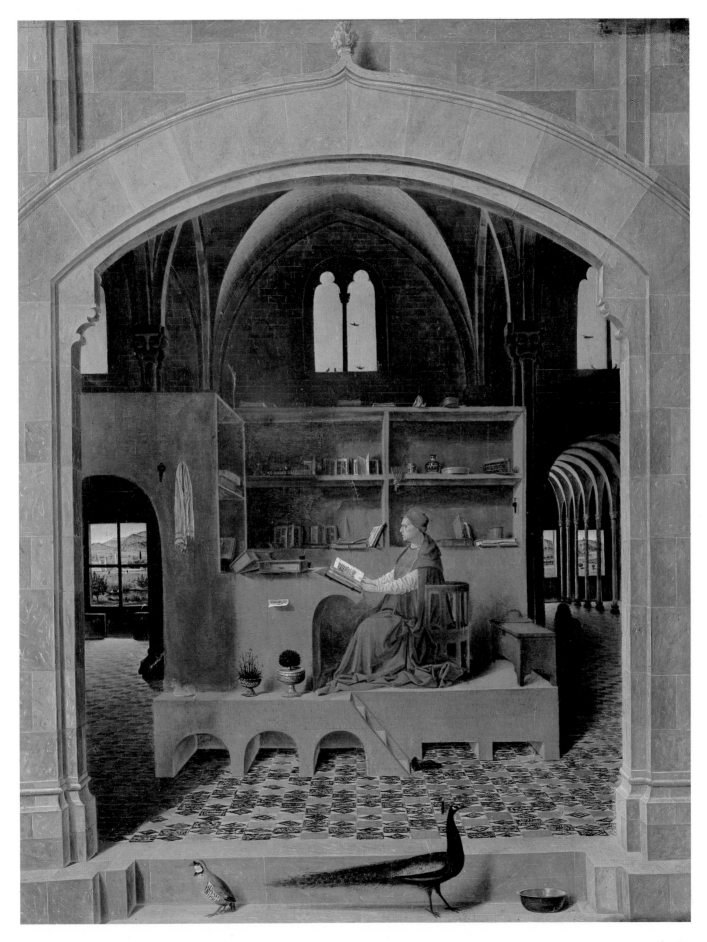

Andrea MANTEGNA *The Agony in the Garden*
*c.*1430/1–1506

Panel, 0.63 × 0.80 Signed: OPUS . ANDREAE . MANTEGNA

Where Florentine painters used landscape primarily as compositional setting, Venetian painters used it to evoke a mood.

Mantegna's picture is of Christ praying in the Garden of Gethsemane on the Mount of Olives, while the Apostles sleep and Judas leads the chief priests and the multitude 'with swords and staves' to arrest him. In the foreground is the brook Cedron, mentioned only in the Gospel of St. John (XVIII, 1). Christ is praying that he may be spared the suffering of the Crucifixion. Cherubs, not mentioned in the Gospels, show him the instruments of the Passion – the cross, flagellation column, lance and sponge. The scene is dominated by oppressive rocks which tighten in streaming concentric layers around the lonely Son of God and the frail, crumbling city of Jerusalem in the background. Behind it, in strong contrast, the structured blocks of stone and the single spiralling rock, seem in themselves a city more enduring. The landscape is arid, with only a few sparse blades of grass. A single fig-tree growing impossibly out of the solid rock, may symbolise redemption. And Mantegna has chosen the face of the rock for his signature, which appears to be chiselled out of the stone.

Three factors contributed towards the sculptural and yet very linear style of Mantegna's early work. His training under the Paduan painter, Francesco Squarcione, had consisted in studying antique sculpture. In Padua the high altar of the Santo was decorated with bronze statues and reliefs sculpted by the Florentine, Donatello. Thirdly, Mantegna was a skilled engraver, inspiring even Dürer to imitate his engraving of *The Battle of the Sea Gods. The Agony in the Garden,* which was probably painted in the 1460s after he had left Padua and become Court Painter to the Gonzaga family in Mantua, has the effect of both a relief and an engraving. In spite of the elaborate use of perspective and foreshortening, the precision of drawing makes the final effect that of a shallow relief sculpture.

Mantegna's brother-in-law, Giovanni Bellini, painted a version of the same scene with a much more open landscape, which is also in the National Gallery.

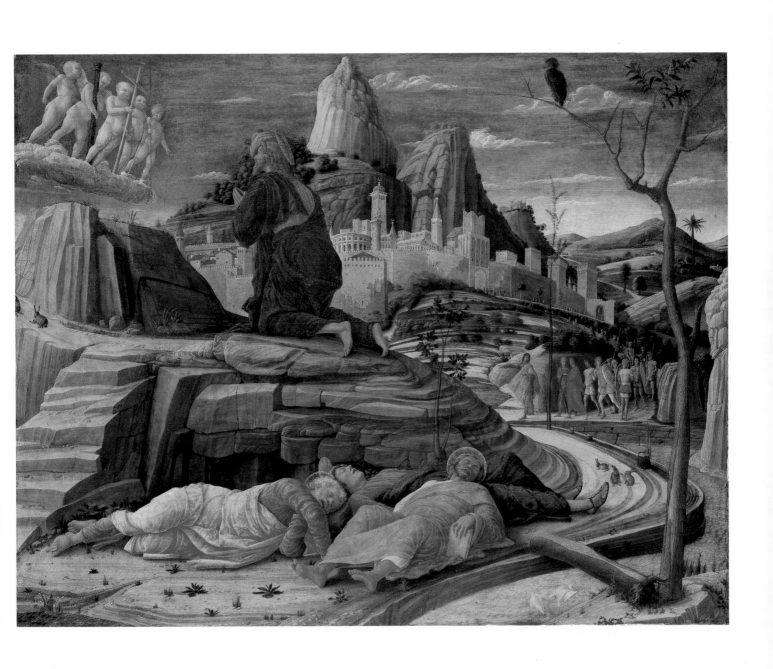

Carlo CRIVELLI
active 1457–1493

The Annunciation with St. Emidius

Panel, transferred to canvas, 2.07 × 1.46 Signed: OPUS CAROLI CRIVELLI .
VENETI . 1486

In 1482 Pope Sixtus IV granted the town of Ascoli Piceno in the Marches in central Italy certain rights of self-government under the general control of the Church. The news of this privilege reached the town on 25 March, the Feast of the Annunciation. Each year thereafter there was a procession on that date to the church of the Santissima Annunziata.

This commemorative altarpiece was painted for that church. The inscription on the ledge, *Libertas Ecclesiastica,* proclaims the freedom of Ascoli Piceno under the Church. In the centre of the inscription are the arms of Pope Innocent VIII, who had succeeded Sixtus IV in 1484; on the left are the arms of Prospero Caffarelli, Bishop of Ascoli Piceno 1464–1500; and on the right, the arms of the city. St. Gabriel is bringing a two-fold message, to the patron saint of Ascoli Piceno, St. Emidius, who holds a model of the town on his knee, and to the Virgin Mary. On the balcony above, a servant has interrupted his master, who was reading a book, with yet another message.

The mystic events related to the Annunciation are integrated with the everyday events of the town. The Holy Spirit, in the form of a white dove, has flown to the Virgin down a golden shaft of light. It is little different from the other birds except that it has flown from a ring of cherubs in the sky rather than from the dovecote. And even those heavenly cherubs recur as carved decoration on the façade of the Virgin's house. In the richly ornate surroundings, symbols related to the Annunciation are blended more or less successfully with everyday objects. The peacock symbolising Eternal Life is less obtrusive than the cucumber which refers to the Immaculate Conception, and the apple which refers to the Fall of Man, who will be redeemed through the birth of Christ. The church of Santissima Annunziata belonged to the Franciscans, and two Franciscan friars seem to be discussing with a father the education of his child. Only the child and one other person shielding his eyes against the light, have noticed the extraordinary events taking place.

Crivelli, a native of Venice, worked mostly in the Marches, but was much influenced by the graphic style of the Paduan painters, in particular Mantegna. His hard line and densely hatched brush strokes create grim-faced figures, and give clear definition to the profuse detail.

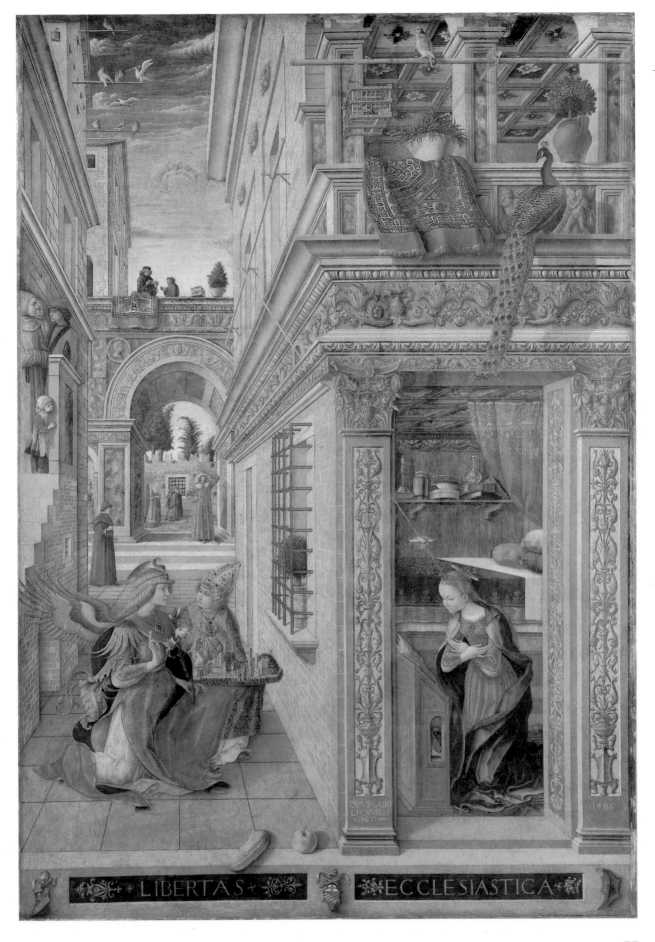

Giovanni BELLINI

Doge Leonardo Loredan

active *c.*1459, died 1516

Poplar panel, 0.615 × 0.45 Signed: IOANNES BELLINUS

Bellini, Mantegna's brother-in-law, was one of the first 15th-century Venetian painters to exploit the potential of the newly introduced technique of oil-painting. This portrait of the leathery and deeply lined face of an old man with his alert and dignified expression is painted with a visual and psychological scrutiny very similar to van Eyck's *Portrait of a Man* (*see* p.63). As in Raphael's portrait of *Pope Julius II* (*see* p.55), the simplicity of the composition, here based on a classical portrait bust, and set against a vivid plain blue background, is imposing in its effect. Only the rich brocade and cap with its laces dangling loose – the official costume of the Doge of the Republic of Venice – indicate the status of the sitter, Leonardo Loredan, elected Doge in 1501. The portrait was probably painted shortly after his election, when he was sixty-five.

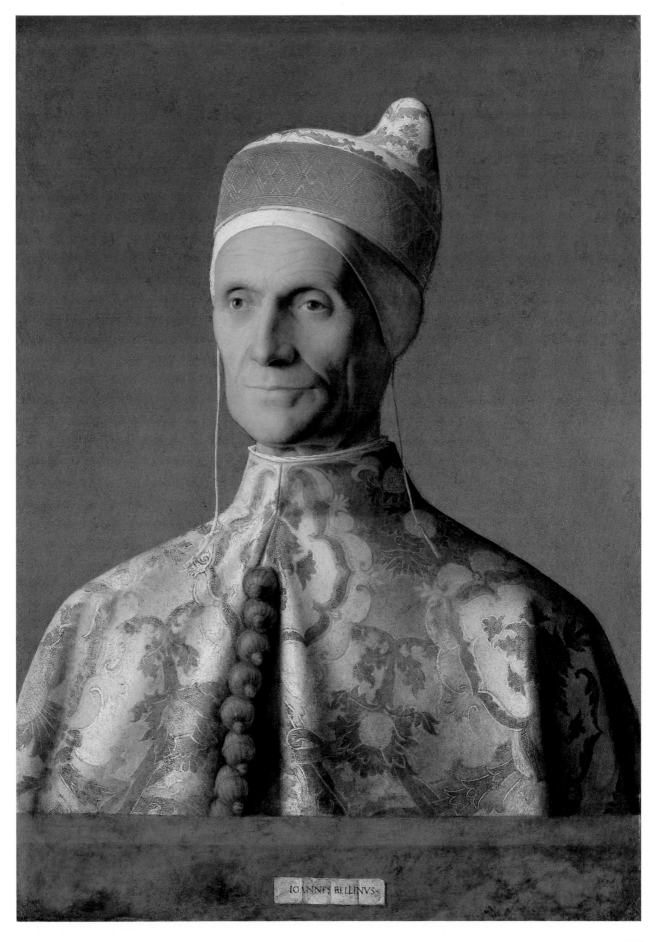

IOANNES BELLINVS

Giovanni BELLINI

The Madonna of the Meadow

active *c.*1459, died 1516

Panel, transferred to a new support, 0.67 × 0.86

'Although he is old, he is still the best in painting', was Dürer's eulogy of Giovanni Bellini, whom he met when he visited Venice during the years 1505 to 1507.

Most of Bellini's pictures of the Virgin and Child alone show a half-length Virgin with a lively, healthy Child standing or seated on a stone parapet, and a landscape behind. In this picture the whole figure of the Virgin is shown, but she is seated on the ground, forming a triangular silhouette against the landscape background. Far from being robust and playful, the Child is sickly and sleeping, as if lifeless. The young Virgin watches sadly over him, her fingertips gently touching in prayer, the expression in her eyes entirely hidden. The reference to the *Pietà*, a subject also painted by Bellini in a picture now in the Accademia, Venice, where the Virgin is shown as an old woman holding the dead body of Christ in her lap, is implicit.

The landscape background, almost miniature in scale, is painted with the same feeling for detail as Mantegna's *Agony in the Garden* (*see* p.75), but has something of the mysterious and idyllic quality which anticipates the atmospheric landscapes of Bellini's gifted pupil, Giorgione. A raven sitting amid bare branches forebodes death. The stork fighting a snake, which may be a theme from Virgil (*Georgics,* II, 319/20), symbolises the victory of Good over Evil. The cowherds with oxen and an Italian hill-city help to create a background of dreamy stillness.

Bellini's early work had been highly linear, like that of Mantegna. By the time of this late work, probably painted about 1500–1510, his style no longer depended on line but on a soft modelling in glowing colours and a clear warm light, which was later to be developed by Giorgione.

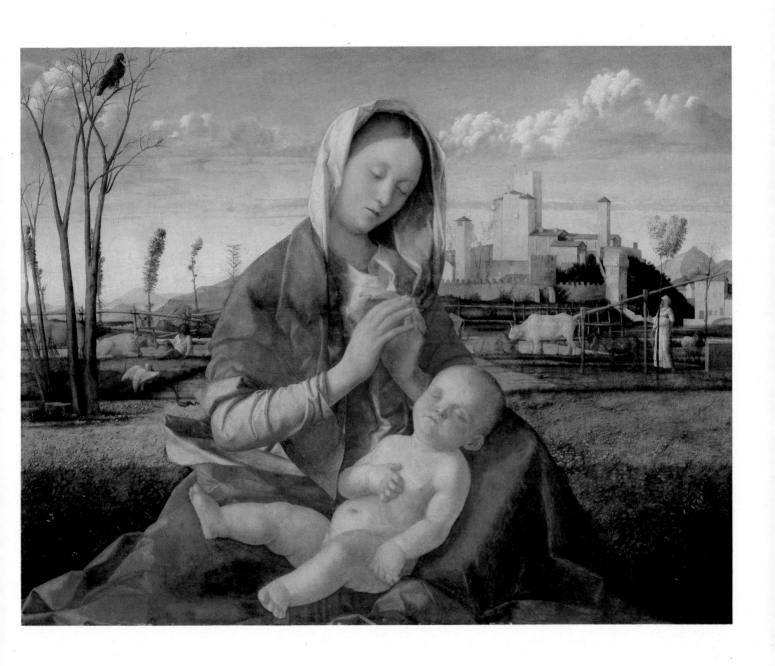

Tiziano Vecellio, called TITIAN *Portrait of a Man*
active before 1511, died 1576

Canvas, 0.812 × 0.663 Inscribed: T.V.

The full genius of Titian is impossible to grasp. It ranged through portraits, mythological paintings and altarpieces; and it rarely flagged. Each work has its own distinctive quality quite unlike any other. He was recognised by his contemporaries as the leading Venetian painter of the High Renaissance. His patrons included the Emperor Charles V, Francis I, Philip II, the Dukes of Mantua, Urbino and Ferrara, Doges, Popes, and Cardinals. He trained with Bellini and Giorgione, and this early portrait of *c.*1512 follows the by then well-established formula of a half-length figure behind a parapet against a plain background, used, for example, by Bellini in his portrait of *Doge Loredan* (*see* p.79). Here, however, Titian has swivelled the figure round to be seen in three-quarters profile and has correspondingly moved the signature T.V. on the parapet, off-centre toward the right. Prominently thrust over the parapet, is the bulky, quilted sleeve, a piece of virtuoso painting, where the brush strokes merge imperceptibly to create the shimmering blue satin.

It has been suggested that this is a self-portrait, although during the 17th century it was thought to represent Ariosto, the author of *Orlando Furioso*. In about 1639 it came into the hands of an art-dealer in Amsterdam where it was probably seen by Rembrandt who based his own self-portrait on it (*see* p.157).

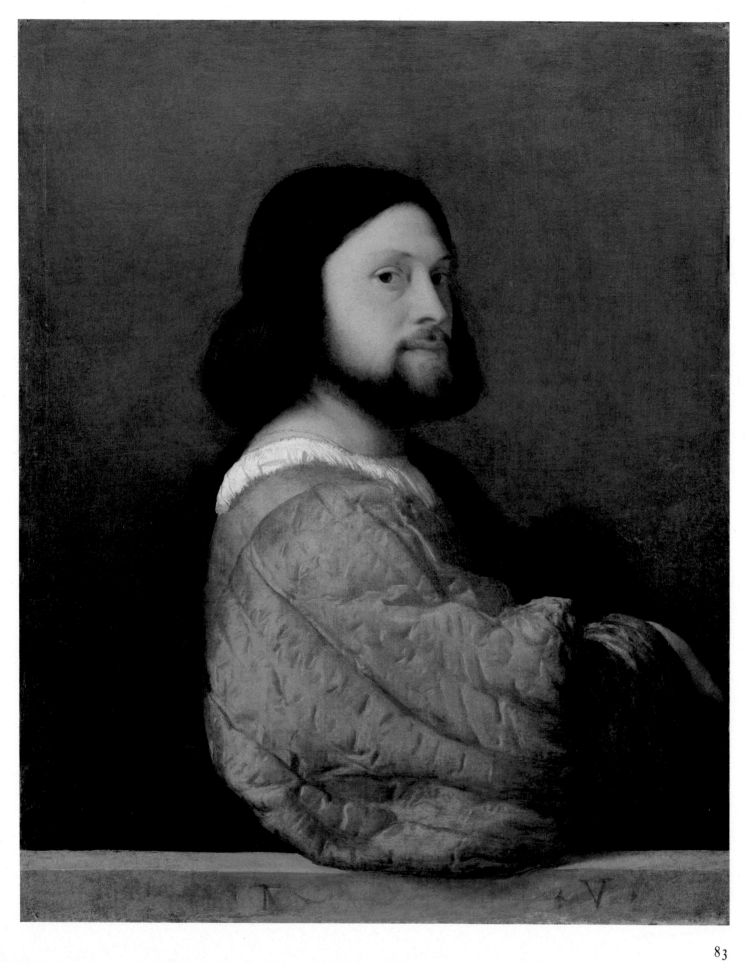

Tiziano Vecellio, called TITIAN *Bacchus and Ariadne*
active before 1511, died 1576

Canvas, 1.75 × 1.90 Signed: TICIANUS F.

The story of Bacchus and Ariadne is related in several classical sources, including Ovid and Catullus.

The wind which takes Theseus' ship ever further out to sea, also swirls through the white sleeve of the abandoned Ariadne, as she wanders in disconsolate disarray along the sea-shore. Her spiralling gesture is expressive both of her farewell to Theseus, and her fear at the encounter with Bacchus, the God of Wine, who is returning from India with a motley merry-making retinue. They are led by a jocund baby faun nonchalantly tugging a severed calf's head on the end of a string. A half-naked woman clashing cymbals is similar in pose and drapery to Ariadne. Fauns, nymphs, satyrs and the drunken Silenus propped up on an ass bring up the rear. Bacchus leaps from his chariot to reassure the frightened Ariadne. The sense of time suspended as he hovers in the air is reinforced by Titian's having chosen to set the event at the ambiguous transition from night into day. The stars lingering above Ariadne's head not only refer to Bacchus' promise to marry her and turn her into a constellation, but are entirely consistent with the mild dawn breaking on the left, while there is still a white moon visible through the trees.

The cleaning of a thick, yellow varnish from the surface in 1969 revealed some of the most glorious colours ever put on canvas. So lush are the blues, pinks, yellows, and so enthralling the composition, that Titian magically makes us believe in the impossible. We accept totally the anomaly in spatial lay-out: that the foreground of shallow waves, with their minuscule curls of white foam, under Ariadne's feet, should immediately be followed by the distant and mysterious landscape behind, with its misty blue mountains and intermittent flashes of light. A joyful nymph behind a satyr, writhing in agony as a snake twists around his limbs, is entirely plausible in the context of these pagan revellers. Amongst the swirling limbs and drapery, only the two cheetahs are still, with feline secrecy. Infra-red photography has revealed that the entire composition was applied to the gesso ground with almost no underdrawing or changes.

The golden urn lying on a golden cloth, the scallop shells strewn on the ground, and the flowers, are highly finished. Such attention to detail, particularly in the foreground, is unusual for Titian, even at this early date. It may be due to the fact that this scene, completed in 1523, was designed as one of a series for the study of Duke Alfonso d'Este in the castle at Ferrara, along with two other bacchanals by Titian (Madrid, Prado). The series included Bellini's *The Feast of the Gods* (Washington, National Gallery of Art), a composition completed by Titian.

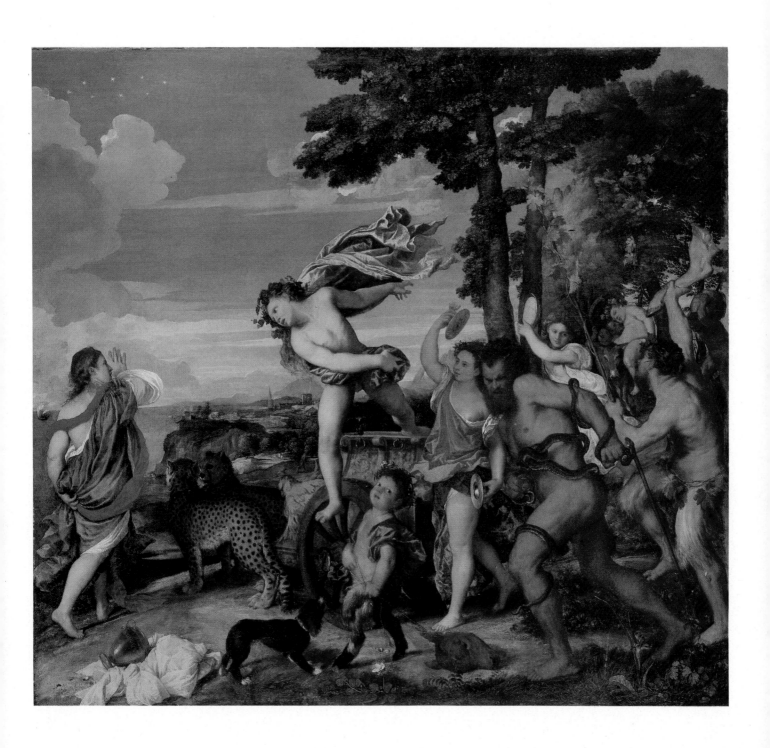

Tiziano Vecellio, called TITIAN *The Vendramin Family*
active before 1511, died 1576

Canvas, 2.06 × 3.01

A relic of the True Cross encased in Venetian crystal stands on an open-air altar, being adored by the Vendramin family. The relic was presented in 1369 to Andrea Vendramin, guardian of the Scuola or confraternity of St. John the Evangelist in Venice, and still exists. It fell into a canal, but remained miraculously suspended above water until Andrea Vendramin jumped in and was able to save it.

The picture was probably commissioned *c.*1543 by Andrea's 16th-century namesake, kneeling by the altar, and his brother, Gabriel Vendramin, stooping in veneration. On either side are Andrea's seven sons. The emphasis on the number three – the three altar steps, and division of figures into three's – culminates in the group on the altar, the cross with a guttering candle on either side. The reference is not only a religious one, to the Trinity, but also to the three ages of man, symbolised by the generations of the Vendramin family: fresh-faced boyhood, the middle-aged bearded profiles, and the old man with a full white beard whose sensitive features strikingly resemble those of the youngest child playing with a puppy. The presence of the 14th-century Andrea Vendramin who first witnessed the miracle of the True Cross is alluded to by the presence of the relic. The 16th-century Andrea Vendramin also had six daughters, but only the male members of the family are shown. For this picture is not only a pledge of religious devotion but also a plea for the continuance of the male line which traced its lineage back to the 14th century. In the event this painting remained in the possession of the Vendramin family until at least 1636 and subsequently passed into the collection of Sir Anthony van Dyck.

Perhaps no other painting demonstrates so forcibly Titian's skill as a portraitist. Although the composition is carefully considered, the colouring rich, and the draperies and furs deftly rendered with broad rapid brushstrokes, the supreme challenge which Titian has so powerfully met is to have studied nine male members of a single family from nine different angles.

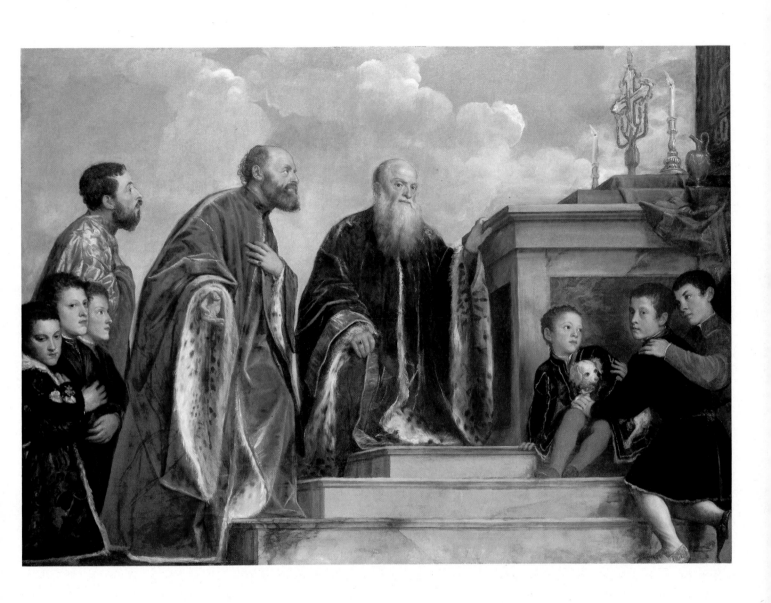

Tiziano Vecellio, called TITIAN *The Death of Actaeon*
active before 1511, died 1576

Canvas, 1.788 × 1.981

The Death of Actaeon, a late work, was probably begun in the 1550s. A comparison with *Bacchus and Ariadne* (*see* p.85) clarifies Titian's development over a quarter of a century. Contours have almost entirely dissolved; colour is almost non-existent; light and shade are of secondary importance. The application of paint is immediate and direct. And no longer is painting a laborious process of craftsmanship as it was for 14th- and 15th-century painters, with all the preparatory stages of seasoning wood, preparing a gesso ground, elaborating a composition in under-drawing. Palma Giovane, Titian's pupil, related how Titian's compositions were formed 'with bold strokes made with brushes laden with colours, sometimes of a pure red earth, which he used, so to speak, for a middle tone, and at other times of white lead; and with the same brush tinted with red, black and yellow he formed a highlight; and observing these principles he made the promise of an exceptional figure appear in four strokes . . . Thus he gradually covered these quintessential forms with living flesh, bringing them by many stages to a state in which they lacked only the breath of life'. Sometimes Titian even dispensed with brushes and painted with his fingers, on to a coarse canvas. Nothing could come between the painter and his subject. Nevertheless, the actual process of painting was not as spontaneous as might appear. Palma Giovane also related how Titian would work at a canvas, then turn its face to the wall, and only return to it several months later.

In Ovid's *Metamorphoses* the story is told of Diana, goddess of hunting, who punished Actaeon for having seen her bathing naked, by transforming him into a stag, so that he was devoured by his own hounds. The picture well exemplifies the way in which Titian approached his canvas, as related by Palma Giovane. The bush in the foreground is defined by a series of frenetic pale yellow brushstrokes applied to a dark ground. How different from Leonardo's minutely observed clump of narcissi in *The Virgin of the Rocks,* (*see* p.49), and yet in its own way no less intense. The essence of movement and atmosphere is captured in the dynamism of the brushstrokes; the spring of a hound is described by a streak of black paint, the rush of water by thick spasmodic blurs of white.

It is possible that the sketchy nature of the picture is partly due to the fact that it remained unfinished. It was one of a series, commissioned by Philip II of Spain, which also included a painting of Diana and her bathing companions surprised by Actaeon (on loan to the National Gallery of Scotland), but it was apparently never sent to Spain.

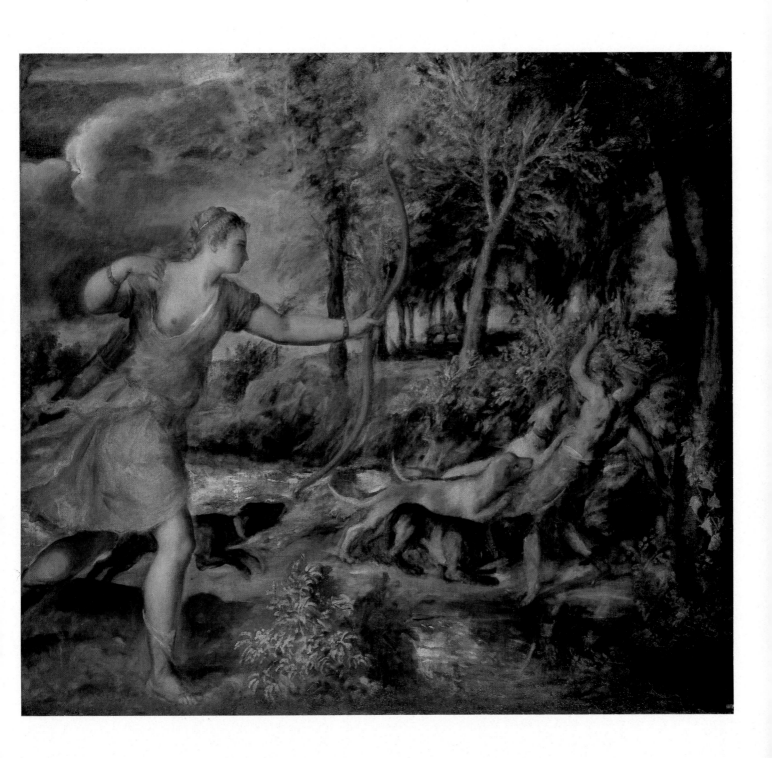

Jacopo TINTORETTO

St. George and the Dragon

1518–1594

Canvas, 1.575 × 1.003

The legend of St. George was made popular in the West as one of the stories in *The Golden Legend:* a dragon which was terrorising the countryside could only be appeased by animal and then human sacrifice. One of the victims was the king's daughter who was rescued just in time by St. George. The fight between the saint and the dragon came to symbolise the victory of Good over Evil. In this painting of the 1560s, Tintoretto has stressed the Christian significance of his subject by showing one of the dragon's victims in the pose of a crucified Christ.

The main action is polarised in two conflicting directions. It stems from the central motionless body of Christ: the princess, dressed in fashionable Venetian costume, flees towards us; St. George's horse plunges away from us toward the dragon and a stormy sea. The figure of St. George is bathed in a supernatural light which radiates from God the Father above. A massive Venetian fort merges with a turbulent cloudy sky. As with Titian, whose pupil Tintoretto may briefly have been, the quick, vibrant brush strokes infuse drapery and foliage with energy and movement.

Tintoretto's real name was Jacopo Robusti, and he derived his nickname from the fact that his father was a dyer (*tintore*). Apart from a single visit to Mantua in 1580, he worked entirely in Venice.

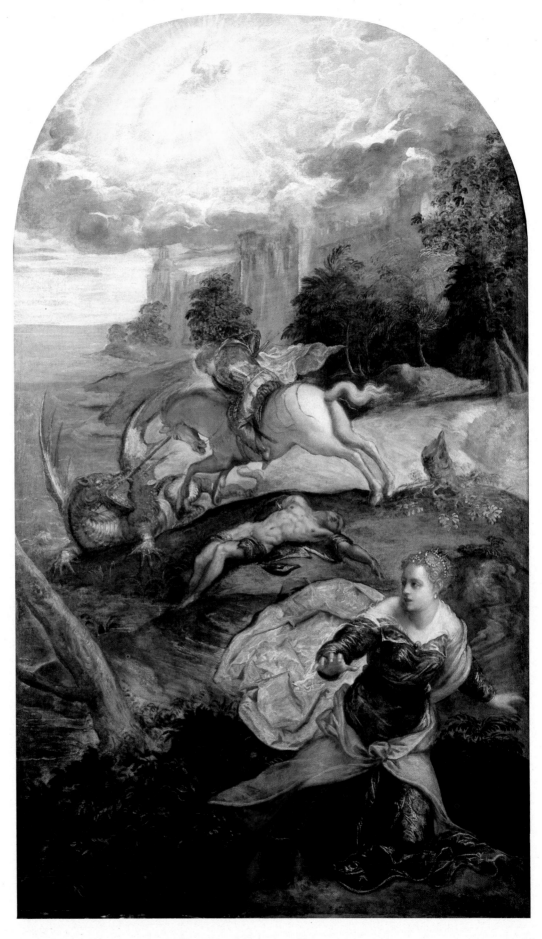

Paolo Caliari called VERONESE

The Family of Darius before Alexander

probably born 1528, died 1588

Canvas, 2.362 × 4.749

Large-scale panel-paintings were highly unsuitable decorations for palaces set amongst the damp lagoons of the Veneto, or by the dank canals of Venice. So Venetian artists from Titian onward developed the use of vast canvases, which were less vulnerable to humidity. Veronese (so-called because he was born in Verona), who with Tintoretto succeeded Titian as Venice's leading painter, was quick to exploit the possibilities of such large canvases which could be filled with dramatic scenes full of pageantry and colour.

Narrative incident packs every corner of this canvas, possibly painted for the Pisani palace *c.*1573: from the apex of the central architectural capriccio and curious bystanders peering over the pale Palladian balustrade, to the bottom corners of the composition where a pageboy leans on a shield, and where wriggling puppies clasped by a dwarf have distracted the youngest girl's attention.

The central confrontation of the two beautifully structured life-size groups – that of Darius' family kneeling in rich fashionable Venetian costume and glittering jewels, and that of soldiers standing by in glittering armour – hinges on a crisis of identity. Darius' family are doing homage to Alexander the king of Persia, the conquering hero, after the battle of Issus. But the mother of Darius, pleading for mercy, has mistaken Alexander's dearest friend, Hephaestion, for the great general on account of his greater height. Later, Alexander magnanimously alleviated her confusion by saying of Hephaestion that he, too, was Alexander. It may be the moment when Hephaestion, dressed in pink, is pointing to Alexander on his left, while the figure in black armour confirms with his right hand that he is Alexander. In his *Italian Hours,* Henry James, however, had no doubt as to which was Alexander: 'You may walk out of the noon-day dusk of Trafalgar Square in November, and in one of the chambers of the National Gallery see the family of Darius rustling and pleading and weeping at the feet of Alexander. Alexander is a beautiful young Venetian in crimson pantaloons, and the picture sends a glow into the cold London twilight. You may sit before it for an hour and dream you are floating to the water-gate of the Ducal Palace . . .'

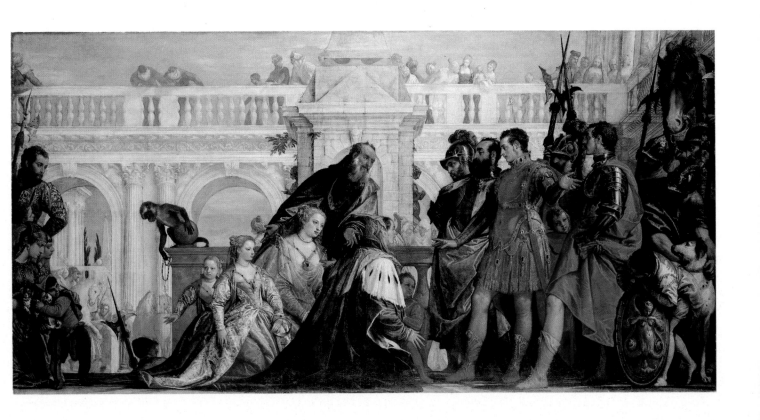

Antonio Allegri, called CORREGGIO

The Madonna of the Basket

active 1514, died 1534

Panel, 0.33 × 0.25

Without the pale figure of Joseph at work with a carpenter's plane in the background, there would be little indication that the Mother and Child in *The Madonna of the Basket* are the Virgin Mary and the Christ Child. Although the sweetness of their affectionate relationship perhaps derives from Raphael, the Virgin is no longer hieratic and remote, enthroned and dressed in the blue robes of the Queen of Heaven. She is wearing ordinary, almost peasant-like clothes, and is seated on the ground. On the grass beside her is a workbasket with cotton and scissors. She has just made a jacket which she is tenderly trying on the Child who wriggles in her lap, his attention distracted by the sunlight on the leaves of the trees. The soft colouring and sensitive modelling are enlivened by a vitality of line which anticipates the Baroque style.

As well as being adept at small intimate studies like this panel-painting, Correggio was a skilled fresco painter. Most famous are his frescoes in the cathedral at Parma, not far from his native town of Correggio, near Reggio nell' Emilia. Vasari, who was always reluctant to admit that anyone but a Tuscan could be an outstanding artist, was generous in his praise of Correggio's works and particularly admired the way he painted hair.

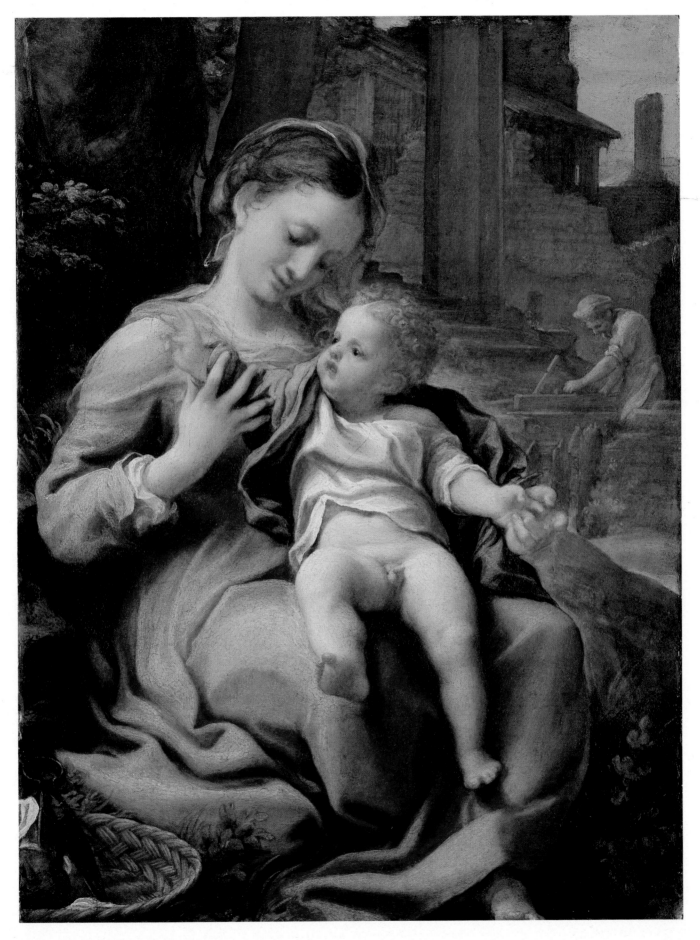

Antonio Allegri
called CORREGGIO

The School of Love

active 1514, died 1534

Canvas, 1.55 × 0.915

It has been suggested that Correggio's *School of Love* may have been painted for Federigo Gonzaga, Duke of Mantua, and that it was a pendant to a picture of *Venus with a Satyr* (Paris, Louvre), since both were recorded in Mantua in 1627. In 1628 it was purchased for the collection of Charles I. The title, which dates back as far as the 18th century, derives from the fact that Mercury, the messenger of the Gods, is teaching Cupid to read. Venus has confiscated his bow so that her troublesome child can finally be tamed with learning. Unusually, Venus is shown with wings, perhaps in order to emphasise that she is the mother of the winged Cupid, or in order to show that she represents an idealistic rather than a sensual type of love.

X-rays have shown that Venus was originally painted looking down at her son, and that Correggio changed her pose so that her gaze should involve the spectator. The picture is perhaps contemporary with Correggio's *Madonna of the Basket* (*see* p.95), probably painted about 1520–1524. The modelling is equally soft, with an absence of any harsh contours.

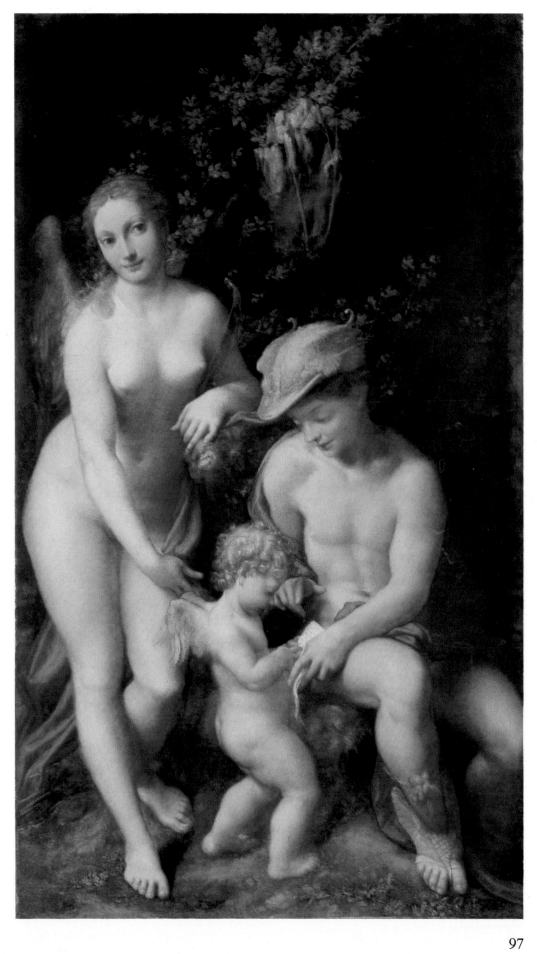

Girolamo Francesco Maria Mazzola, called PARMIGIANINO

The Vision of St. Jerome

1503–1540

Poplar panel, 3.43 × 1.49

When in 1527, during the sack of Rome, Imperial soldiery burst noisily into Parmigianino's studio, the painter was so engrossed in this work (*'intento alla frenesia del lavorare'*) that he failed to notice them.

It is not surprising that Parmigianino refused to be distracted, since this altarpiece, which was commissioned by a certain Maria Bufalini for the church of San Salvatore del Lauro in Città di Castello, was the culmination of a large number of preparatory studies. Over twenty related sketches and drawings show how Parmigianino experimented, in particular with the pose of the Virgin and Child. The drawings reveal that Parmigianino was studying Raphaelesque solutions for the Virgin and Child, as exemplified in the *Madonna of Foligno* (Rome, Pinacoteca Vaticana) which was then on the high altar of Santa Maria in Aracoeli in Rome. But finally, Parmigianino chose to model the pose of the Virgin and Child on a sculpture by Michelangelo, now in Notre Dame, Bruges, which he had perhaps seen on earlier visits to Rome. This was sculpted in about 1501, and may have been sent north in 1506. The division of the altarpiece into two distinct zones may also come from Raphael: perhaps from the early *Crucifixion* he painted for San Domenico, Città di Castello, in 1503 (also in the National Gallery), or from his last work, the *Transfiguration* (Rome, Pinacoteca Vaticana), completed by his pupils.

The visionary quality of the altarpiece also explains Parmigianino's rapt absorption in it. A contorted John the Baptist, wild-eyed, holding a makeshift Cross and dressed only in animal skins, points toward the Christ Child; behind him the undergrowth glows with a strange light. St. Jerome, with a Crucifix, lies awkwardly and out-of-scale, apparently having a vision, although there is no tradition that St. Jerome ever had a vision or that the picture acquired its title any earlier than the 19th century. The Virgin, with a coyly provocative Child leaning between her knees, is enthroned on a crescent moon, perhaps a reference to the Apocalypse, the light radiating from behind her. In her hand she holds a martyr's palm, symbol of the Passion which Christ will undergo.

Parmigianino's eclectic style, derived from Raphael, Leonardo, Michelangelo and Correggio – the latter, like him, came from the area around Parma – typifies what is known as *'Maniera',* or stylish grace.

Lorenzo LOTTO

A Lady as Lucretia

c.1480, still alive 1556

Canvas, probably transferred from panel, 0.959 × 1.105

This picture came originally from the Pesaro Palace in Venice and the sitter may well be Lucrezia Valier, who married Benedetto Pesaro in 1533. Her costume indicates a date of about 1530, so perhaps the picture was commissioned as a marriage portrait. In the hand on which she wears her wedding ring she holds a drawing of her namesake, Lucretia, a Roman lady distinguished for her beauty and marital fidelity, who having been raped by Sextus Tarquinius, stabbed herself to death.

In order to stress the analogy between the Venetian and the Roman Lucretia, a paper lying on the table bears a quotation from Livy's *History of Rome* (1, 58):

NEC ULLA IMPUDICA LUCRETIAE EXEMPLO VIVET

By the example of Lucretia, let no woman live on
once her virtue has been blemished.

There is perhaps a hint of irony implicit in the connection between the word 'impudica' and the fact that for the pose of Lucretia in the drawing, Lotto has used that of the classical statue of the *Venus pudica,* while the Venetian Lucrezia echoes the gesture. Perhaps 'she doth protest too much'. The rich pendant which swings at her breast has two playful *putti* embracing a scarlet jewel with more than a touch of the suggestion of the *Amor vincit omnia* brooch worn at her breast by Chaucer's prioress. Lucrezia's costume is also slightly ambiguous: green was a colour often worn by Venetian courtesans. Lotto may have been indulging in a harmless visual tease of his fearsome lady sitter.

Lotto's account books survive for the years 1538–1556 and from these emerge the character of a difficult man who often quarrelled with his sitters.

NEC VLLA IMPVDICA LV
CRETIA EXEMPLO VIVET

Giovanni Battista MORONI

c. 1520–1578

Canvas, 0.970 × 0.740

The Tailor

Not a king nor a doge, not a prince nor a pope, but a tailor commissioned this portrait from Moroni in about 1570. Moreover, he is shown with the tools of his trade and seems to be asking in Savile Row manner what sort of a suit exactly the gentleman had in mind. The cloth he cuts is black, the fashionable colour of the time, but he himself wears a more brightly coloured costume. The portrait comes at a time when patronage of the arts in Italy was beginning to shift toward the middle classes. Moroni's patrons came, on the whole, from an affluent middle-class – lawyers, prelates – mainly in Bergamo and Brescia. Where his portraits are arresting, his religious paintings tend to be feeble pastiches of Moretto and Titian. He was known as the 'poor man's Titian' and was greatly influenced by him as well as by his own master, Moretto. The influence of Lotto is also apparent: the tailor looks us in the eye with the same directness and tilt of the head as Lotto's *Lucretia* (*see* p.101).

Michelangelo Merisi da CARAVAGGIO

The Supper at Emmaus

1573–1610

Canvas, 1.140 × 1.962

Balanced precariously on the edge of the table is a still-life of lush autumnal fruits, perfectly painted, and each one pitted, bruised or rotting. Caravaggio's brilliant career as a painter was similarly marred. His decadent and violent life shocked his patrons, as did his direct unidealised approach to his subject-matter. His method of painting directly on to the canvas from the model, dispensing with preparatory drawings and sketches, shocked contemporary artists. When he fled Rome in 1606 charged with murder, his highly individual 'tenebrist' style, based on the dramatic contrast of light and shade, also fell into disrepute, and was largely superseded in Rome by the more classicising style of contemporaries such as Guido Reni, although French, Spanish (*see* Zurbarán, p.141) and Dutch painters propagated his 'tenebrism' in the north.

Caravaggio's paintings were often rejected because the patrons who commissioned them objected to the fact that he used coarse peasants as models for the disciples and the Holy Family. Here the supper at Emmaus, described in the Gospel of St. Luke (XXIV, 30–31), is set in a tavern. Christ, portrayed as an effete, beardless youth with a sensual face, has just blessed the bread and wine as he did at the Last Supper, thereby revealing to the two disciples that he is not a fellow pilgrim but the resurrected Saviour. One of the disciples, wearing the pilgrim's symbol, a scallop shell, flings back his clumsy hands in disbelief. Cleophas' whitened knuckles tighten with incredulity as he pushes back his chair. So extreme is the foreshortening that the ragged hole in his sleeve looks as if it has been made by his elbow poking through the canvas.

The shock of recognition is dramatically heightened by the startling realism of the brusque foreshortened gestures, the psychological study of the facial expressions, and the deep shadows cast on the wall and on the glaringly white table-cloth. The one flaw in the realism is the study of the fruit-laden basket, which is almost identical to an independent still-life, previously painted for Cardinal del Monte about 1596. Its inclusion is, in fact, an anachronism since the supper at Emmaus did not take place in the autumn as the grapes, pears, apples, and figs would suggest.

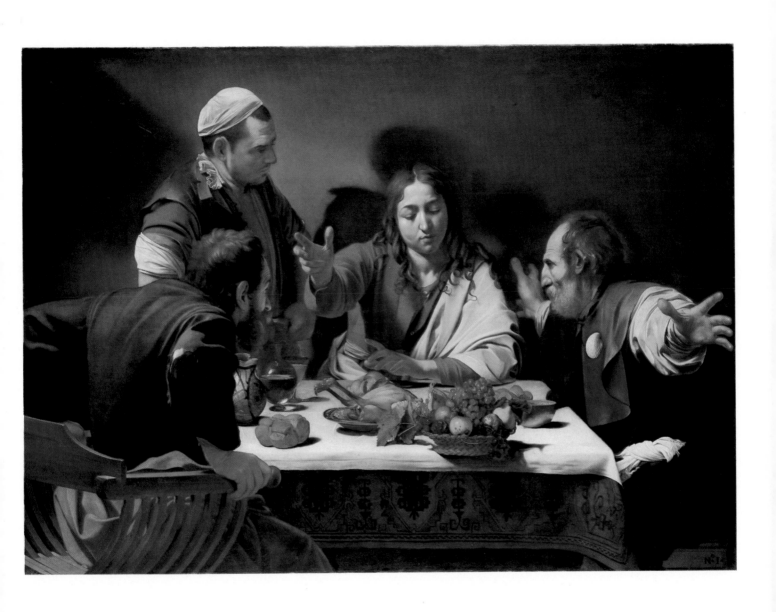

Giovanni Francesco Barbieri, called GUERCINO

Angels Weeping over the dead Christ

1591–1666

Copper, 0.368 × 0.444

The fact that he was squint-eyed, il Guercino, in no way jeopardised the career of Giovanni Francesco Barbieri, a painter who came originally from Cento, a small town in the duchy of Ferrara which had virtually no native tradition of painting. He seems to have been largely self-taught, and worked mainly in Bologna, apart from a brief spell in Rome, 1620–23. He became the leading painter in Bologna after the death of Guido Reni in 1642.

His feeling for rich, pure colour and texture is well exemplified in this small devotional painting of two angels mourning over the body of the dead Christ, with its saturated grape-purple, plum-red, and characteristic blue, its soft blurred contours, and exquisitely modulated tone. Although he was to develop into a fully-fledged Baroque painter of flamboyant forms and exciting colour effects, this early work, probably painted about 1617–18 in Bologna, is moving in its simplicity, monumental in its absence of detail. Christ's wounds are discreetly neat and unobtrusive, and his halo is the palest suggestion of light. The angels mourn, still and subdued.

It is possible that Guercino took this picture to Rome with him in 1620 when he went to work for the newly elected Pope Gregory XV, who himself came from a Bolognese family. The picture is mentioned in an inventory of 1693 in the Borghese collection in Rome.

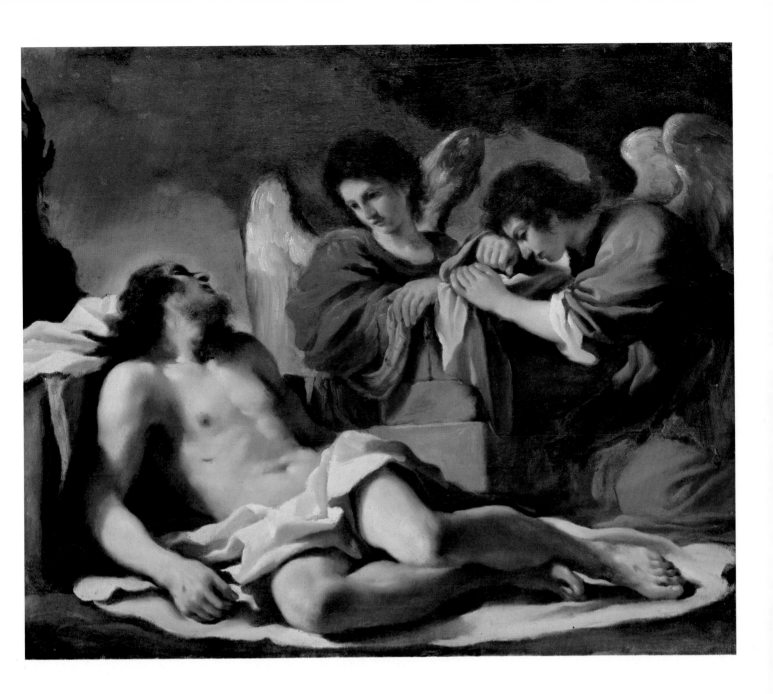

Nicolas POUSSIN
1594(?)–1665
Canvas, 1.54 × 2.14

The Adoration of the Golden Calf

During the last decade of the 16th century and first half of the 17th century, the enlightened and munificent patronage of popes, cardinals and princely families acted like a centripetal force, attracting painters to Rome from all over Italy and Europe. From Germany came Elsheimer; from Flanders came Rubens; from Bologna came the Carracci family and Guido Reni. And from France came Claude Lorraine – and Poussin.

From 1624 onward, Poussin worked almost entirely in Rome where he was deeply influenced by classical sculpture and by the works of Raphael and his pupils. The revellers in *The Adoration of the Golden Calf* seem to have been based on works by Raphael's pupil, Giulio Romano: *Apollo and the Muses* (Florence, Pitti Palace) and *The Triumph of Priapus.* Dancing figures were also common on classical relief sculpture, and here the effect is very much that of a classical frieze: the composition is classically controlled – the figures' frenzied movement is frozen, the swirling draperies are expressive of concentrated energy; the foremost figures are deeply cut out of light and shade, dramatically built up in russet tones, while the figures at the back are shallow and sparsely painted.

It is apt that the models should be pagan, given the story, which comes from Exodus XXXII. Moses had gone up to Mount Sinai to receive the Law of God, but when he failed to return, the Israelites became impatient and asked Aaron for other gods. At Aaron's command, they threw all the gold they had into a fire, and from it emerged a golden calf. Here Aaron urges the Israelites to worship the idol. Eerily lit by a half-hidden moon, the narrative unfolds from right to left with rhythmic pace, across the figures dancing with abandon, to two women in the background who have noticed that Moses has returned. In fury at the Israelites' foolishness, he is shattering the Tablets of the Law given to him by God.

The painting originally had a pendant, *The Crossing of the Red Sea,* (Australia, Melbourne, National Gallery of Victoria). Both were painted for Amadeo dal Pozzo, Marchese di Voghera, for his palace in Turin.

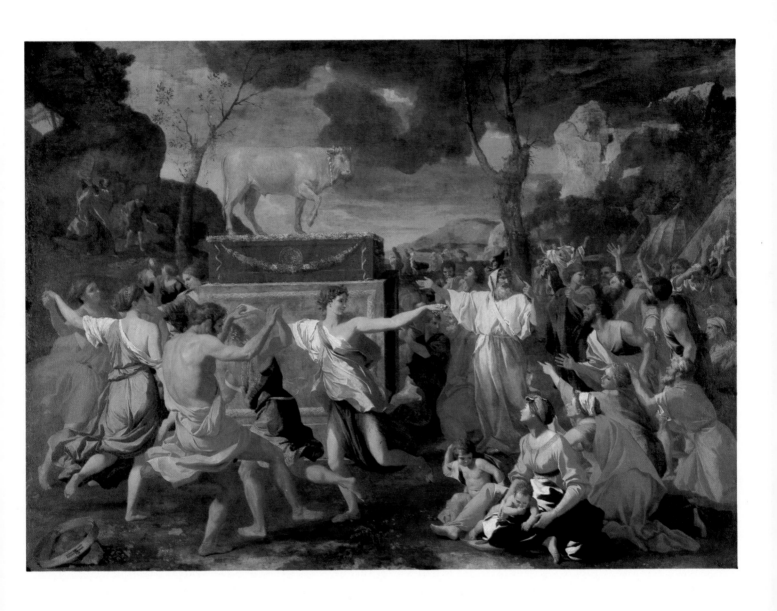

French School

CLAUDE Gellée, called Le Lorrain

1600–1682

Seaport: The Embarkation of the Queen of Sheba

Canvas, *c.*1.485 × 1.94 Inscribed: LA REINE DE SABA VA (TROV (ver) SALOMON.
Signed: CLAUDE GIL: I.V. FAICT POUR SON ALTESSE.
LE. DUC. DE. BVILLON. A. ROMA, 1648.

Claude Gellée, who was born in Lorraine in France, is supposed to have started his career as a pastry-cook, but subsequently became the studio assistant of the Roman landscape painter, Agostino Tassi, and spent most of his working life in Rome. He rapidly became a popular landscape artist, and his work was already being forged during his lifetime. The *Liber Veritatis,* a sketchbook in which Claude recorded the compositions of all his pictures to guard against forgeries, shows that the *Embarkation of the Queen of Sheba* was originally intended for Prince Pamphili. However, the final picture was eventually bought by the Duc de Bouillon, general of the papal army in Rome, and sent to him in 1648 after he had returned to France. *The Marriage of Isaac and Rebekah,* known as *The Mill,* also in the National Gallery, was painted as its pendant.

The Neapolitan coast, which greatly impressed Claude when he visited Naples, together with Roman classical and medieval buildings, forms the basis of an imaginary and elegantly idealised setting. To make sure that we can identify the subject, Claude has carefully inscribed the title, disguised as graffiti on the quay steps, relating that the action concerns the departure of the Queen of Sheba on her way to visit King Solomon (I Kings, X, 1ff). But the minuscule figures, however active they may be in preparing for the voyage, are dwarfed by the imposing buildings. What interests Claude is not so much the events of the story, as its setting – the reverse of Poussin, for whom the landscape usually contributed to the dramatic action rather than being the main focus. The principal protagonist of this picture is light: creamy toward the horizon, and becoming ever crisper and more staccato as it catches the crests of the waves and breaks against ships and shore. Of all the figures, it is not the tiny figure of the Queen of Sheba who attracts our attention, but the solitary figure of a boy sprawling on the quayside, shielding his eyes from the dazzling brightness of the rising sun.

Claude became extremely popular in England in the 18th and 19th centuries. Constable paid numerous visits to one of the founding collectors of the National Gallery, Sir George Beaumont, in order to copy his Claudes, especially *Hagar and the Angel* (now in the National Gallery), and Turner set out specifically to emulate Claude, stipulating in his will that his own *Dido Building Carthage* should hang beside the *Embarkation of the Queen of Sheba*. Dickens in *Little Dorrit* poked fun at the 19th-century adulation of Claude in the person of Henry Gowan who had become a Painter 'partly because he had always had an idle knack that way', and whose pictures distinguished society ladies 'declared with ecstasy to be perfect Claudes'.

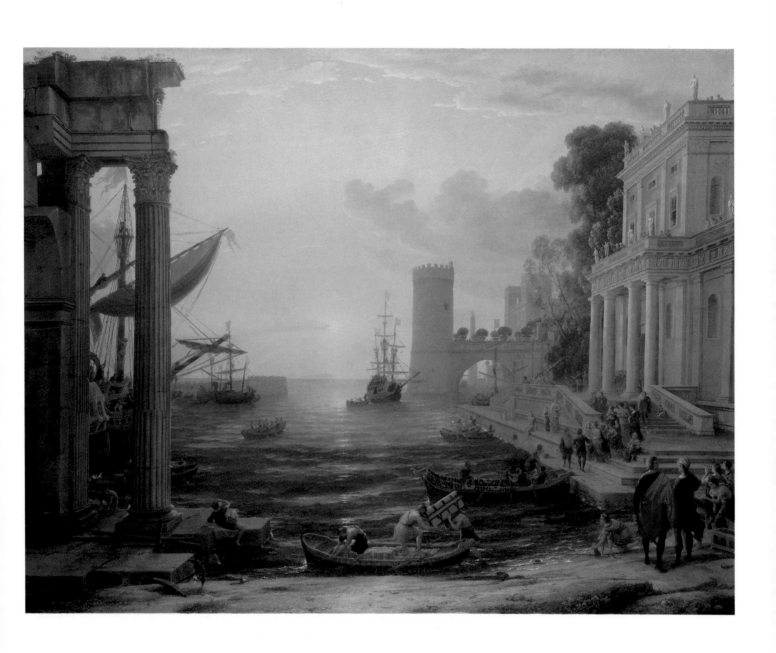

Master of the
St. Bartholomew Altarpiece

St. Peter and St. Dorothy

active late 15th, early 16th century

Oak panel, 1.255 × 0.711

This painter is so called after a large panel originally in St. Columba's in Cologne, now in Munich, Alte Pinakothek, painted in about 1505–10, showing St. Bartholomew with a kneeling donor and Sts. Agnes and Cecilia. This was probably the centre of an altarpiece of which the panels with St. Peter and St. Dorothy in the National Gallery formed part of the wings. St. Dorothy is shown carrying a basket of flowers because when she was mocked on her way to martyrdom roses were sent to her from paradise. St. Peter holds the keys to the Kingdom of Heaven.

The painters of the Cologne School were deeply influenced by the realism of Early Netherlandish paintings, evident here in the characterisation, particularly the aged features of St. Peter, and in the ponderous drapery folds.

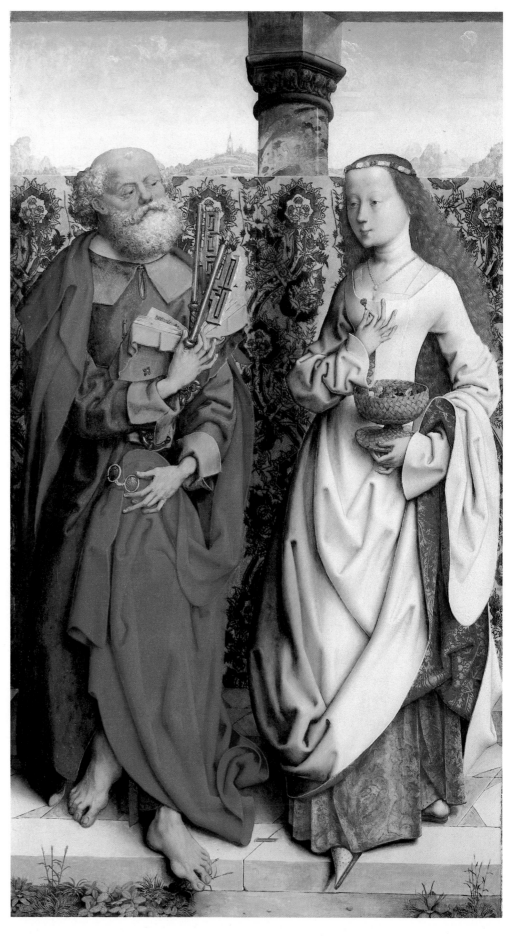

Lucas CRANACH the Elder *Cupid Complaining to Venus*

1472–1553

Panel, 0.813 × 0.546

Although we are accustomed to think of the Renaissance as a peculiarly Italian phenomenon, there was in the North too a quickened interest in classical antiquity, as well as in the nature of Man and the Universe.

Lucas Cranach's picture of a naked woman in a supremely elegant hat has an inscription, of which the first two lines derive from Theocritus (*Idyll XIX*):

DUM PUER ALVEOLO FURATUR MELLA CUPIDO

FURANTI DIGITUM CUSPIDE FIXIT APIS

SIC ETIAM NOBIS BREVIS ET PERITURA VOLUPTAS

QUAM PETIMUS TRISTI MIXTA DOLORE NOCET

While Cupid was stealing honey from the hollow
of a tree-trunk, a bee stung the thief in the finger.
Even so does brief and transient pleasure which we
seek harm us with sadness and pain.

Venus, the Goddess of Love, then mocked her son, Cupid, saying that the wounds he inflicted on others were much more painful. Translations of Theocritus' text were made by German scholars in 1522 and 1528.

Cranach painted several pictures of Venus. Here, leaning seductively on the branch of an apple-tree, she has obvious associations with Eve. In the background, typical German river scenery, mirrored precisely in the water, is painted with charming detail.

In 1505 Cranach became Court Painter in Wittenberg to Frederick the Wise, Elector of Saxony, where he met Luther and painted his portrait several times. From 1552 until his death he lived in Weimar.

Cranach's signature, seen here on the stone, was a small winged serpent which derived from his arms, presumably a pun on his name, the German for dragon being *drachen*.

Albrecht ALTDORFER *Christ taking leave of His Mother*

*c.*1480–1538

Panel, 1.40 × 1.15

The most outstanding painter of the Danube School, which was considerably influenced by both Cranach and Dürer, was Albrecht Altdorfer.

The story of Christ taking leave of his mother is related in the *Meditations on the Life of Christ* written by an anonymous Franciscan during the 14th century. Christ bade farewell to his mother in the village of Bethany before entering Jerusalem for the last time. The Virgin, the disciples, and Mary Magdalen, pleaded in vain that he should not go. But Christ knew that he must go to Jerusalem to be crucified.

Here the arrangement of the figures foreshadows the Crucifixion. Christ raises his hands in blessing; soon they will be raised higher on the cross. The Virgin on the left, fainting with grief, and St. John the Evangelist standing on the right, are shown exactly as they are in paintings of the Crucifixion.

A little of the frenetic and intensively worked underdrawing is beginning to show through the sleeve of St. Peter's white robe. The elongated, almost clumsy, yet very beautiful, figures are charged with emotional tension, which is accentuated by dripping, spiky foliage painted with insistent detail. The colours are intense: electric blue, blood red, crimson. Through the arch is glimpsed a yellowish sky with fiery pink clouds. Very typical of Altdorfer's work of the early decades of the 16th century is the use of a curved shape, the arch of a bridge, vault, cave, or tree, to give the composition of the figures a fluid rhythm. With Altdorfer, landscape assumed an unprecedented importance in narrative painting, bestowing a weird and unreal atmosphere in a way which was greatly to influence Elsheimer, as well as the 17th-century Flemish landscape painters.

The family of donors in the bottom right-hand corner has not yet been identified.

The picture was painted in about 1520 and is a great rarity in this country which has only one other painting by Altdorfer – a small landscape also in the National Gallery.

117

Hans HOLBEIN the Younger

The Ambassadors

1497/8–1543

Oak panel, 2.07 × 2.095 Signed: IOHANNES HOLBEIN PINGEBAT 1533

> But O good God what vaileth all this gear?
> When death is come, thy mighty messenger,
> Obey we must, there is no remedy.
>
> (Sir Thomas More, 1478–1535)

The strange shape which occupies the foreground is an elongated skull, seen in distorted perspective, which reverts to a recognisable shape when viewed from the bottom-right hand corner. Bizarrely obtrusive, it must provide one of the keys to the meaning of this complex double-portrait.

Jean de Dinteville was French ambassador to the Court of Henry VIII and in the month of April 1533 was visited in London by his friend, Georges de Selve. Jean de Dinteville, in rich court dress, is on the left, wearing the Order of St. Michael, and a badge with a skull on his cap. An inscription on the hilt of his sword gives his age as twenty-nine. Georges de Selve, who became Bishop of Lavaur in 1526, is more soberly dressed in clerical garb. He rests his elbow on a book which has an inscription giving his age as twenty-five. The two men stand on a cosmati mosaic pavement similar to the floor still to be seen at Westminster Abbey. On the table is a display of objects whose meaning has never been explained.

The objects on the top shelf are all concerned with the heavens: a celestial globe, a portable cylindrical sun-dial, which gives the day as 11th April, two quadrants, a polyhedral sundial which gives the time as 9:30 or 10:30, and a torquetum, an instrument for determining the position of celestial bodies. In the signature, the artist gives the date as 1533.

On the lower shelf of the table are objects relating to this world together with a terrestrial globe. A half-open arithmetic book may refer to learning. A case of lutes and a pair of calipers may refer to the arts. The lute has a broken string which may allude to the transience of life interrupted by death. In the open hymn book, with musical annotation, is written, in German, Luther's rendering of *Veni Creator Spiritus* (Come, Holy Ghost). The religious symbolism is taken up in the Crucifix which hangs at the top left-hand corner. The message of the picture seems to be that all human learning and human skills in the arts are eventually annihilated by death; at the Last Judgment all souls will be weighed by St. Michael, but those who have obeyed God's commandments will be redeemed through the Passion of the crucified Christ.

It was probably Jean de Dinteville who took the picture back to his château at Polisy, from where it was moved to Paris in 1653.

Holbein was born in Augsburg, and worked in Basel from about 1519 until about 1524. Sir Thomas More, in a letter to Erasmus in 1526, recorded that Holbein was in London. Apart from a few visits to the Continent, he worked mostly at the Court of Henry VIII, painting portraits and other works until his death in 1543.

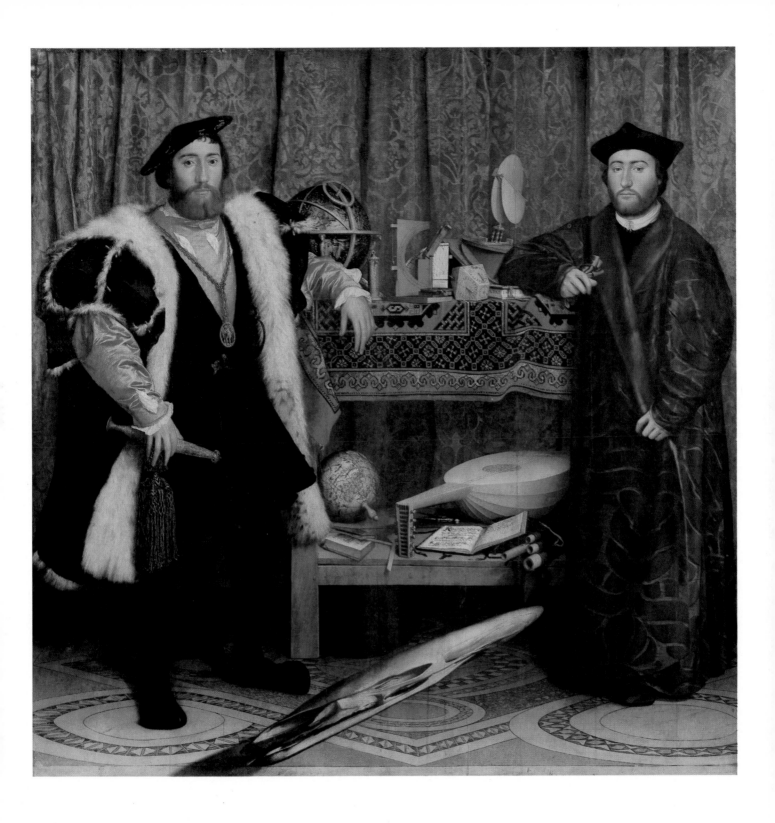

Pieter BRUEGEL the Elder *The Adoration of the Kings*

active 1551, died 1569

Oak panel, 1.11 × 0.835 Signed: *BRVEGEL M.D.LXIIII*

Pieter Bruegel the Elder is perhaps first and foremost famous for having put landscape as a virtually independent genre on the map in 16th-century Flemish painting. It is therefore all the more surprising to find landscape entirely excluded from this Adoration scene. A few crooked rafters and wisps of straw are the only contextual references in this composition densely crammed with figures, painted in 1564. The subject of the Adoration had previously been treated as the centre panel of a triptych by Hieronymus Bosch, a painter whose figure style exercised great influence on Bruegel in the cruel coarse realism which verges on surrealistic caricature. The composition may also have been influenced by Italian Mannerist painting: Bruegel was in Italy for a number of years in the early 1550s.

The motif of the delicate Child shrinking from the wizened, hoary old king who pays homage to him is typical of the shrewd characterisation which Bruegel brought to everything he painted, as is the inclusion of the incidental detail of a figure whispering in St. Joseph's ear.

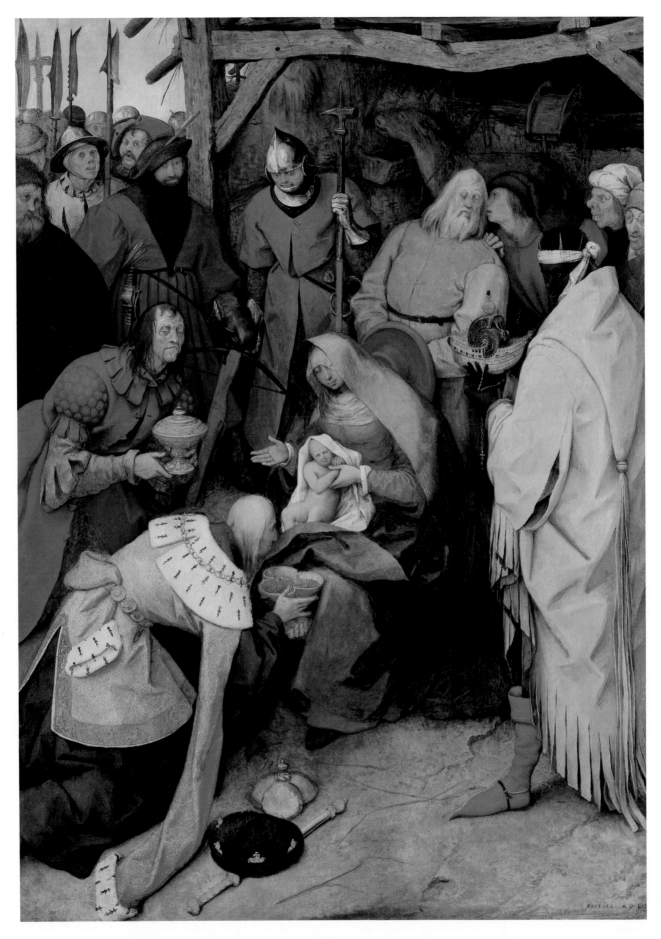

Sir Peter Paul RUBENS

Samson and Delilah

1577–1640

Panel, 1.85 × 2.05

The Rome which the great Flemish painter, Rubens, visited during the years he spent in Italy, 1600–1608, was still stunned by the uncompromising realism of Caravaggio's art (*see* p.105). Rubens, a relatively immature painter at that date, was deeply influenced by him.

The story of Samson and Delilah (Judges, XVI, 4–19) relates how Delilah lured from Samson the secret of his extraordinary strength, which lay in his hair. When she had lulled him to sleep, she called a man to cut off the seven locks from his head, and delivered the weak Samson into the hands of the Philistines for the sum of eleven hundred pieces of silver. The wrinkled old woman, who is not mentioned in the biblical version, has been introduced from paintings by Caravaggio, such as *Judith Beheading Holofernes* (Rome, Galleria Nazionale). In spite of the gigantic size, rich colours, and powerfully sweeping brushstrokes, the mood of this act of betrayal is almost tender. The central focus of the Baroque cluster of figures, which anticipates the expressive sculptures of Bernini, is Samson's strong sleeping head. It is framed by hands – his own, resting lovingly on Delilah, hers, resting no less gently on his powerful back, and finally, the hands wielding scissors, delicately fastidious in order not to wake him.

While he was in Italy, Rubens studied most of the great Italian masters and used his knowledge in a way which was never imitative, always creative. Here, Samson's limp muscular arm, which is contrasted with Delilah's tense and very feminine arm, comes from Italian depictions of the dead body of Christ, such as Caravaggio's *Entombment*. With typical flexibility, Rubens has adapted a drawing he originally made of a female nude for Samson's twisted body.

Delilah is partly the result of the drawings Rubens made of Michelangelo's *Night* in the Medici chapel in Florence. And, in the stone niche, a Michelangelesque statue of Venus, ignoring the appeal of a blindfold Cupid, underscores the symbolic fate of the love-lorn Samson. Not everything is integral to the story. The study of an antique vase probably reflects Rubens' interest in collecting, a passion frequently referred to in his prolific correspondence.

Although the study of different light effects in a dark chamber – light from an oil-lamp, a candle, and torch – suggests the influence of Caravaggio, it may also indicate how aware Rubens was of the location the picture was destined for. It was commissioned by one of Rubens' earliest patrons, Nicholas Rockox, a man who was several times Burgomaster of Antwerp, and was in his possession by *c.*1613. A painting of *c.*1630–35 shows the great parlour of Rockox's Antwerp house with the *Samson and Delilah* hanging over the fireplace. The real light cast by the flickering flames of the fire would have made the painted study of candle and torchlight strikingly effective.

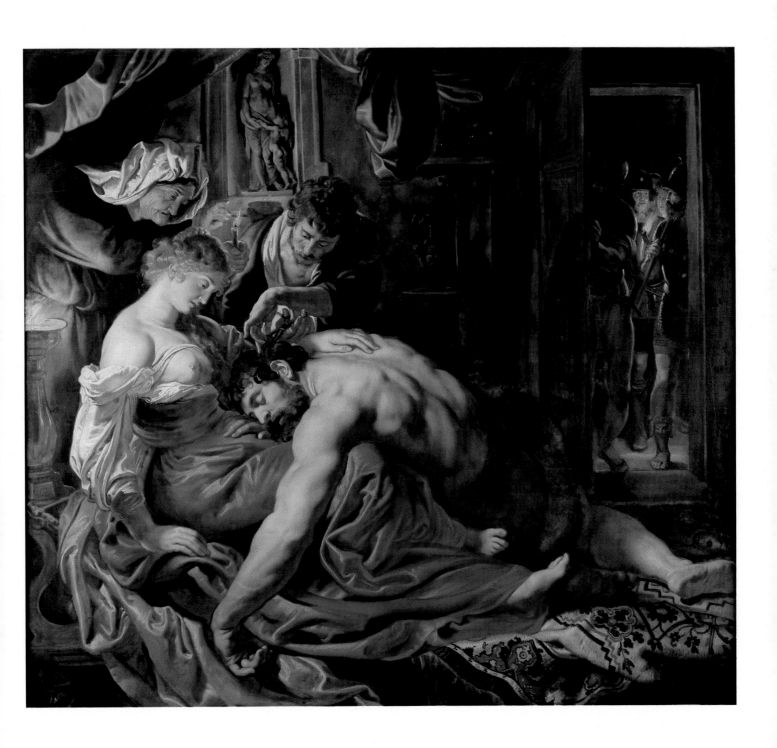

Sir Peter Paul RUBENS

1577–1640

Oak panel, 0.994 × 1.35

The Watering Place

Rubens is most famous for his portraits, and mythological and religious paintings. As far as is known no landscape paintings were actually commissioned from him. However, throughout his life he was a passionate and persistent landscape painter. His nephew related how after he had bought the country mansion of Het Steen, some way outside Antwerp, in 1635, 'he would sometimes withdraw in solitude, and there he enjoyed painting landscapes after nature, since the countryside was delightful'. He would make sketches of branches, willows and other trees reflected in water, and used them, in ever-changing combinations, when he painted several very similar bucolic scenes. One of these is *The Watering Place,* set in the flat sparsely wooded Flemish countryside, with peasants and cattle.

It is a complex structure, built up of eleven oak panels. Rubens first painted a central scene of a shepherd leaning on his staff, guarding his sheep by the edge of the water. Subsequently he added to the panel on all sides. In order to maintain the essentially radial effect of the composition he painted out the sun and moved it further along the horizon toward the left. He also painted out the shepherd boy whose form is still faintly discernible, even to the naked eye. Rubens seems to have begun the panel in the 1620s, but probably continued to work on the picture intermittently, even once it had been framed: certain areas, such as some of the foliage, are highly finished; some areas, such as the reflections of the cattle in the water, are thinly and sketchily painted.

The picture made a great impression on Gainsborough when he saw it in the collection of the Duke of Montagu and he subsequently painted his own version of the same theme (also in the National Gallery).

Sir Peter Paul RUBENS

'*Le Chapeau de Paille*'

1577–1640

Panel, 0.79 × 0.54

The nickname of *Le Chapeau de Paille* (the straw hat) given to this portrait has been explained as arising from a confusion over the French words *feutre* which means felt, and *feurre* which means straw. The sitter is, in fact, wearing a felt hat, of the kind which was popular in Flanders during the early 1620s. The slightly hesitant young woman, shown outdoors against a cloudy sky, wisps of her hair escaping in the breeze, may be Susanna Fourment, daughter of an Antwerp silk and tapestry merchant, whose sister, Helene, Rubens married in 1630, after his first wife had died in 1626. Susanna Fourment had herself lost her first husband and in 1622 re-married. It may be that this was a marriage portrait. The ring on her fore-finger is prominently displayed as she draws her shawl more closely about her. Rubens seems to have painted the entire head and hat first, and then added a very blue sky around them, painting out some locks of hair, and some of the plumes on the hat.

127

Sir Peter Paul RUBENS

Peace and War

1577–1640

Canvas, 2.035 × 2.98

An understanding of Rubens' activities as a courtier and diplomat is crucial to the unravelling of his allegory of *Peace and War*. The picture shows Peace at the centre, pressing milk from her breast in order to feed the small child, Plutus, the god of Wealth. Minerva, goddess of Wisdom, protects her from the attack of Mars, the god of War, who is dressed in black armour. He is attended by one of the Furies who starts to flee. Cupid the god of Love, and Hymen, the god of Marriage, carrying a torch, lead two small girls toward a cornucopia. Even a leopard and satyr have been tamed. A dancer with a tambourine and a woman carrying treasure symbolise the delights of peace. A winged putto holds an olive wreath and caduceus, symbols of peace, above the figure of Peace.

The picture was presented by the artist to King Charles I in 1630, and presumably celebrated the successful conclusion of the diplomatic mission which had brought Rubens to England. He had come on behalf of the ruler of the Spanish Netherlands, the Infanta Isabella, in order to bring about peace between Philip IV of Spain (*see* p.135) and Charles I of England (*see* p.131).

While at the Spanish Court in 1628, Rubens had, according to Velázquez's father-in-law, Pacheco, copied everything by Titian that Philip IV possessed. The result, evident here, was a much freer handling, compared for example, with the early pictures such as *Samson and Delilah* (*see* p.123). Equally, the spiralling and unfolding figure compositions, set against sweeping landscapes and incandescent skies, seem to find their origin in Titian.

After Charles I's execution in 1649, his collection was auctioned and dispersed. This painting was purchased by the dealer, Buchanan, in Genoa in 1802.

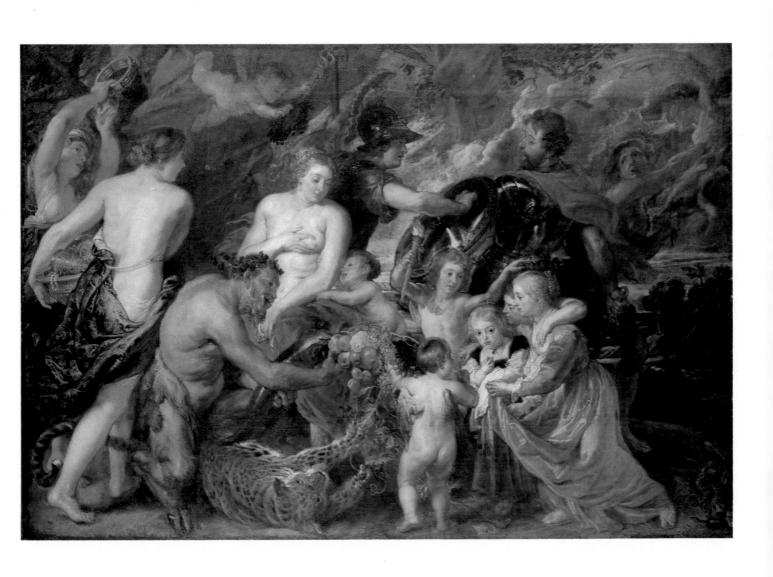

Flemish School

Sir Anthony VAN DYCK

1599–1641

Canvas, 3.67 × 2.921

*Equestrian Portrait
of Charles I*

'Le prince le plus amateur de la peinture qui soit au monde', was Rubens' description of Charles I. The King was not only a great collector, owning works by Titian, Mantegna, Tintoretto, Correggio, Raphael and Rembrandt, but he was also a great patron. He commissioned several works from Rubens, whom he knighted, and also from Rubens' outstanding pupil, van Dyck. Van Dyck came to England in 1632, when he too was knighted by Charles I, and lived there until he died.

This equestrian portrait of Charles I was painted by van Dyck in about 1638. The head is almost identical to one of the poses van Dyck had used in a triple portrait (Royal Collection) which had been sent to Bernini a few years earlier for the Roman sculptor to use as a model for a portrait bust of the king. Charles is wearing Greenwich-made armour, and around his neck the lesser George of the Order of the Garter. Although the composition bears some resemblance to Titian's portrait of *The Emperor Charles V on horseback* (Madrid, Prado), it is more likely to have been based on the classical statue of Marcus Aurelius in Rome which van Dyck would have seen when he visited Italy in 1621. While the slender rather melancholy king sits tranquil and confident in the saddle, his horse is all fire and spirit, foaming at the mouth, muscles rippling in nervous excitement. The king was well-known as an excellent horseman and accomplished in the skills of war.

C. V. Wedgwood in *The King's Peace* has described him as 'of the intractable stuff of which martyrs are made'. Only four years after this portrait was painted, the Civil War broke out, and in 1649 the king was beheaded. He stepped out onto the scaffold through a window of the Banqueting Hall at Whitehall for which he had commissioned Rubens' magnificent ceiling depicting the Divine Majesty of Kingship.

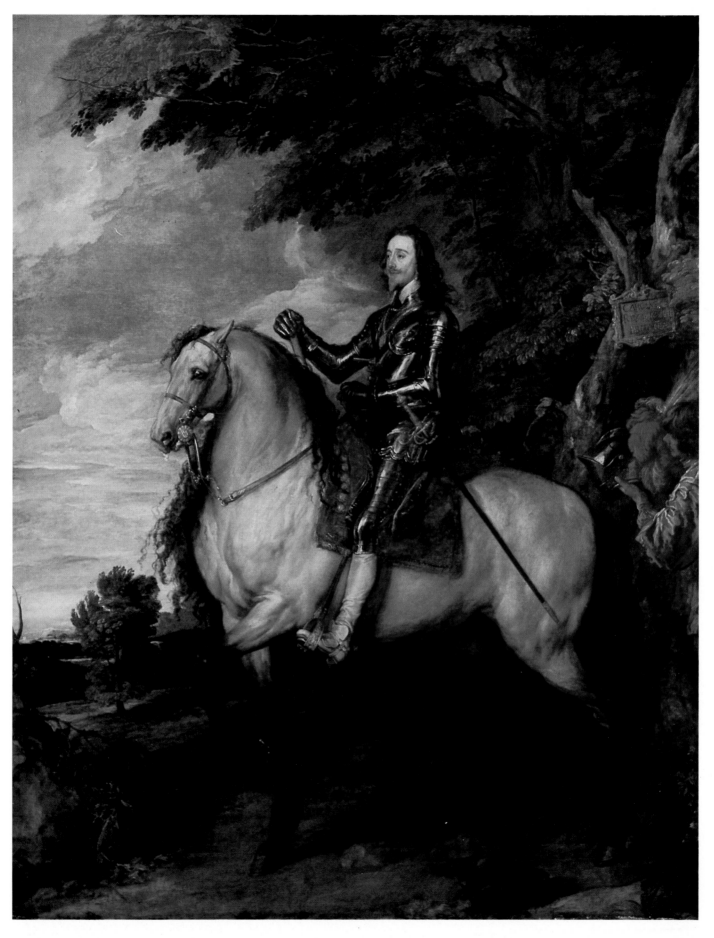

Jacques van OOST
1601–1671

Portrait of a Boy

Canvas, 0.805 × 0.63 Signed and dated: AETATIS SUAE II 1650 IVO

The inscription at the side of the portrait tells us that the child was eleven when he was painted, but the sitter is unknown. He would obviously much rather be out in the snow, but resignedly clasps his hands in his fur muff. Van Oost has sensitively observed the slightly solemn expression of suppressed vitality, pensive brown eyes and half parted lips, and the different qualities of his eyelashes, eyebrows, hair, and the fur of his muff and much downier fur of his hat.

Van Oost, who worked as a portrait painter in Bruges, had visited Italy sometime between 1621 and 1628. This portrait, with the whiteness of the boy's shirt which stands out against four tones of brown, and the three-quarter pose set against a plain background, may perhaps suggest the influence of north Italian painters, such as Lotto or Moroni.

Diego VELAZQUEZ

Philip IV of Spain

1599–1660

Canvas, 1.95 × 1.10 Signed on the paper: *Senõr. Diego Velazqũz Pintor de VMg*

It says much for Philip IV's esteem for Velázquez that he should have been permitted to show the king holding a letter actually addressed to the king from himself: Sire. Diego Velázquez Painter to your Majesty.

The pose of Philip IV, with his hand resting on the hilt of his sword, resembles a portrait of the king Rubens had painted during a visit to Spain in 1628 or 1629, although when Velázquez had become Court Painter to Philip IV in October 1623, he had been promised that he alone would have exclusive right to paint the king.

Here the king is shown in unusually splendid costume compared to the plain black normally worn at the Spanish Court, with the Order of the Golden Fleece around his neck; a magnificent plumed hat lies on the red velvet table cloth behind. Velázquez has accurately observed the slightly dandified appearance, the softly waved hair, curling moustache, myopic brown eyes, full weak lips, and prominent Hapsburg jaw. The *pentimenti* of the king's right leg, originally painted further to the left of the canvas, add an involuntary touch of realism, as if Philip, weary of posing, had just shifted his leg. In fact, Velázquez probably returned to the portrait over a number of years, from *c*.1631–1635. He was inclined to be slow, although the apparent deftness of his technique belies this. The incrustations of the king's brocade costume are rendered with quick flicks of thick paint. The Spanish Royal Collection was rich in paintings by Titian, commissioned and collected by the Emperor Charles V and Philip II, and there is no doubt that Velázquez studied with profit the technique of the great Venetian painter.

The portrait probably hung in the library of the Escorial; it was removed from there on behalf of Joseph Bonaparte and was given by him to General Dessolle in 1810. It passed through various hands before being purchased for the National Gallery in 1882.

Diego VELAZQUEZ

'The Rokeby Venus'

1599–1660

Canvas, *c.*1.225 × *c.*1.77

'The Rokeby Venus', which takes its name from Rokeby Hall in Yorkshire where it hung in the 19th century, is the only surviving painting of a female nude by Velázquez. It was painted some time before 1651 when it is described in an inventory of the collection of the Marqués del Carpio, son of the King's first Minister, in Madrid.

Velázquez has combined two traditional themes of Venus: at her mirror attended by Cupid, and Venus recumbent. Both themes were often painted by Titian. At least two pictures of a reclining Venus had been commissioned by Charles V and Philip II respectively, and were in the Spanish Royal Collection. However, the pose is closest to the *Sleeping Venus* attributed to Giorgione (now in Dresden). This painting was recorded in the Casa Marcello in Venice from 1525 until 1648. In 1629 Velázquez had left Madrid to visit Italy and study the great Venetian painters, so it is possible that he saw it. The pose has also been related to the fact that when in 1650–1651 Velázquez was in Rome, he ordered casts of classical statues for the Royal Collection.

The composition divides clearly into broad horizontal blocks of harmonious colour which unfold down the canvas from the pink of the top left-hand corner through beige, grey and white, with a flicker of green gauze. Venus' soft rosy flesh is painted with a delight in the pearly luminescence of a young body extended on a soft couch, very different from the childish body of the Cupid holding the mirror. However, Venus is inaccessible. The painting represents a subtle refinement on the Venetian Venuses who face bravely and blatantly forward. Here she has turned her sleek back on the spectator. The image of her face in the mirror is deliberately blurred, a tantalising suspicion of beauty. *The Kitchen Scene with Christ in the House of Martha and Mary* in the National Gallery, with its still-life study of eggs, garlic and fish, proves how convincingly realistic Velázquez could be if he chose. Here he has deliberately chosen not to be. Venus is put at one remove from the spectator. She is looking, not at herself, but at the spectator – only she meets his gaze *via* the mirror.

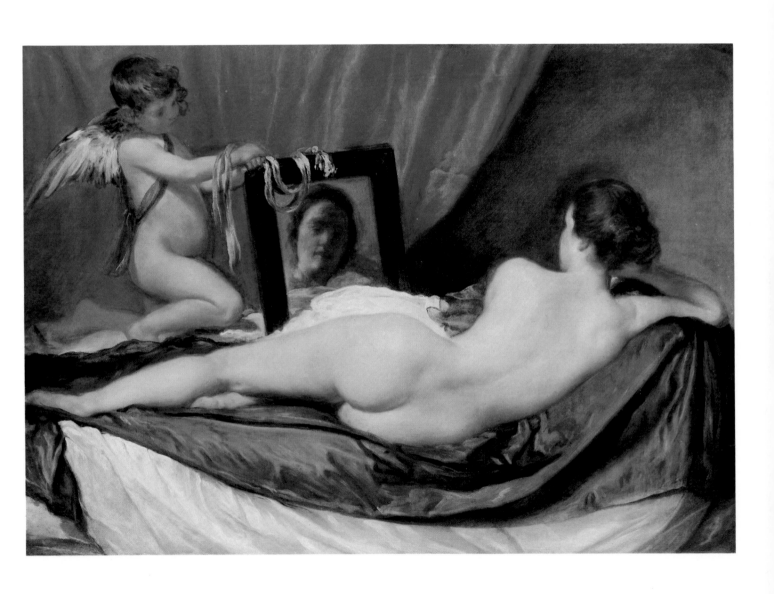

Bartolomé Esteban MURILLO

The Two Trinities

1617–1682

Canvas, 2.93 × 2.07

The source of the subject-matter of this picture appears to be the story of Christ told in Luke, II, 48. The Virgin and Joseph had been searching desperately for Christ who was in the Temple, and Christ said to them: 'How is it that you sought me? Did you not know that I must be about my Father's business?' They did not realise that by his father, he meant God. Here the distinction between Christ's earthly and heavenly father, and his role as a link between heaven and earth, are stressed. Joseph's status as earthly father of Christ is indicated by the flowering rod: each of the Virgin's suitors brought a rod to the high priest of the Temple; Joseph's rod blossomed as a sign that he was chosen to be her husband, and a dove came out of it and settled on his head. The Christ Child, standing at the top of three steps, puts his hands in those of the Virgin and Joseph. His head forms the apex of the group of three. It also links vertically with God the Father through the Holy Spirit in the form of a white dove. From Christ's halo radiates the light which illuminates the faces of his earthly parents.

Murillo painted this altarpiece for an unknown church *c.*1681, towards the end of his life. He worked mainly in Seville where in 1660 he was the founding President of the Seville Academy. The sentiment of his pictures appealed particularly to English taste, and he was popular in England from the 18th century onward. Gainsborough was greatly influenced by him in his 'fancy pictures' of peasant children.

Francisco de ZURBARAN
1598–1664

Canvas, 1.63 × 1.05

St. Margaret

The nickname of *Le Chapeau de Paille,* which has remained with Rubens' portrait of a woman in a felt hat, might more aptly have been given to the painting of St. Margaret of about 1635 by the 17th-century Spanish painter, Zurbarán. The virtuoso still-life study of the wide-brimmed straw hat would have been worthy of Caravaggio himself, whose tenebrist style, based on the extreme contrast between light and shade, strongly influenced Zurbarán. The intense realism of her woven Spanish saddle-bag, her devotional book, undulating linen ruffs, and the uncompromising expression on her severe face, contrasts oddly with the wavering fairy-tale dragon which snarls up at her.

St. Margaret is supposed to have been swallowed by a dragon which then burst, so that she emerged unharmed. She consequently became the patron saint of childbirth.

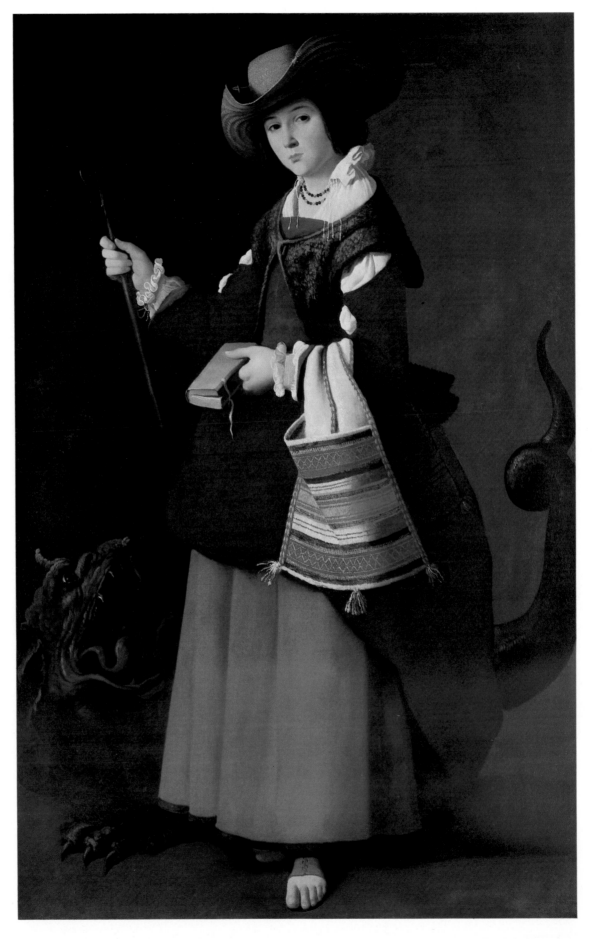

Francisco de GOYA

Doña Isabel de Porcel

1746–1828

Canvas, 0.820 × 0.546

Goya said that he worked from Nature, Velázquez and Rembrandt. His portrait of Doña Isabel de Porcel stems from all three. She is shown with her hands held proudly on her hips, her head held high. The full features of her face, which catches the light, are highly finished with rosy tints, and the swirling lace of her black mantilla is very freely painted. Doña Isabel and her husband, Don Antonio Porcel, whom she married in 1802, were close friends of Goya. He also painted Don Antonio's portrait, but this was subsequently burnt. According to tradition, the two portraits were painted during a visit to their home in gratitude for their hospitality. This one was exhibited in 1805 at the Academy of San Fernando in Madrid.

We can be sure that Doña Isabel really was very beautiful, since Goya never flattered his sitters, and he never shrank from portraying ugliness. His portraits also seem to discover a hardness, even cruelty, in human beings, which finds full expression in his satirical pictures, as much as in the more obviously anguished series of the *Disasters of War*, or in pictures of bull-fights. Nevertheless, he was much in demand as a fashionable society portrait painter, and numbered amongst his clientèle such people as the Duke of Wellington, whose portrait by Goya is also in the National Gallery.

Goya was to exercise an enormous influence on modern painters, particularly Manet (*see* p.196) and Picasso.

Hendrick AVERCAMP

1585–1634

*A Winter Scene
with Skaters near a Castle*

Oak panel, diameter 0.407 Signed: HA

Avercamp's circular picture of skaters on ice, painted *c.*1609, perhaps in the town of Kampen where he worked, is very like a child's toy glass ball containing a snow-scene. One feels that if one were to shake it, the whole scene would become a flurry of snow-flakes. Avercamp was dumb, and it seems peculiarly apt that he should have specialised in painting winter landscapes, scenes which one associates with stillness amd muffled sound. At this date winter scenes were still a rarity in painting.

With painstaking detail, deriving originally from the art of Pieter Bruegel the Elder, Avercamp has included a myriad of incidents. A blackbird sitting on a snow-covered branch sings with its beak wide open; sedate couples dance some sort of gavotte on the ice; two people have just lost their balance and are toppling backward; one woman has lost her skate and her partner is bending to put it back on; a man bows to a masked woman whose partner has had his attention distracted elsewhere.

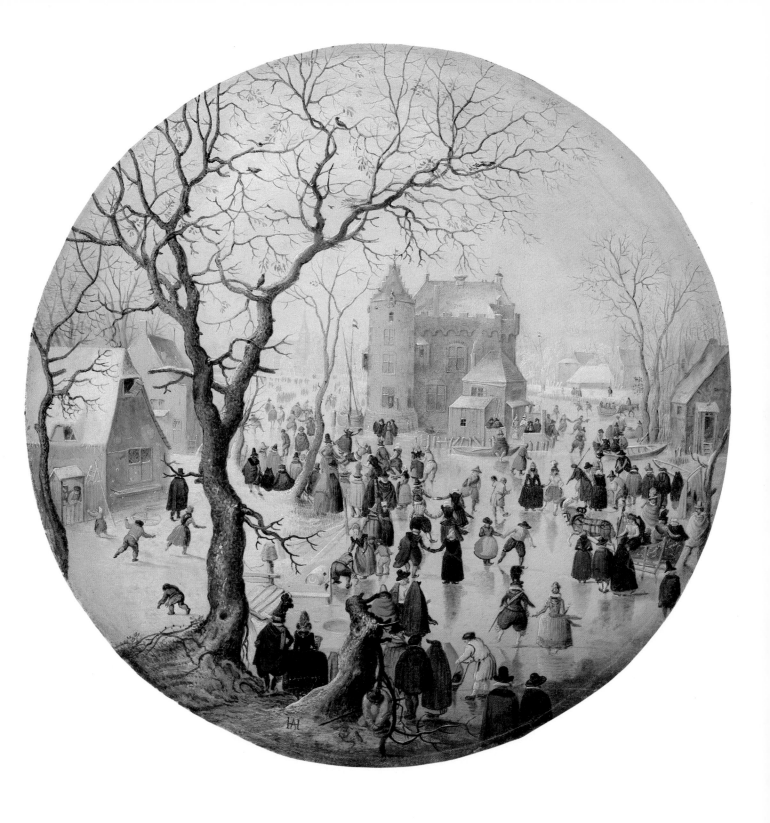

Pieter SAENREDAM

The Grote Kerk, Haarlem

1597–1665

Oak panel, 0.595 × 0.817

The Haarlem painter, Saenredam, specialised in painting topographical views and church interiors. He was scrupulously methodical in his approach. For this painting of 1637 of the interior of the Grote Kerk in Haarlem, a church which still exists, he made both a preparatory drawing and a cartoon to transfer the design to the panel. However, when it came to the final painting he enlarged the columns in the foreground, intent on emphasising their massive bulk which offsets the fine web-like Gothic fan-vaults, the labyrinth of slim rib-vaulted arches of the south transept, and the tiny anecdotal figures. Saenredam's pure, scrubbed style particularly suited the stark Protestant churches of Holland. To have created such an effect of light and solid three-dimensional space using almost no colour except white was an achievement never matched by contemporary painters of church interiors.

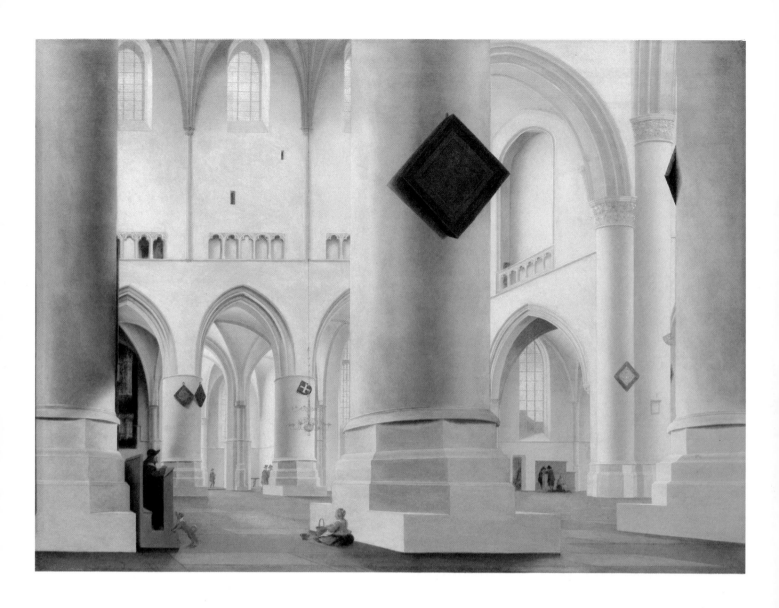

Willem KALF

Still Life

1619–1693

Canvas, 0.864 × 1.022 Signed lower left: *W. Kalf*

The very words *'pronk still leven'*, the Dutch words for this type of lavish still-life display, are redolent of pomp and circumstance. This picture was commissioned for the glory of the Amsterdam Archers' Guild *c.*1653 from Willem Kalf, who specialised in still-lifes. An elaborate silver statue of the martyrdom of St. Sebastian (*see* p.43), patron saint of archers, bound to a tree as a target for two Roman soldiers, supports the mount of a buffalo horn which was used by the Archers' Guild for ceremonial drinking. Today the horn is in the Historisch Museum, Amsterdam.

The objects selected, which suggest a delicious feast, lack any of the symbolic allusions which often haunt the arrangements in 17th-century Dutch still-lifes. They have been chosen purely for the magnificence of colour and texture. Each one in some way demonstrates the play of light over a different surface: the sparkle of the beaded surface of the lobster shell, the gleam of the succulent flesh of a peeled lemon, the shining horn handle of a knife, and the subtle texture of the furred weave of the oriental carpet. The interplay of reflections draws the composition together, as each object reflects, or is reflected by, another. The brilliant scarlet of the lobster's shell stridently dominates. It casts a faint pink shadow on the yellow rind of the lemon, and is reflected in the shallow pewter dish, the glasses, and the horn with its silver rim.

The whole arrangement is laid out on a marble table supported by a *putto* with arms flung back, perhaps Cupid, whose association with archery is more light-hearted than that of St. Sebastian.

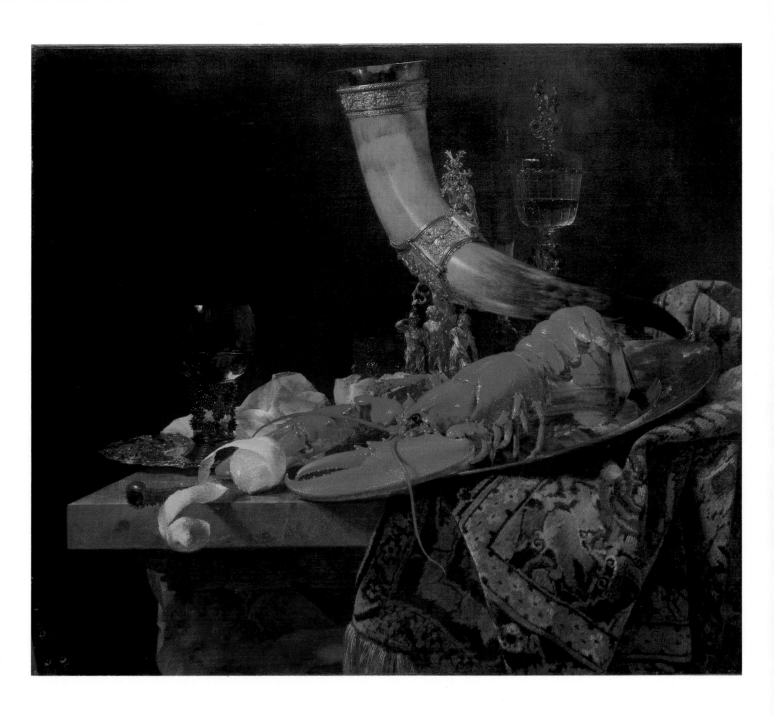

Nicolaes BERCHEM *Peasants with Oxen at a Ford*

1620–1683

Oak panel, 0.471 × 0.387 Signed: *Berchem*

The *'Drang nach Süden'*, or yearning for the South, attracted many Dutch painters to Rome during the 17th century. Not only was the hilly landscape of the Roman campagna more appealing than the flat stretches of Holland, and its golden dazzling sunlight very different from the cold grey light of the north, but also it was the most exciting place for a landscape painter to be. There Elsheimer and the Carracci, and then Claude in particular, had evolved the art of landscape painting as an independent genre. Several Dutch painters went to Rome and painted Italianate scenes, while those who stayed at home often imitated them.

Nicolaes Berchem, a Haarlem painter, is recorded as having visited Rome in the company of another Dutch painter, J. B. Weenix, from 1642 until 1645. This picture of peasants with oxen by a stream, painted in the late 1650s, clearly reflects his Italian experience, particularly in the sky which is a roseate gold, the Italianate landscape, and the inclusion of a ruined Roman aqueduct overgrown with creeper. The figures wear Italianate costume.

Berchem's repertoire was more varied than that of most 17th-century Dutch painters. Amongst more than eight hundred works he produced are winter landscapes, hunts, battles, harbour scenes, religious and mythological pictures, as well as etchings and engravings. One of his many pupils was Pieter de Hoogh.

Berchem sometimes painted the figures in landscapes by other Haarlem painters, including Hobbema and Ruisdael. By 1677 he had moved to Amsterdam where he died in 1683.

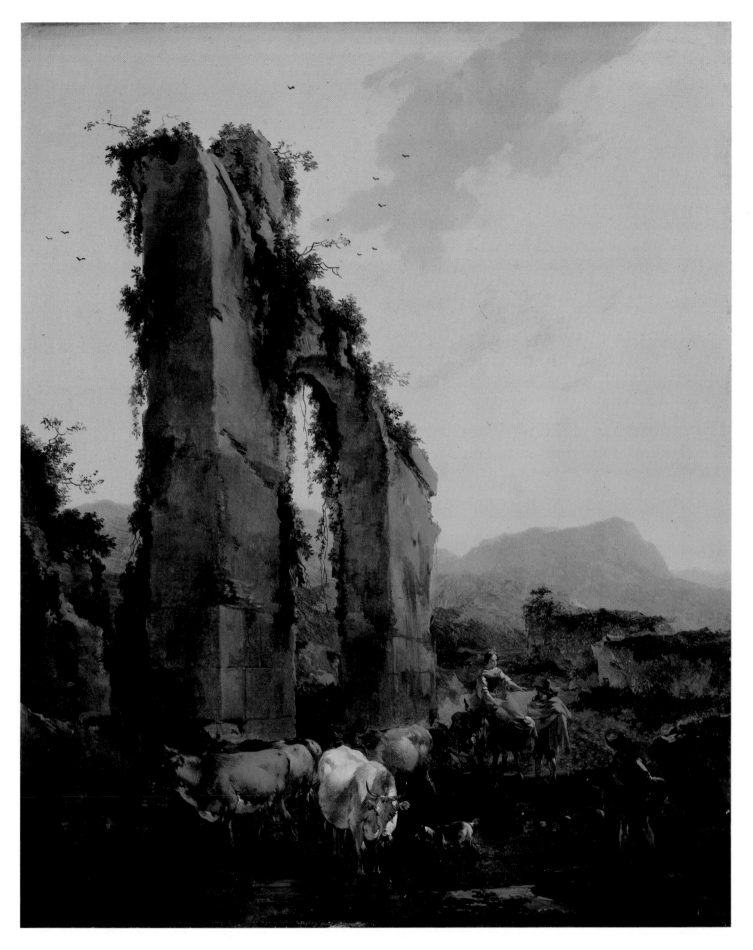

Jan STEEN

Skittle Players outside an Inn

1625/6–1679

Oak panel, 0.335 × 0.270

Like much Dutch genre painting, many of Jan Steen's pictures are humorous homilies in paint, sometimes grotesque to the point of caricature. Often they moralise, for instance, on the *Effects of Intemperance,* the title of another of his pictures in the National Gallery. As Steen's father leased a brewery for him at Delft in the mid-1650s, he had plenty of opportunity to observe these effects.

In contrast is this small picture, painted about 1662. Outside an inn, with a placard of a white swan, a woman and two men idle in the sun, sharing a drink. A small boy has stopped the game he was playing with a stick to watch a man bowling at skittles. Two men slouch beside, waiting for the skittles to fall, although any movement seems impossible in the heat of this drowsy summer's day. The sunlight sparkles in the foliage and catches the tops of the fence, and the cap of the woman passing by in the lane.

Steen worked principally in Leiden, living briefly in Delft, The Hague and Haarlem. In 1672 he became the landlord of an inn in Leiden where he died in 1679.

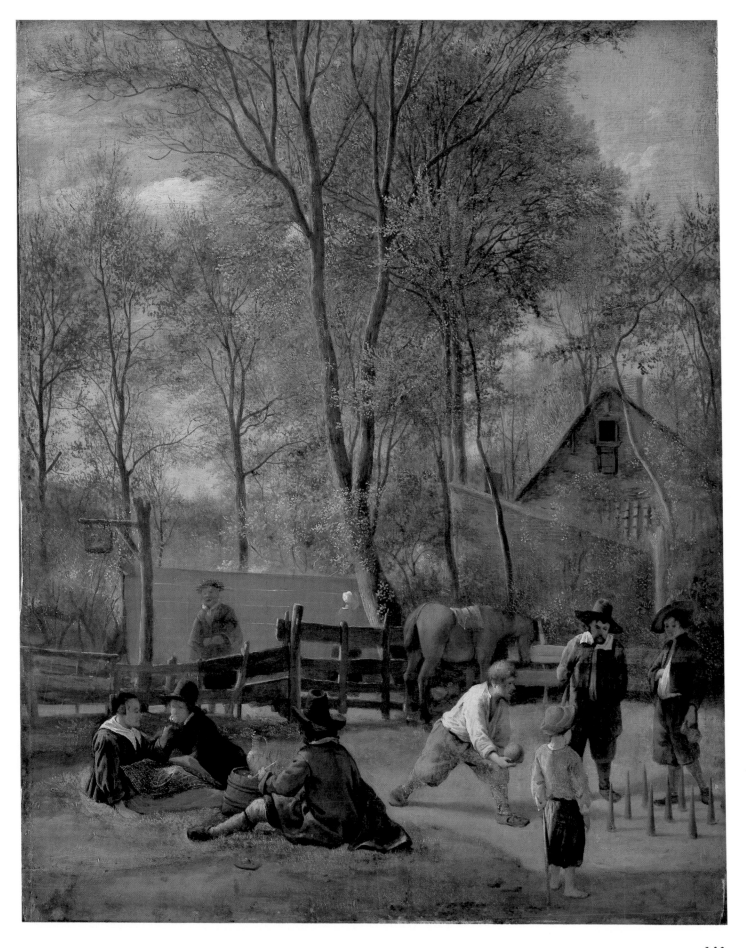

153

Jan VAN DER HEYDEN
1637–1712

*The Huis ten Bosch
at The Hague*

Oak panel, 0.216 × 0.286 Signed on the stone, bottom left: IVDH

The undulating band of cool green which runs along the bottom of this exquisite tiny painting gives the impression that one is standing on tiptoe to peep over a tall hedge into a private garden. Strolling in the sunshine are ladies and gentlemen. A gardener is peacefully hoeing amongst delicately painted shrubs. The house in the background still exists near The Hague. It is known as the Huis ten Bosch (the house in the wood), and was built to the design of Pieter Post between 1645 and 1652 for Amalia van Solms, wife of the Stadtholder, Prince Frederick Hendrick of Orange. Van der Heyden, an Amsterdam artist, painted several views of the house. This particular one, painted *c.*1670, shows the back of the building.

Van der Heyden specialised in architectural views, but his other skills included designing fire-engines and street-lighting.

REMBRANDT

Self-Portrait

1606–1669

Canvas, 1.020 × 0.800 Signed: *Rembrandt f.* 1640

Rembrandt had moved from Leiden, his birthplace, to Amsterdam in 1631. The year 1640 was a time of great prosperity for him. Not only was he famous and successful, but also he was married to the wealthy Saskia von Uylenborch. In September 1640 his son, Titus, was born and two years later Saskia died, worn out by pregnancy and childbirth.

Rembrandt based his self-portrait at the age of thirty-four, on Titian's *Portrait of a Man* (*see* p.83), which was probably in Amsterdam in about 1639 in the collection of a Portuguese-Jewish merchant and art-dealer, Alfonzo Lopez. Rembrandt shows himself as a slightly effete and even opulent young man. His numerous self-portraits provide a remarkable record, not only of the development and ageing of his own facial features, but also of his character. Here he is still intent on displaying his skill in differentiating between textures – linen, velvet, fur, and satin. By the time he came to paint his self-portrait aged sixty-three (also in the National Gallery), the emphasis had strikingly altered. There is the same face, highlighted by dramatic contrast between light and shade, the famous Rembrandt *chiaroscuro*. But the interest in materialism has gone; the focus is all on the saddened and stoic character of an old man.

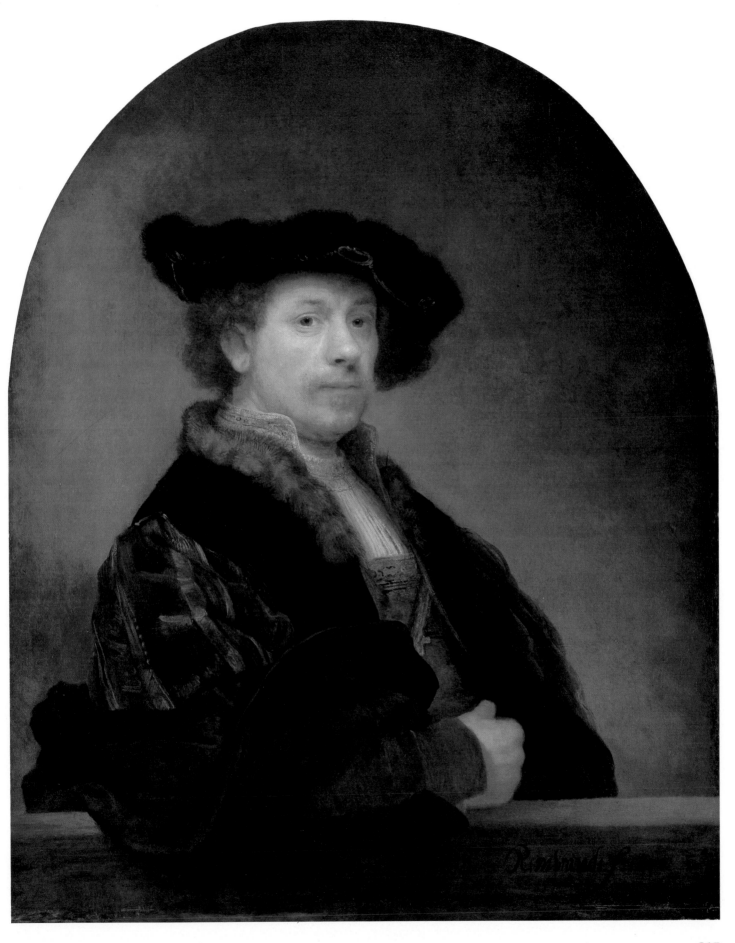

157

REMBRANDT

A Woman Bathing in a Stream

1606–1669

Oak panel, 0.618 × 0.470 Signed: *Rembrandt f. 1655*

The terms of Saskia's will made it impossible for Rembrandt to marry again without great financial loss. From about 1649 onward he lived with Hendrickje Stoffels. She seems to have been the model for this small oil sketch of a woman who has thrown aside a rich robe and is tentatively stepping into the water. It is thought to be a study for a *Susannah and the Elders,* although no similar composition by Rembrandt survives. He made several sensuous studies of Hendrickje, using the same broad and flamboyant brush strokes, lacking any completely smooth outline, which here convey a sense of fresh and somewhat mischievous spontaneity.

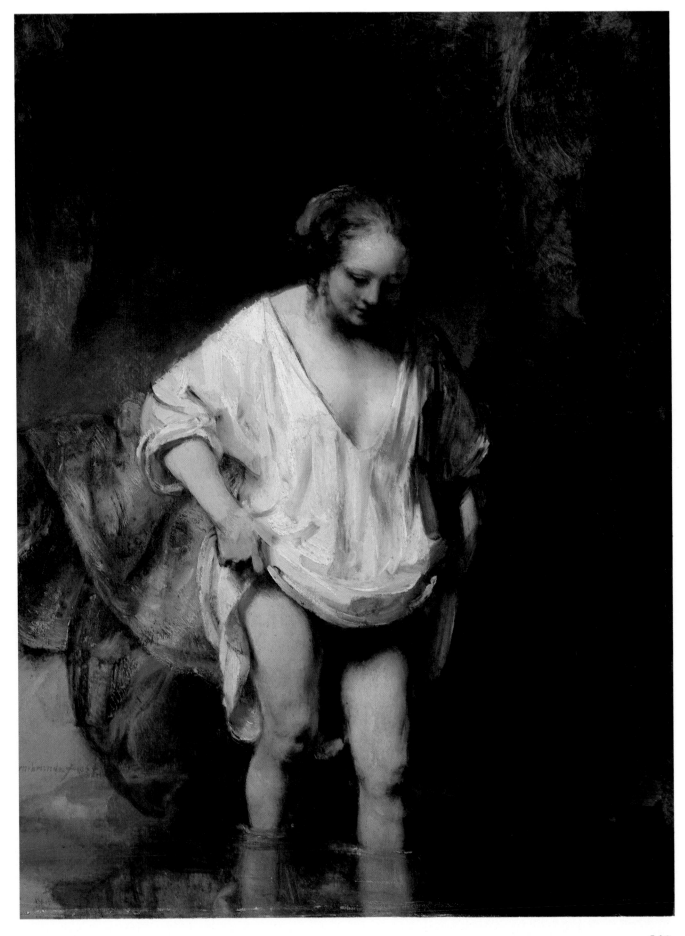

REMBRANDT

Margaretha de Geer

1606–1669

Canvas, 1.305 × 0.975

Although he never visited Italy, Rembrandt was deeply influenced by Raphael's portraits. In this painting of Margaretha de Geer of about 1661 when she was aged about 78, the three-quarter pose is almost aggressively frontal, but the powerful hands of the stern old woman clutching a handkerchief and the arm-rest of the chair, are probably taken from Raphael's portrait of *Julius II* (*see* p.55). Margaretha de Geer, who died in 1672, was also painted by Jacob Gerritz. Cuyp and Nicolaes Maes, and another portrait of her by Rembrandt is in the National Gallery. She was the wife of Jacob Trip, a merchant of Dordrecht, whose portrait by Rembrandt is also in the National Gallery. He too was painted several times, and it has been suggested that the portraits were intended for their dozen or so children.

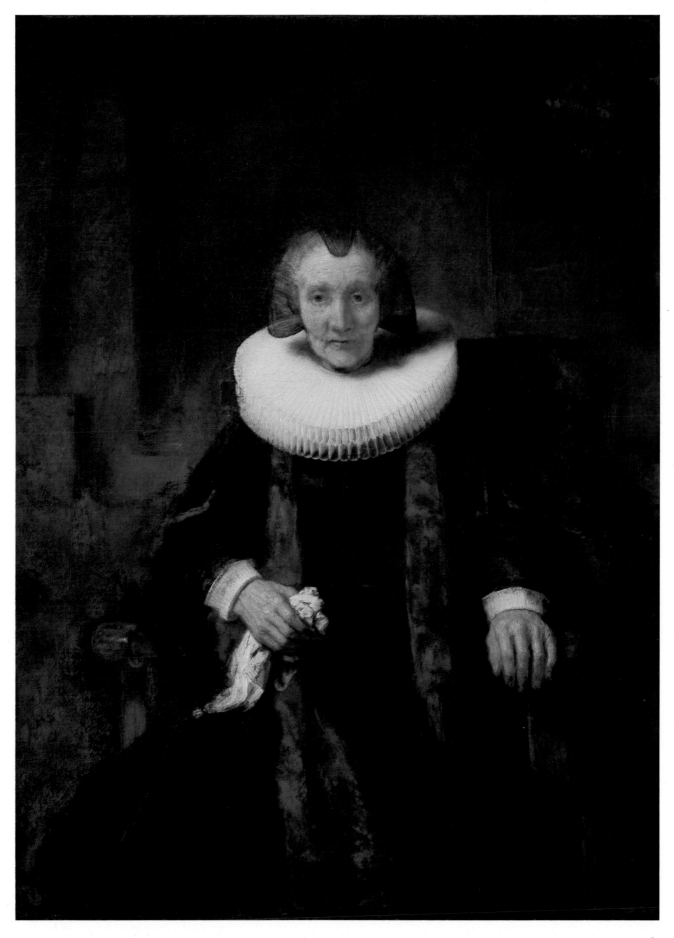

Jacob van RUISDAEL
1628/9–1682

*Landscape with a Ruined Castle
and a Village Church*

Canvas, 1.09 × 1.46 Signed: *JvRuisdael*

Two thirds of the picture surface is devoted to a clouded billowing sky
with the faint forms of birds in flight. But for church spires and the top of
a small clump of trees, the long stretch of the horizon is almost unbroken.
The time is mid-harvest and two men are gathering corn-stacks in the
fields, while a woman walks toward the church along a lonely path.
Typical of Ruisdael is the way in which the sun breaks sporadically
through the clouds, casting scattered pools of light across the country, an
effect which was to influence Constable (*see* p.180). The view, painted in
the mid 1660s, is near Haarlem, where Ruisdael spent most of his
working life; he painted at least four other pictures of the same view. As
was common amongst 17th-century Dutch painters, the *staffage*, or figures,
in the left-hand corner, have been put in by another artist, in this case
Adriaen van de Velde. Ruisdael was a close friend of Berchem, who also
sometimes painted the figures in his pictures.

Ruisdael probably studied under his uncle, Salomon van Ruysdael.
The nephew's was, however, a more romantic approach to nature. He
often painted slightly desolate scenes of decay: ruins, rotted tree-trunks, or
pools of stagnant water covered with lilies. In this picture the distance
conveyed seems almost infinite: at a single glance one can survey the tiny
delicate water-lilies of the pond in the foreground and the steeple of a
church spire on the far distant horizon.

Ruisdael's father was a picture dealer. This was true of several painters
and their families. The art market of 17th-century Holland was very
different from that of 17th-century Italy. Patronage was lavished on
cabinet pictures which were sold at fairs, bakeries, and so on. Because such
work was not necessarily painted for a specific location or patron, as was
the case in Italy, there were greater opportunities for dealers and
middlemen.

Pieter DE HOOGH

A Woman and her Maid in a Courtyard

1629–after 1684(?)

Canvas, 0.737 × 0.626 Signed: P.D.H. 166 –

De Hoogh is an example of a painter whose work deteriorated as he grew older, particularly after he had moved from Delft to Amsterdam in about 1661. However, this picture of a maid cleaning fish in a courtyard was painted while he was still in Delft and still at the height of his powers. It has been suggested that the wall at the end of the garden is the old town wall of Delft. Perhaps it was the influence of Vermeer which sustained his skills as a genre painter, since they painted very similar tranquil and controlled domestic scenes of women and their maids engaged in daily chores, and both studied the fall of light on everyday objects. De Hoogh's pictures do not invest these objects with the same symbolism that is found in Vermeer. They do, however, often verge on narrative, as here with the approach of a gentleman down the pathway, and the implied dialogue between the maid and the mistress whose face we cannot see.

De Hoogh, with other 17th-century Dutch painters, was interested in closely observed reality, following a tradition which had already begun in the 15th century with Early Netherlandish painters. In this picture, the broom, bucket and bowl are carefully studied, and the observation of the uneven brick paving is so convincing that it seems as if the picture's very canvas is buckling.

Johannes VERMEER *A Woman standing at a Virginal*
1632–1675

Canvas, 0.517 × 0.452 Signed: *IV Meer*

A Woman standing at a Virginal and its possible companion piece, *A Woman seated at a Virginal,* which were together in the same collection during the 19th century, are late works of *c.* 1670. They may not be among Vermeer's finest work, and yet they have an exceptional quality. Characteristic of Vermeer is the light which streams in through a window on the left and catches the gilded picture frame, the brass studs of the blue velvet chair, and the bunched pearly satin of the woman's dress and her pearl necklace. Splashes of scarlet bows interrupt what is otherwise a predominantly blue and white composition. It amounts almost to a boast, that with the very same colours Vermeer can differentiate between the matt hard smoothness of a white plaster wall and the soft rich folds of a white satin dress, between the furred blue velvet of the chair and smooth blue of a bodice.

Ostensibly painted for sheer delight in colour, composition and texture, Vermeer's pictures extend beyond the immediately visible into symbolism and a complex commentary on life. Music was a commonplace symbol of love; as the woman stands improvising idly at the keyboard, the picture of Cupid behind tells us that she is dreaming of her lover. The mountainous landscapes painted on the instrument and in the gilt-framed painting suggest that he is far from the flat fields and canals of Holland – perhaps in Italy, which was a favourite haunt of Dutch painters during the 17th century. The empty chair turned toward her emphasises the sense of her absent lover.

Meyndert HOBBEMA

The Avenue, Middelharnis

1638–1709

Canvas, 1.035 × 1.41 Signed: *M. hobbema. f. 1689*

It is possible that Hobbema took the basic idea for this composition from a picture by Albert Cuyp, probably painted in the 1650s, of *The Avenue at Meerdervoort* (now in the Wallace Collection, London). The latter shows a similar view down the centre of a tree-lined avenue, a church on the left, and this time on the right, a canal. Hobbema's use of the arrangement is, however, much subtler and more sophisticated than Cuyp's. The trees are very tall and slender, bare-trunked, tufted only at the top, and the dusty track stretches far back to the small village in the background. The atmosphere is peaceful: a man strolls with his dog, his gun resting on his shoulder; a couple pause in the lane to talk; a man is pruning his hops. These are very small glimpses of human life amidst broad expanses of field with patches of light, similar to those found in the paintings of Ruisdael, Hobbema's teacher. The sense of space is above all created by the sky which takes up three-quarters of the picture surface.

Middelharnis lies on the north coast of the island of Over Flakee in the province of South Holland at the mouth of the Maas. The view has changed little, and the church of St. Michael still stands, as does the Town Hall, whose tower can be glimpsed to the east of the church. The barn on the right of the avenue survived until about 1879.

Hobbema worked mainly in Amsterdam. At the age of only thirty he changed his career to that of a wine-gauger there, although he continued painting intermittently.

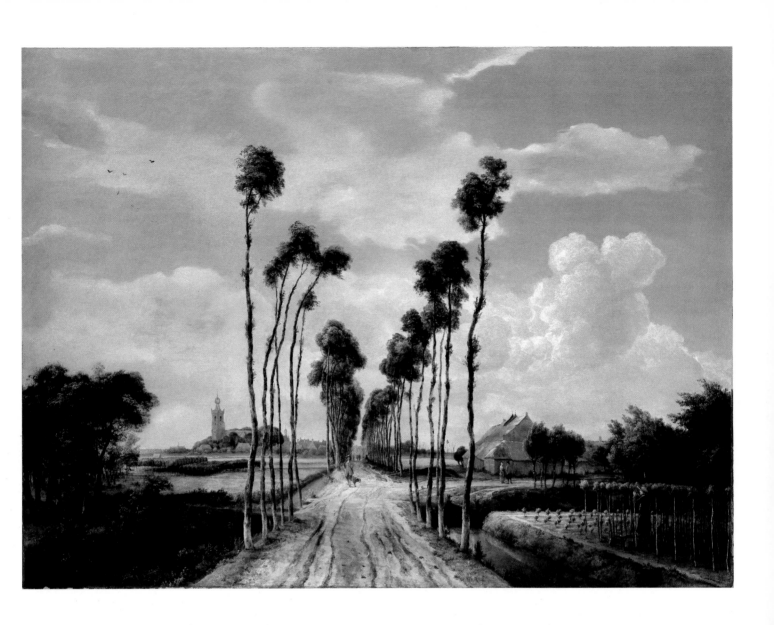

William HOGARTH

The Marriage Contract

1697–1764

Canvas, 0.70 × 0.91

This is the first of a series of six pictures called *Marriage à la Mode,* painted in 1743–5, satirising marriages of the wealthy middle classes to the impoverished nobility, which were common in England at the time.

In this picture the marriage contract is being drawn up. The earl's creditors thrust the mortgage for the unfinished house, seen through the window, at him; he seems indignantly to reply, pointing at the family tree, that one descended from the Dukes of Normandy should not be bothered with such trifling things as money. His coronet decorates even his crutches and the footstool on which he rests his gouty foot. Meanwhile, the girl's wealthy merchant father reads the marriage contract which will solve the earl's financial problems. The lawyer who prepared the contract is sharpening his quill and flirting with the unhappy bride-to-be who twiddles her engagement ring mournfully on her handkerchief. The earl's son and heir — and the bridegroom-to-be — a fop and dandy, sits taking snuff and admiring himself in the mirror. Every detail of the setting is a comment on the situation. Amongst the pictures on the wall, one of a gorgon watches the scene screaming, and horrible scenes of martyrdom and suffering presage the future miseries of the couple. The two dogs chained to each other symbolise the marriage of the ill-assorted pair.

The other pictures in the series show the disintegration of the marriage which ends with the wife's lover, the lawyer, killing her husband, followed by her own suicide.

Hogarth's purpose was deliberately didactic and he engraved this series for more widespread distribution in 1745. He wrote in conscious echo of Shakespeare: 'my picture is my stage, and men and women my players'.

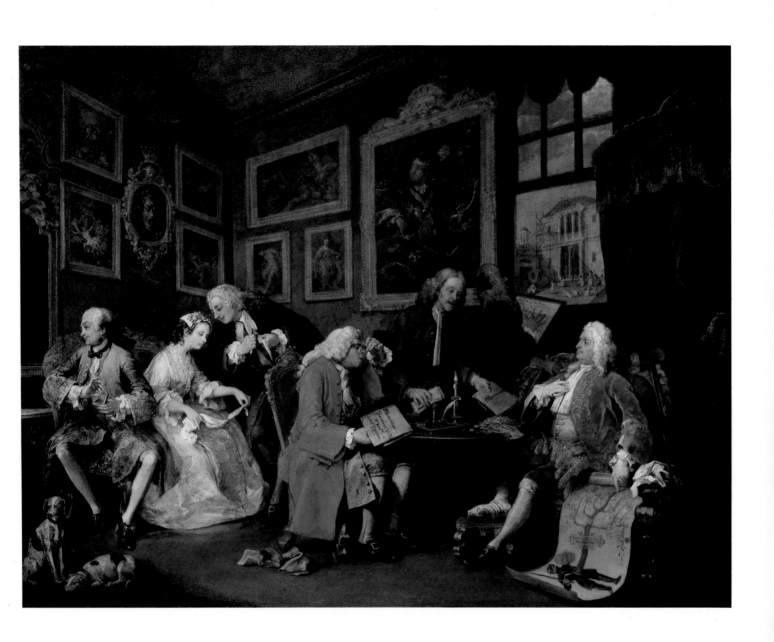

Sir Joshua REYNOLDS

Captain Robert Orme

1723–1792

Canvas, 2.40 × 1.47 Signed: *J. Reynolds pinxit* 1756

For Reynolds, as for Vasari, Michelangelo represented the peak of artistic achievement: Vasari had seen all painting as culminating in Michelangelo; Reynolds saw all painting after Michelangelo as deteriorating. He admired Old Masters passionately and advocated the Grand Manner, particularly in his *Discourses,* the lectures which he delivered to the Royal Academy, of which he was founding President in 1768. In his portrait of the dashing Captain Orme, painted in 1756, he adapted in reverse the pose of a horse and rider in a fresco by the early 17th-century Florentine painter, Jacopo Ligozzi, which he had sketched in the cloister of the church of Ognissanti in Florence when he visited Italy in 1752.

Robert Orme (1725–1790) was a Lieutenant in the Coldstream Guards and aide-de-camp to General Braddock; he had been wounded in an ambush by the French near Fort Duquesne, later renamed Pittsburg, in 1755, shortly before the outbreak of the Seven Years' War, and had returned to England. Reynolds conveys something of the sitter's heroism in battle in the thundery sky, black with cannon smoke, which clears to a brightly-lit pale blue around Orme's head. However, the portrait apparently failed to please. It was still in Reynolds' studio when he died, suggesting that it was rejected by the sitter, and probably never paid for.

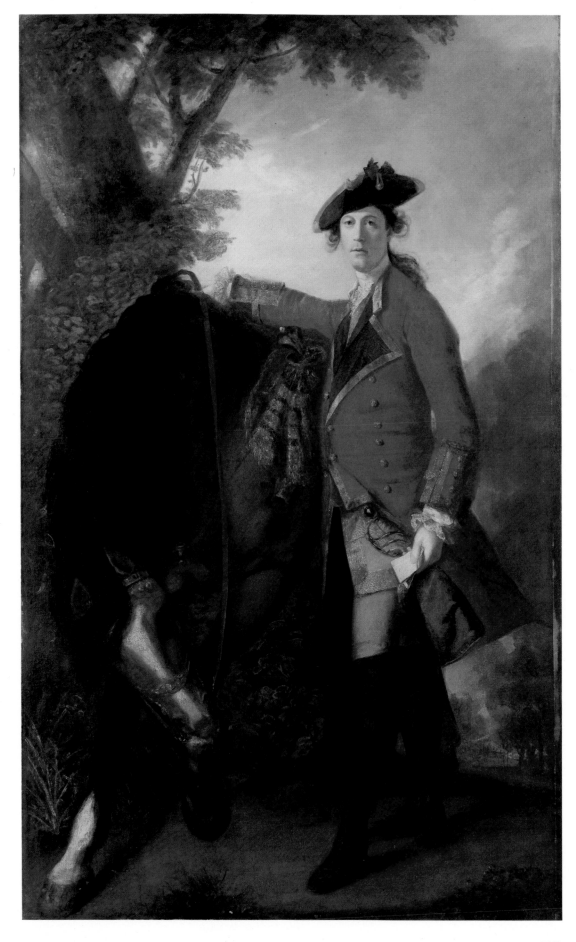

Thomas GAINSBOROUGH

1727–1788

Canvas, 2.362 × 1.791

The Morning Walk

'Hope is the Pallat Colours we all paint with in sickness', Gainsborough wrote to a friend in May 1788. He was to die in August that year. His late portraits, of which this is one, are curiously drained of the shimmering bright colours he had used in earlier ones. But, where *The Morning Walk* poignantly marks the close of the career of one of England's greatest portrait painters, it marks a beginning for the sitters. They are William and Elizabeth Hallet who were married in July 1785, and this marriage portrait was painted in the autumn of that year. Serenely detached, the couple seem to float forward out of the canvas in powdered elegance. The gauze of Mrs Hallet's shawl flutters softly at her elbow. A fluffy Spitz dog accompanies them. A delicate transparent landscape is sketched into the background. The whole is painted with a light feathery touch characteristic of Gainsborough's late style which he achieved by using six foot long brushes, standing equidistant from canvas and sitter.

Although for Gainsborough business was, as he put it, 'chiefly in the face-way', he loved painting landscapes, and set most of his portraits out-of-doors. He yearned for the countryside and once wrote to a friend:

'I'm sick of portraits and wish very much to take my Viol da Gamba and walk off to some sweet Village where I can paint Landskips and enjoy the fag End of life in quietness and ease'.

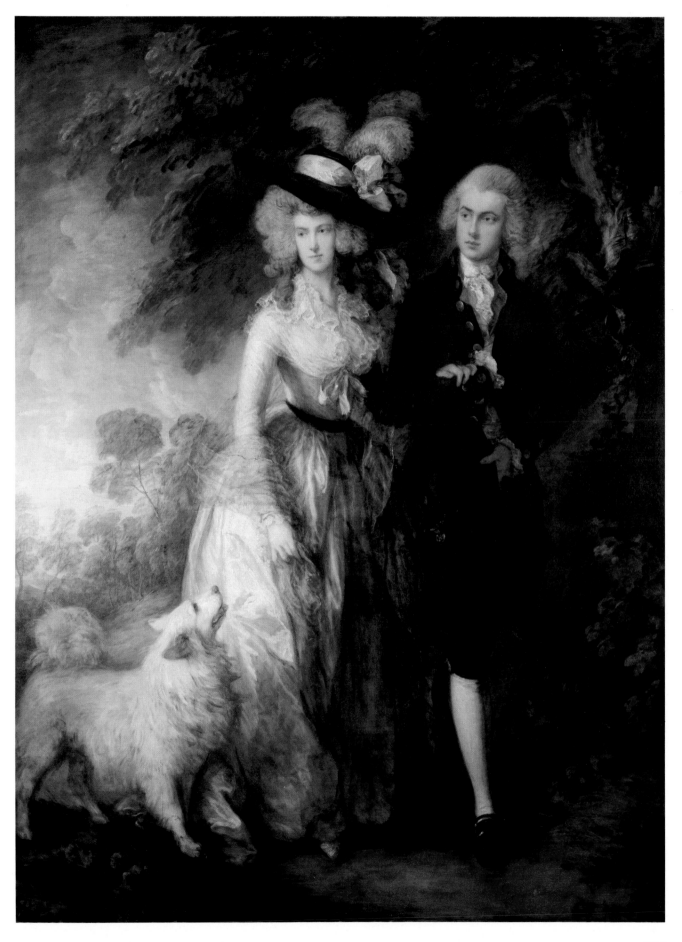

George STUBBS *The Melbourne and Milbanke Families*

1724–1806

Canvas, 0.972 × 1.493

Stubbs' glossy and very formal composition painted *c.*1769 shows the Milbanke and Melbourne families posed stiffly with their horses and carriage. The sitters from left to right are Elizabeth Milbanke, first Viscountess Melbourne; her father, Sir Ralph Milbanke, Bt.; her brother, John Milbanke; and her husband, Peniston Lamb, first Viscount Melbourne. Stubbs' interest in animals was perhaps greater than his interest in people. In 1766 he had published an *Anatomy of the Horse* for which he engraved his own plates. In this family portrait the characterisation of the horses is more acutely observed than that of the sitters. The composition is very similar to the portrait of *Colonel Pocklington and his Sisters,* dated 1769 (Washington, National Gallery of Art), which has exactly the same setting of the oak tree and distant lake.

The descendants of the sitters were to achieve some fame. The son of Lord and Lady Melbourne was to become Queen Victoria's Prime Minister. Sir Ralph Milbanke was the grandfather of Anne Isabella Milbanke who married the poet, Lord Byron.

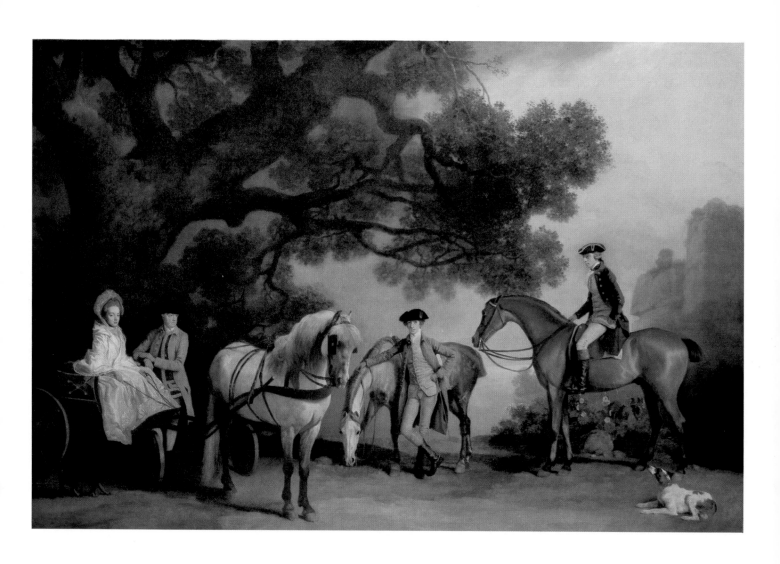

Sir Thomas LAWRENCE

Queen Charlotte

1769–1830

Canvas, 2.394 × 1.473

Lawrence's was a precocious genius. At the age of only twenty-one he was given his first major royal commission – for this portrait of Queen Charlotte wearing a bracelet with a miniature of her husband, George III. It was exhibited at the Royal Academy in 1790 and helped to establish him as a leading portrait painter. No painter before him – not Ramsay, Zoffany, Cotes, West, or even Gainsborough – had succeeded in painting the Queen as anything but plain and listless. Nor did Lawrence succeed where others had failed. In his portraits of a similar date, such as that of Elizabeth Farren (New York, Metropolitan Museum), his sitters, even the most aristocratic, sparkle with life. Lawrence offended the Queen by asking her to talk, in order to animate her features. Eventually she refused to sit for him, and the Assistant Keeper of her Wardrobe modelled for the final details. In fact, most of Lawrence's energies seem to have been concentrated on the effects of the dress of pale blue silk shot with lilac, a gauze shawl and lace cuffs, and the landscape background with a view of Eton College Chapel from Windsor Castle.

The composition of a seated figure by a window stems from the Renaissance, particularly from Titian, and was much used by Gainsborough. Lawrence followed the advice of Reynolds, and studied the Old Masters, especially Raphael and Veronese. But his greatest debt was to Gainsborough, and in his portraits, he achieved exactly what Gainsborough had recommended, namely, 'a variety of lively touches and surprising Effects to make the heart Dance'.

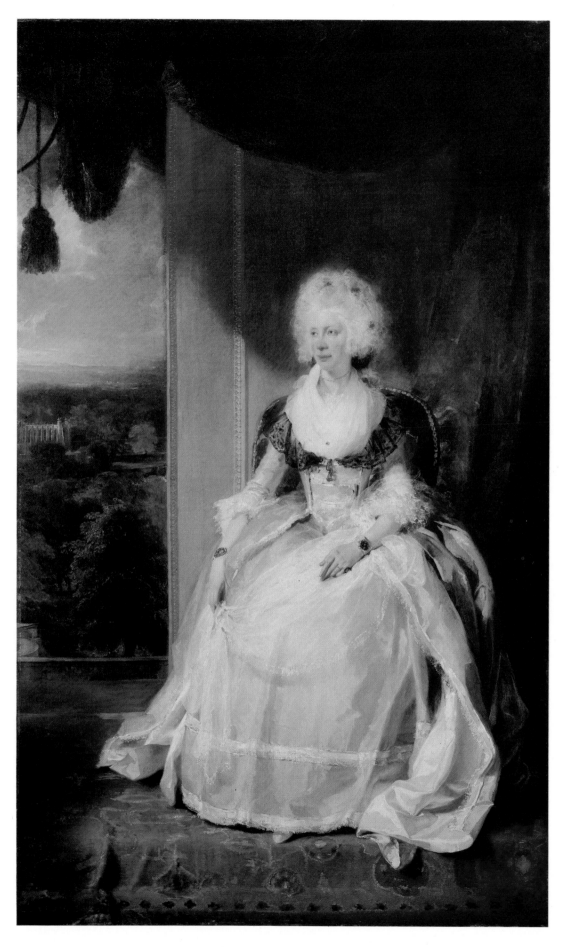

John CONSTABLE

The Hay Wain

1776–1837

Canvas, 1.305 × 1.855 Signed: *John Constable pinx*ᵗ *London 1821.*

It is ironic that what is perhaps the most popular English landscape painting was not appreciated by the English public when it was first exhibited at the Royal Academy in 1821. Its bright fresh colours, naturalness, and thickly applied paint, were anathema to a public used to idealised landscapes. Failing to find an English buyer, it was eventually bought by a Frenchman, and sent off from Charing Cross in May 1824 to be exhibited at the Paris Salon that year. There its realism excited considerable admiration. The remark was overheard: 'Look at these English pictures – the very dew is on the ground'.

This realism derived in part from Constable's familiarity with Suffolk. The view is of the farmer Willy Lott's cottage, on the river Stour, painted from Flatford Mill of which Constable's family had the tenancy. The Stour, which Constable painted almost obsessively, reminded him of his 'careless boyhood'. The scene is specific; so is the time of day. Although Constable himself referred to it as the 'Wain', it was actually exhibited at the Royal Academy under the title *Landscape, Noon*. Five years later Constable was to exhibit *The Cornfield* (also in the National Gallery) with exactly the same title of *Landscape, Noon*, accompanied by a quotation in the catalogue from Thomson's *Summer:*

> A fresher gale
> Begins to wave the woods and stir the stream
> Sweeping with shadowy gust the fields of corn,

lines which might equally well apply to *The Hay Wain*.

Constable has chosen a high viewpoint with a strong diagonal emphasis, in much the same approach as Rubens used in his *Watering Place* (*see* p.125), to create a peaceful, rural idyll reminiscent of Gainsborough's landscapes. His interest, however, is not so much in creating an atmosphere, as in investigating in detail the phenomena of the natural world, and the changing effects of nature, particularly of light. The fitful pools of light in the fields, when the sun breaks momentarily through billowing clouds, is as much a weather study as it is a tribute to the 17th-century Dutch painter, Ruisdael (*see* p.162). He considered the sky 'the *key note*': '(it is) the source of light in nature and governs everything'.

Before Constable started this ambitious work, he first mapped out his ideas in a full-scale study (London, Victoria and Albert Museum). In the final version he made a few changes, omitting a figure on horseback at the edge of the stream and substituting a barrel which he eventually painted out and which is now beginning to show through. In 1821, a few months after he had completed this picture, Constable wrote to a friend:

'But the sound of water escaping from Mill dams, . . . willows, old rotten banks, slimy posts, and brickwork. I love such things . . . As long as I do paint I shall never cease to paint such places'.

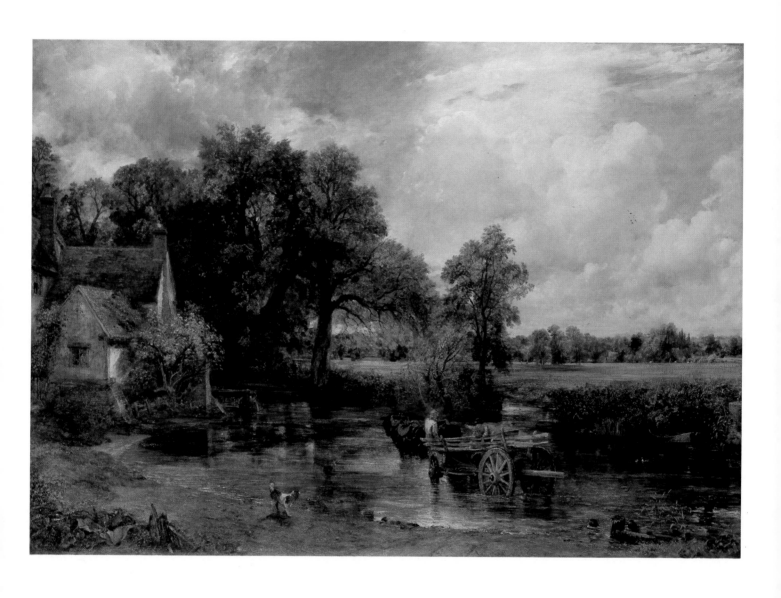

Joseph Mallord
William TURNER

1775–1851

Canvas, 0.91 × 1.22

The 'Fighting Téméraire'
tugged to her last Berth
to be broken up

Constable's obsession with the Suffolk countryside was matched by Turner's obsession with the sea.

The Fighting Téméraire was towed from Sheerness to Rotherhithe for destruction in 1838. *The Téméraire* took her name from a French ship captured at Lagos Bay in 1759; her crew had greatly distinguished themselves at the Battle of Trafalgar in 1805, and she was thereafter known as *The Fighting Téméraire.*

Turner contrasts the two ships: the slender dignified ship with its sails furled, which already has the unreal pallor of a wraith, is being ignominiously towed by a squat black ugly tug, aggressively spewing soot and flames through its funnel. Turner's sad comment on the Industrial Revolution, and the transition from sail to steam, is also symbolised by the elements. The pale setting sun is thin and flat; only its rays and their reflections remain, painted in exceptionally thick raw impasto, almost seeming to scorch through the canvas. The sun has not yet disappeared below the horizon, yet the moon is already gleaming high in the sky.

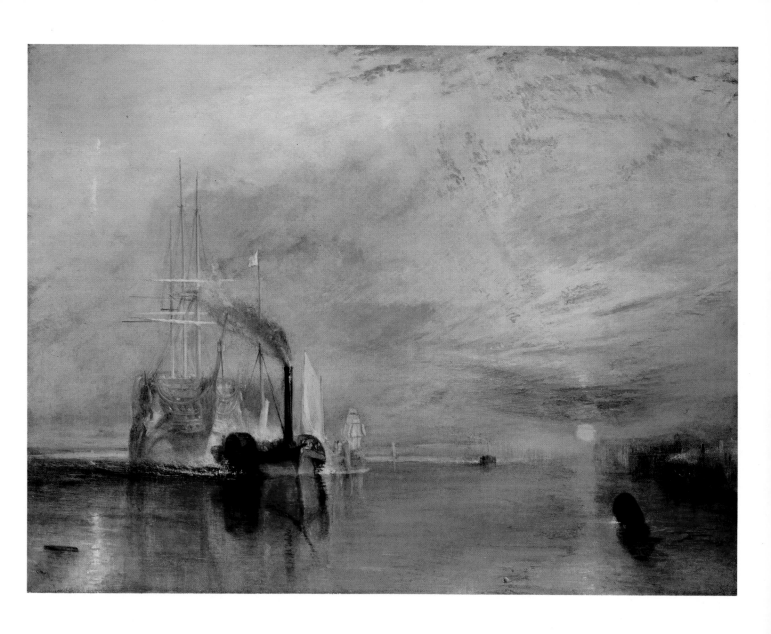

Giovanni Antonio Canal, called CANALETTO

The Stonemason's Yard

1697–1768

Canvas, 1.238 × 1.629

Venice has changed little since, in about 1726–30, Canaletto painted this view from Campo San Vidal across the Grand Canal to the church of Santa Maria della Carità. At the right of the church is the façade of the Scuola della Carità (now the Accademia), and in the right background, the pediment of the façade and campanile of San Trovaso. Venetian balconies are still covered with innumerable pots with plants; the laundry is still strung out across the street; Italian mothers still drop their brooms and rush to pick up their screaming *bambini*; long white blinds still darken damp rooms against the sunlight. Canaletto shows the Venetians preparing for the day. A dilatory cockerel has apparently just appeared on a window-sill. The morning sunlight shining from the east picks up every detail of the patchy walls, faded wooden shutters, the woman shaking out the sheets, and the woman spinning on her balcony. In the foreground the masons are chipping at blocks of stone perhaps intended for the re-building of the nearby church of San Vidal. Their measuring instruments rest against the rough-hewn pillars, while a woman leans over the top of one of the capitals.

Canaletto and Venice seem synonymous today. He did, however, also visit England during the years 1746–56, where he painted views of Eton College, and some country houses, including Warwick Castle. But it was in the Italian sunlight that his art flourished most successfully.

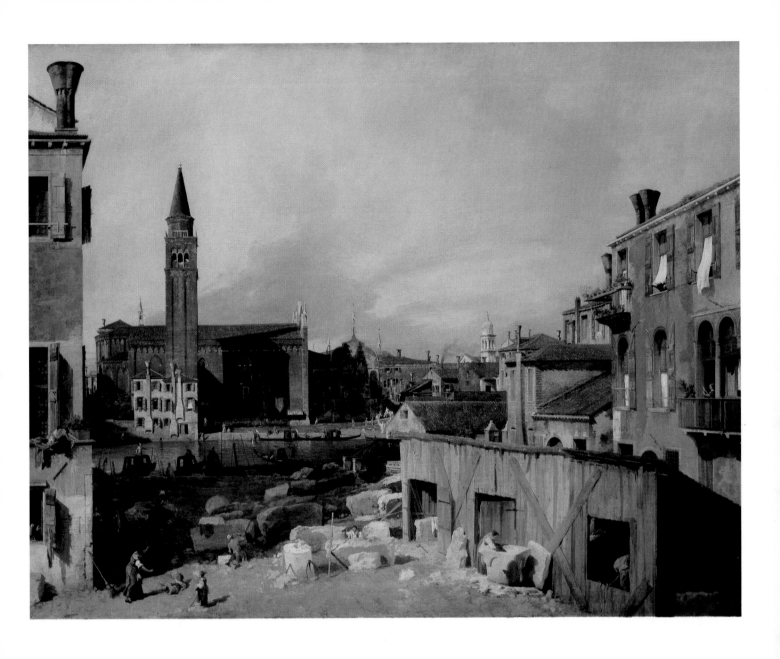

Giambattista TIEPOLO

1696–1770

Canvas, 2.92 × 1.904

An Allegory
with Venus and Time

Tiepolo's ceiling, designed to be seen from below, is of an allegory of Venus and Time. It was probably painted in about 1753–8 for one of the numerous Venetian palaces owned by the Contarini family. Venus, with her attribute of two doves fluttering above her, and accompanied by the three Graces, has just given birth to a child whom she has washed in the earthenware pot she holds with her right arm; with a last affectionate stroke of the baby's head, she consigns him to the arms of winged Time, whose hour-glass is strapped to his waist; he has momentarily laid down the scythe with which he cuts off mortal life. He is to take the child down to Earth, seen below. A fat winged Cupid, clutching an enormous and promising sheaf of arrows, tumbles over the clouds at Time's feet.

The painting may have been commissioned to celebrate the birth of a son to the Contarini family, one of the very oldest in Venice, although the exact event has not been established. The birth of the child is accompanied by a sense of optimism for his future: the majestic naked figure of Venus in pink, white and yellow, is like Aurora, goddess of the dawn, and is bathed in the symbolic light of dawn. Behind her the ethereal blue sky seems to stretch back into infinity.

Jean-Baptiste CHARDIN

The Young Schoolmistress

1699–1779

Canvas, 0.616 × 0.667 Signed: *chardin*

From early in his career Chardin was deeply influenced by 17th-century Dutch paintings which became popular in France during the 18th century. He began by painting still-lifes, especially of game, and objects associated with the kitchen, such as pots, copper pans and earthenware, or arrangements with fruit, nuts, goblets, and carafes. In about 1732 he turned to genre painting and produced small paintings of domestic scenes – women doing the laundry, mending, peeling vegetables, preparing children for school, or giving them their evening meal – often producing several versions of the same scene. In his pictures, the same objects often recur with reassuring familiarity. With quiet colours Chardin created a world which is stable, tranquil and secure.

A few of his pictures showing a single child building a house of cards, spinning a top, or holding a battledore and shuttle-cock are like enlarged details extracted from one of these genre scenes. The children are shown with captivating simplicity, absorbed as only children can be. In *The Young Schoolmistress,* exhibited at the Paris Salon of 1740, Chardin paints an affectionate portrait of a small child whose dimpled round face only just reaches over the top of the desk, pointing in perplexed concentration with a fumbling and doubtless sticky finger at a school book. The elder girl points out the letters with an elegant and precise gesture. She looks at the child, patiently awaiting an answer.

They are unlikely to be Chardin's own children: his son was born in 1731, and his daughter had died in 1736 at the age of only three.

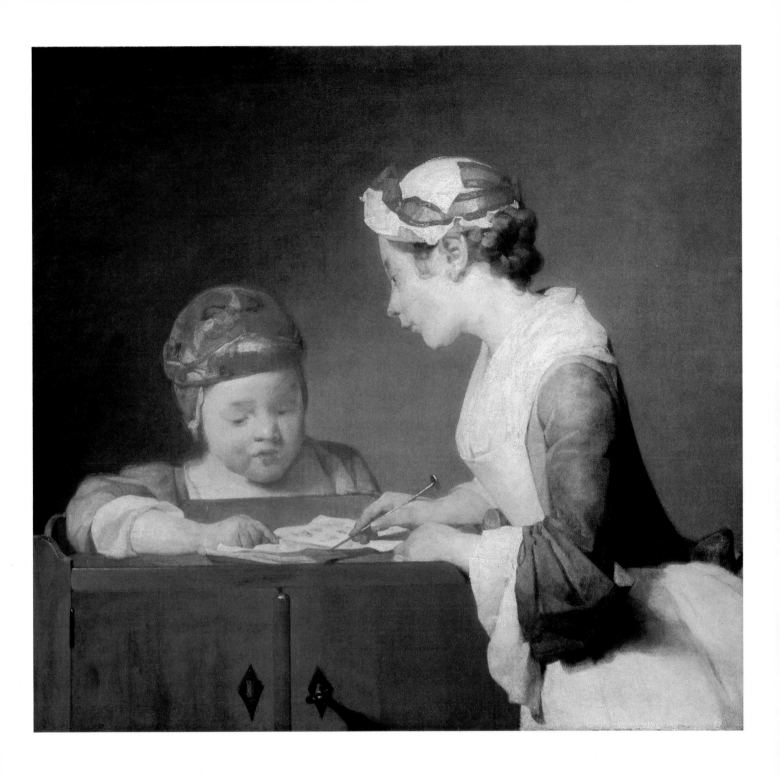

Nicholas LANCRET

1690–1743

Canvas, 0.889 × 0.978

*A Lady and Gentleman
with two Girls in a Garden*

This picture was exhibited at the Paris Salon of 1742, a year before Lancret's death, under the title *Une dame prenant du Caffé avec des Enfans.*

Drinking coffee or chocolate was a fashionable pastime in 18th-century Europe. Lancret's charming domestic idyll set in an ornamental Rococo garden is probably a portrait of a particular family. The father watches affectionately while the mother feeds spoonfuls of the treat to her daughters. The elder one waits patiently, eyes fixed on the cup. The younger one has thrown down her doll in her eagerness and has a large white napkin tied around her, to prevent spills down the frills of her yellow dress. There is a gentle humour in the fact that the doll, abandoned face-down on the ground, is dressed in exactly the same red, white and blue satins as the mistress of the house.

The introduction of a still-life into this type of genre picture derives originally from 17th-century Dutch painting. Here the delicate study of the silver pot and cups also suggests the influence of Chardin, Lancret's contemporary, who at this time was also painting genre scenes, usually set indoors, and more sober in mood and colouring. Like Watteau, Lancret had trained with Claude Gillot, and their two styles could not always be told apart. But, although Lancret was influenced by Watteau's delicate pastel-like palette, Watteau's pictures were frequently overshadowed with an ethereal melancholy, while Lancret's remain always pretty confections.

François-Hubert DROUAIS *Madame de Pompadour*

1727–1775

Canvas, 2.170 × 1.568 Signed on work-table: *Peint par Drouais le fils*
 la tête en avril 1763
 le tableau fini en mai 1764

By the time this portrait was completed, the sitter was dead. Madame de Pompadour, mistress of Louis XV, died at Versailles at the age of forty-three on 5th April 1764. One month later the fashionable portrait painter, Drouais, finished this portrait. Anxious to establish its status as painted from life, the artist records in the signature that the head was done in April 1763, although the whole was finished in May 1764. In fact the head is on a separate square piece of canvas, confirming that Drouais painted it independently and added it to the whole in his Paris studio.

Several pastel studies, as well as two almost identical oval half-length portraits of Madame de Pompadour (now in a private collection and in the Musée des Beaux Arts, Orléans), in exactly the same dress but holding a white fur muff, were commissioned from Drouais, in June 1763. The fact that these were executed between the time Drouais painted the head and then completed the entire portrait, is a sure indication that the likeness pleased the sitter.

Madame de Pompadour was a generous patron of the arts and supported, amongst others, Voltaire and Boucher. Drouais shows her at her tapestry frame, surrounded by signs of her interests and accomplishments: a mandolin, a worktable, an artist's portfolio and books. One volume is missing from the shelf and lies nearby her. Her small head with plump double-chin, crimped hair, child-like eyes, and apprehensive expression, is silhouetted against a bare expanse of wall. Isolated from the profusion of objects around her, from the glories of her flowered dress, ribbons and lace, this worldly courtesan seems intensely vulnerable.

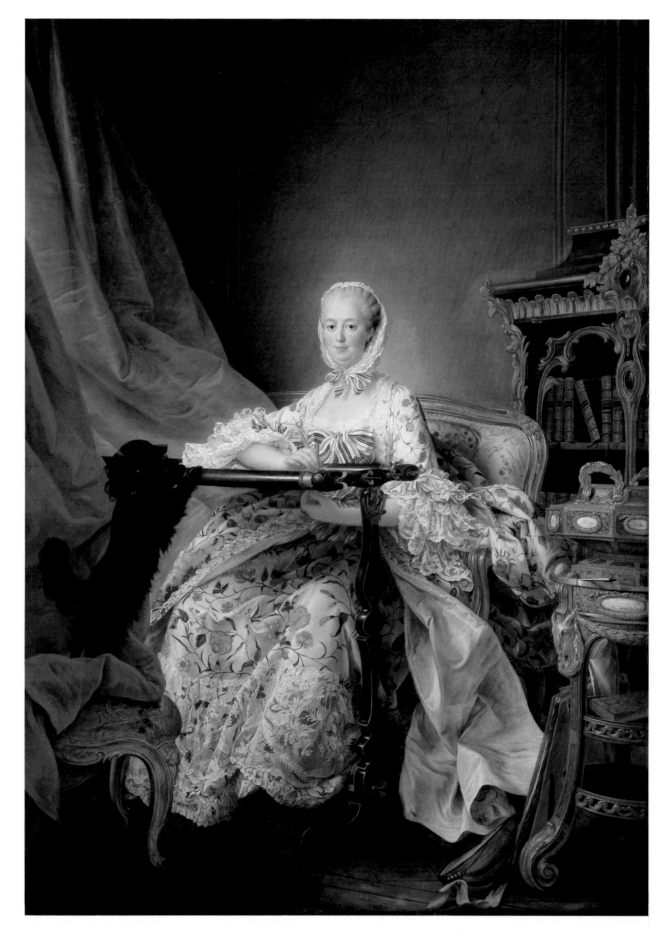

Jean-Auguste-Dominique INGRES *Madame Moitessier*

1780–1867

Canvas, 1.20 × 0.92 Inscribed: *Mᵉ Inès Moitessier née de Foucauld*
Signed: *J. Ingres 1856.* AET LXXVI

It is more usual for the inscription on a portrait to record the age of the sitter, rather than that of the painter. And yet, here, while Ingres records only the name of the sitter, Madame Inès Moitessier, née de Foucauld, he stresses that he himself was seventy six when the portrait was completed in 1856. He is perhaps hinting at the effort it cost the ageing painter to complete this picture which he had begun twelve years earlier in 1844.

Originally he had refused to paint Madame Moitessier. When he eventually met her, he was so captivated by her beauty that he agreed. But the portrait caused him infinite trouble. In 1847 he was still working on it. In 1851 he had abandoned it entirely and painted a fresh portrait of *Madame Moitessier standing* in a black dress with a garland of flowers around her head (Washington, National Gallery of Art). Then in 1852 he returned to the original portrait and finished it four years later.

The ageless Madame Moitessier looks quite oblivious of all the trouble she has caused the artist. Resplendent in a fashionable Second Empire dress of flowered chintz, whose *décolleté* line shows to the best advantage her sleek and plump shoulders, she reclines on a rose-coloured *canapé*. She was the wife of a wealthy banker, and in her affluent surroundings, wearing opulent jewellery, she is the very epitome of the *bourgeoisie*.

After training in David's studio, Ingres had been in Italy in 1806–24, as winner of the Prix de Rome, and had been deeply impressed by the work of Raphael and by classical sculpture, all of which are reflected in Madame Moitessier's smooth polished limbs and classical outlines. He also visited Naples, and based her pose, with the head resting against her forefinger, on the figure of a woman in a wall-painting from a villa in Herculaneum, which was known as Flora when it was found in the mid-18th century.

Originally Ingres had asked Madame Moitessier to bring her small daughter, 'la charmante Catherine', and intended to incorporate her; but he only got as far as sketching the child's head under her mother's left arm before expunging her from the portrait as 'insupportable.'

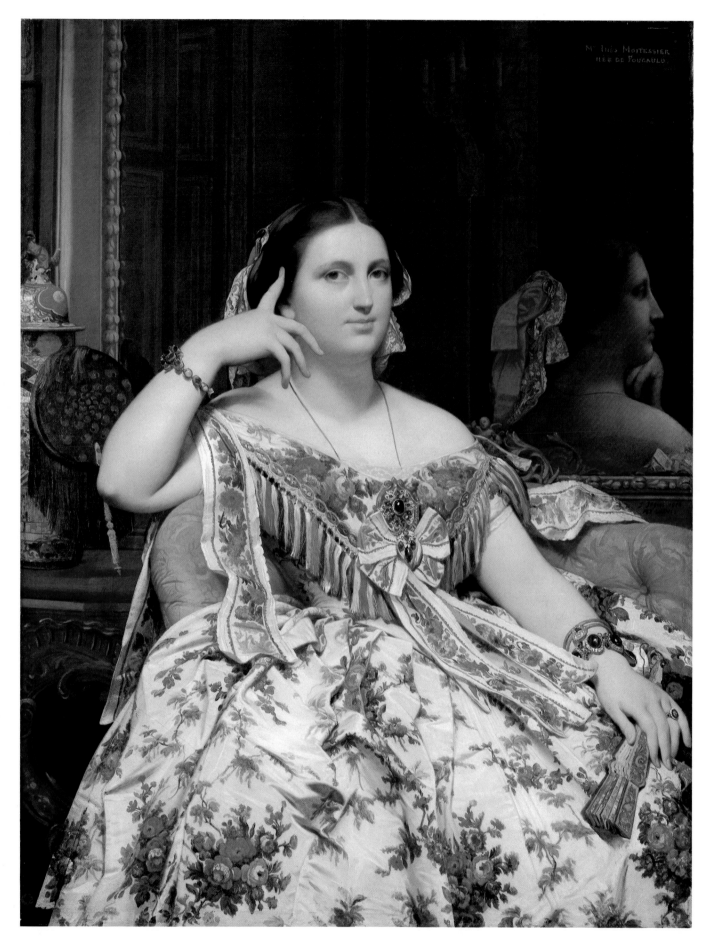

Edouard MANET
Music in the Tuileries Gardens
1832–1883

Canvas, 0.76 × 1.18 Signed: *éd Manet* 1862

Faces of unknown people seen amongst a crowd tend to blur, while the familiar faces of friends stand out with striking clarity. Manet's picture of fashionable Parisians, gathered around an unseen orchestra in the Tuileries Gardens, includes amongst the confused crowd the clearly recognisable portraits of some of his friends, mirroring contemporary artistic and intellectual life: Albert de Balleroy, a painter; Zacharie Astruc, a sculptor; Offenbach, the composer; the poet and critic, Baudelaire; the poet, novelist and critic, Gautier; and the painter, Fantin-Latour. Manet himself stands on the left looking out of the picture with the isolated detachment which characterises self-portraits in Renaissance paintings.

The immediacy of this small picture, with its informal composition lacking any central narrative focus, the apparently haphazard scattering of empty chairs, an open parasol, a hoop, a lap-dog, the discrepancy of scale in the figures, and the sketchy handling of intermittent passages have all the spontaneity of a genuine *plein air* painting, rapidly executed on the spot. In fact, Manet made several fragmentary sketches for the picture which he evidently completed in the studio, carefully composing the two main horizontal bands of colour linked by a softly curving tree. Amid the black of the men's frock coats, the few colours of women's dresses are carefully balanced, mainly pale apricot and powder blue. The two women seated in the left foreground, and the small girls playing with a bucket and spade, stylistically reminiscent of Goya, reflect the hours Manet spent with other contemporary painters copying, particularly the Spanish paintings, in the Louvre.

When in 1863 Manet exhibited this, together with thirteen other canvases, at Martinet's, the dealer, who handled much of his work, the critics were scandalised by what they called the caricature of colour. Little did they realise how important Manet's impressionistic technique was to become. Manet longed for official recognition, and although friendly with the Impressionist painters – Monet, Renoir, Sisley and Pissarro – he was unhappy at being associated with them and refused to participate in the Impressionist exhibitions.

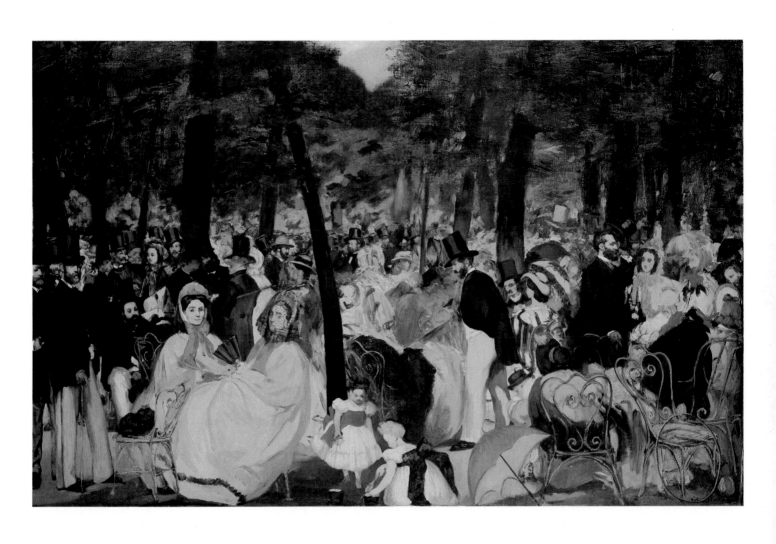

Claude MONET
1840–1926

Canvas, 0.73 × 0.92 Signed and dated: *Claude Monet* 1869

La Grenouillère

In the autumn of 1869 Monet was in a frenzy of frustration. The Salon was fast approaching, and he had in his mind '*un rêve*' – a dream of a painting of La Grenouillère he wanted to exhibit. But he was so poor that he had had to stop painting because he lacked the money to buy colours. He had already managed to paint what he disparagingly called '*quelques mauvaises pochades*', of which this sparkling study is probably one. It is painted on a used canvas, presumably a measure of economy necessitated by his reduced circumstances, and is one of several such sketches which he made of La Grenouillère, a popular bathing resort outside Paris on the Seine. Here we see the bathing cabins on the left and a foot-bridge which boldly divides the canvas into two equal halves. The bridge led to an island, known as the Camembert because of its shape, and to a floating café, not shown in this picture, which were the subjects of a separate study, now in the Metropolitan Museum, New York.

Side by side with Monet sat Renoir painting exactly the same scene. Renoir was a staunch friend during this time, bringing food to the Monet family from his own table. Although there was little jollity in the Monet household, Renoir found Monet a good painting companion.

In January 1869 Monet had written to the painter, Bazille, begging him to send him various colours – including *lots* of black, white and cobalt blue. These colours dominate the painting of the water: blue and black applied in long thick strokes where the empty boats loll in the shadows, and brisk dabs of white on blue where a dazzle of water and light is splashed up by the figures bathing beyond the bridge.

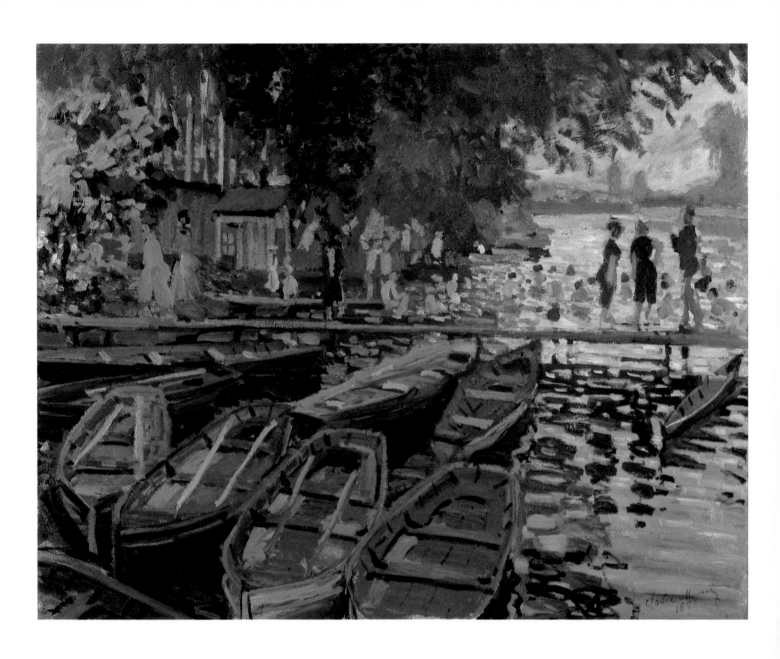

Edgar DEGAS

La-La at the Cirque Fernando, Paris

1834–1917

Canvas, 1.17 × 0.775 Signed: *Degas*

Degas' admiration for the French classical style, and especially that of Ingres, was unequivocal, but his sympathies were increasingly with the Impressionists. He took part in the first Impressionist exhibition in 1874, and from then on exhibited regularly with the Impressionists. Like them, he drew on daily Parisian life for his subject-matter, which was deliberately unacademic and daringly banal. It divides quite sharply into glamorous public spectacle – the races, ballet, circus, cabaret – and private, intimate studies of women washing, or combing their hair – but always he is absorbed in capturing the grace of movement and line.

La-La at the Cirque Fernando was exhibited at the fourth Impressionist Exhibition in 1879. The deceptive immediacy of this picture of the mulatto stunt girl, as she dangles dangerously by her mouth, is achieved by the vertiginous viewpoint – looking up into the vaults of the Cirque Fernando, which had been built in Paris in 1875. During the years 1878–79 Degas made several charcoal sketches of La-La and of the rope, the mouthpiece and the architecture with notes on colour. He combined them in a drawing and in a pastel study (London, Tate Gallery) which is equally dazzling in its gaudy oranges and purples, before he eventually painted the final composition. The changes between study and painting are significant. In the pastel the legs are further apart; in the oil painting Degas has shown them twisting together in order to emphasise the pivotal axis of the spinning figure. One can almost smell the sawdust and hear the gasps as La-La whirls gently to a halt.

Edgar DEGAS

Hélène Rouart in her Father's Study

1834–1917

Canvas, 1.61 × 1.20

Henri Rouart, an amateur painter and collector, was a friend of Degas, and Degas had painted Hélène as a child seated on her father's knee. In this portrait of 1886, Hélène Rouart is shown still associated with her father. She is in his study, surrounded by the objects he collected: a glass case contains Egyptian statues; on the wall behind her is a Chinese wall hanging, an early seascape by Corot, and a drawing by Millet. As in Vermeer's picture of *A Woman Standing at a Virginal* (*see* p.167) the pensive expression on her face and the prominent position of an empty chair underline the absence of a loved person.

The painting remained unfinished, perhaps because Degas' eyesight was beginning to fail. At his death it was still in his studio.

The soft but rich tones, and broad areas of subtly blended colour anticipate the intimate interiors of Vuillard (*see* p.213).

Pierre-Auguste RENOIR

Les Parapluies

1841–1919

Canvas, 1.80 × 1.15 Signed: *Renoir*

We are accustomed to associate the Impressionists above all with bright colours. In *Les Parapluies* Renoir has boldly confined himself almost entirely to the colours of an overcast day: bluish-grey, and grey, rather than black, umbrellas and clothes.

Renoir made preparatory sketches of a woman with a parasol (Belgrade, National Museum), and of a girl carrying a bandbox. He worked on the picture over a number of years, beginning in about 1881, and perhaps completing it about 1884 or 1885. He had visited Italy in 1882, and had been deeply impressed by the work of Raphael. This may account for the discrepancy in style: most of the figures are treated impressionistically; but the figure of the girl carrying a bandbox has an almost porcelain finish. It is noticeable in pictures of the years around 1885–87, for example, *Les Grandes Baigneuses* (Philadelphia, Museum of Art), that Renoir gives the figures clear classical outlines, also attributed to his admiration for Ingres, while the background is created with less defined impressionistic strokes.

Several sources for *Les Parapluies* have been suggested: the contemporary craze for Japanese woodcuts, some of which showed women opening parasols, or an etching by Manet of 1870 called *La Queue à la boucherie*. Equally plausible, however, is that Renoir was simply inspired to take a slice of contemporary Parisian life. He was fond of quoting Pascal: *'Il n'y a qu'une seule chose qui intéresse l'homme, c'est l'homme'*. His own abiding interest, clearly apparent in his huge output, was man – or woman.

There is in *Les Parapluies,* as with many of Renoir's paintings, narrative human interest. It has just started to rain, and we are left with dramatic uncertainty. Will the bare-headed girl accept shelter from the man immediately behind her? Or perhaps from the painter himself?

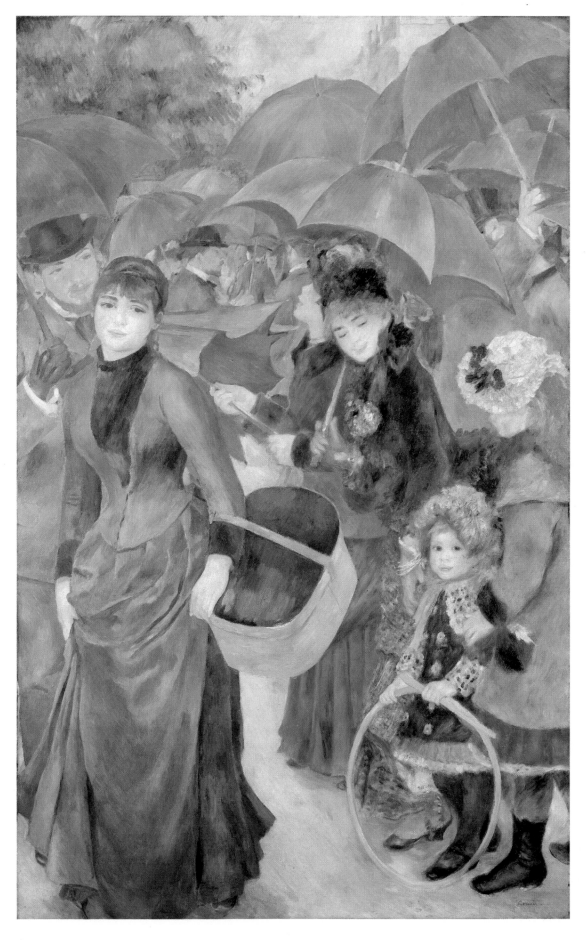

Georges-Pierre SEURAT
1859–1891

Canvas, 2.01 × 3.015 Signed: *Seurat*

Bathers at Asnières

Seurat is best known for his invention of the technique known as Divisionism, a system juxtaposing different colours which resolve into a single image when viewed at a distance. This picture of bathers is the first of his compositions on a large scale and precedes *La Grande Jatte* (Chicago, Art Institute) in which he adopted *'pointillisme'* using different coloured dots rather than brushstrokes. Here he uses a combination of different techniques: only the area around the boy's hat is painted with *'pointilliste'* dots; the water is done with thick Impressionist brush strokes, like those of Monet (*see* p.199) and the grass with criss-cross strokes of various hues – pink, orange, yellow and green. The figures are artificially silhouetted against the background, against light on one side, and against dark on the other – particularly obvious in the boy sitting on the bank with his legs in the water. They are painted with the clean outlines and clear modelling of Piero della Francesca whom Seurat much admired. The figure with just his shoulders half out of the water is reminiscent of the figure undressing in Piero's *Baptism* (*see* p.33).

The motionless hazy atmosphere of a summer's day is taken up in the haze of industrial smoke in the background. A woman in a passing ferry modestly hides behind a parasol, so as not to see the naked boys. The setting is the left bank of the Seine at Asnières, a suburb to the north-west of Paris. The clump of trees on the right is the tip of the island known as La Grande Jatte, the subject of the next large-scale painting Seurat was to paint. The factory chimneys are at Clichy; Seurat has omitted a second arched bridge beyond the railway bridge since it would have disturbed the mathematical proportions of the composition. The structure of the composition was elaborately worked out, based on the proportional system known as the Golden Section, and Seurat made numerous studies of individual details before he painted the final version.

Vincent VAN GOGH *Sunflowers*

1853–1890

Canvas, 0.921 × 0.73 Signed: *Vincent*

Pissarro said of Van Gogh that he would 'either go mad or leave the Impressionists far behind.' In the event he did both.

Van Gogh had come to Paris from Holland in 1886, curious to see the works by Monet, Pissarro, Degas, Seurat and others which his brother, Theo, who was a dealer, handled. His early pictures had been dark and he was at first amazed at the lightness of Impressionist paintings. Under the guidance of Pissarro he went through a short-lived impressionistic phase.

By 1888, after he had moved to Arles, he had completely rejected Impressionism and was painting with strong expressive colours, thickly applied, to create bold patterns. Here the heavily textured flowers blaze against a luminous golden screen of basket-weave impasto, their petals bunched up and bristling or straggling spikily. This picture is one of six versions painted in 1888, followed by several replicas the following year. Van Gogh wrote to his brother that he intended them to decorate the studio he hoped to share with Gauguin in Arles, and in fact a picture by Gauguin painted in December 1888 shows Van Gogh at work at his easel on a painting of sunflowers.

Gauguin's stay in Arles was not a success. The two painters quarrelled violently and eventually Van Gogh, in a fit of insanity, attacked Gauguin. Van Gogh was admitted to a mental hospital. In 1890 he shot himself.

Van Gogh had deeply admired Seurat and was particularly interested in his colour theories. After Van Gogh's death, Seurat organised a memorial exhibition for him to be shown at the Salon des Indépendants in 1891, but died himself, aged only thirty-one, before the exhibition opened.

Henri ('le Douanier') ROUSSEAU

Tropical Storm with a Tiger

1844–1910

Canvas, 1.298 × 1.62 Signed: *Henri Rousseau* 1891

Henri Rousseau was an amateur painter whose primitive style, mocked by some, came to be greatly admired mainly by leading artists at the end of the 19th century, particularly by Picasso. He claimed that before he became a customs officer in Paris (hence his nickname 'le Douanier'), he had served as a regimental bandsman in Mexico, and that this had provided him with the fantastic and exotic settings for his pictures. In fact, his journeys seem only to have taken him as far as the Jardin des Plantes. While a tiger is by no means an unexpected animal to find amongst tropical plants, the moustachioed men in striped cycling vests which Rousseau often places in such a setting do cause some surprise.

This picture of a tiger bounding through the long whispering grass during a storm was first exhibited at the Salon des Indépendants in Paris, 1891, under the title *Surpris*. Later, in 1895, Rousseau described it as representing a tiger pursuing explorers.

None of Blake's 'fearful symmetry' here – only make-believe patterns of spiky shapes which serve as a camouflage amongst the grass for the slightly absurd tiger.

Edouard VUILLARD

The Chimneypiece

1868–1940

Canvas, 0.515 × 0.775 Signed: *E Vuillard.* 1905

In 1905, the same year that this picture was painted, Gide wrote of Vuillard: 'he is the most personal, the most intimate of story-tellers . . . (he) speaks almost in a whisper – as is only right, when confidences are being exchanged – and we have to bend towards him to hear what he says'. Vuillard's intimate interiors often show people sitting around a fireplace, the hearth being the centre of family life and close personal relationships. Here he has focused on a fireplace, dispensing with people, who are only present in the paraphernalia of personal belongings cluttering the mantelpiece. Thrust haphazardly into a glass are wild flowers – meadowsweet, bramble blossom, and daisies – picked from the fields in late summer; and the clothes drying by the fire hint at summer showers; the medicine bottles suggest the faintly claustrophobic atmosphere of a sick-room. Tucked crookedly behind the flowers are photographs. Vuillard seems himself to have worked from photographs. He was one of a group of painters who called themselves the Nabis (prophets), and who included Bonnard. Their art was based primarily on the decorative arrangement of flat patches of bright colour, as in this picture, dominated as it is by the flowered wall-paper.

Odilon REDON

Ophelia among the flowers

1840–1916

Pastel, 0.640 × 0.910 Signed: ODILON REDON

Redon's pastel of flowers fuses two images. If the picture is looked at vertically, it is of a bunch of mainly scarlet and lilac flowers, with blue and green leaves, with little discipline and order except by virtue of the fact that their invisible stems are confined within the geometric outlines of a vase. Flowers were to Redon 'fragile, scented beings, admirable prodigies of light'. Redon was a close friend of the symbolist poet, Mallarmé, and in fact, if we look closely at the glorious mass of colour, none of the flowers is botanically identifiable; they merely suggest the *idea* of flowers.

If the picture is looked at horizontally, it emerges that Redon has converted part of the outline of the vase into the profile of a sleeping girl wearing a wreath, 'fantastic garlands', around her head. The flowers become the floating confused images of her dreams, evoking the underlying symbolism of death and association with the death of Ophelia. The silhouette of the vase creates images of rocks, and sun or sea, at dawn or sunset. There is a deliberate blurring from one image to another, touching on different colour associations of the sub-conscious mind. Pastel was the ideal medium for this type of dream-like nebulous effect of half-finished forms. Redon drew several pastel studies of bouquets, and of young girls associated with a chaotic profusion of brilliantly coloured flowers, perhaps partly in response to Millais' picture of the drowned Ophelia (now in the Tate Gallery, London), which was exhibited in Paris in 1905. This particular pastel was done within three years from that date.

Although Redon wrote 'I glorify life which makes me love the sun, the flowers, and all the splendours of the external world', the images he created are very much of the internal world of dreams and the imagination.

Paul CEZANNE

Bathers

1839–1906

Canvas, 1.272 × 1.961

Compared with Seurat's *Bathers* (*see* p.207), Cézanne's painting of a similar subject, painted about 1900–1905, towards the end of his life, appears very modern. Although the subject is clearly women bathing, the picture is almost abstract: the faces of the women are anonymous; their bodies are distorted into geometric shapes, built up with clearly discernible brush strokes and flat areas of green, yellow and pink, outlined in blue paint. They merge with the landscape which is built up with the same hues, only darker in tone, and structured blocks of nascent Cubism. The scene is devoid of any overt narrative content; it seems to be concerned only with pattern, shape and colour.

However, the picture is actually extremely classical, both in composition and subject-matter. There is an almost Renaissance lucidity in the geometric arrangement of the figures as the base of a pyramid. And the rhythm of the composition is articulated by the landscape in an entirely conventional way. Even the subject-matter is traditional: the presence of the small dog relates the subject of nude women bathing to a theme from classical mythology often treated by Renaissance painters, for example, by Titian – that of Diana and her companions bathing surprised by Actaeon, or of Diana and Callisto.

Cézanne painted several versions of the Bathers. He was a superb water-colourist and often his oil-paintings have the appearance of being water-colours, particularly in their limpid palette of clear blues, yellows and greens.

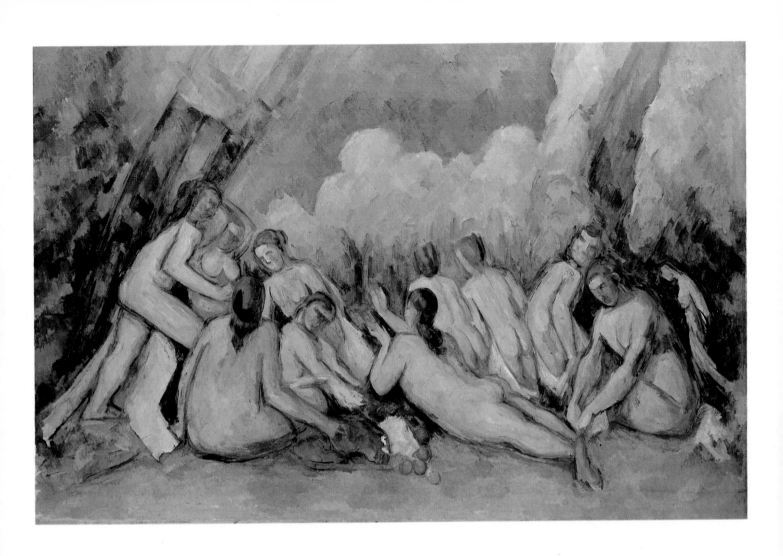

Pablo PICASSO

1881–1973

Canvas, 0.92 × 0.73 cms Signed: *Picasso*

Bowl of Fruit,
Bottle and Violin

This, the first abstract painting to be acquired by the National Gallery, represents a rejection of the entire Western tradition of painting of the previous six centuries. 'I paint what I know, not what I see', wrote Picasso. Within less than one decade, Picasso and Braque, and with them the entire Cubist movement, began deliberately to ignore the rules of linear and aerial perspective, the modelling of an object with a consistent source of light, and virtuoso painterly technique. Painting became an intellectual as well as a visual exercise.

For the Cubists, the main objective was to paint an object, not from merely one restricted viewpoint, but exploring all its different facets while conceding the two-dimensional nature of a painted canvas. By 1914, probably about the date he painted this picture, Picasso had gone a stage further. Objects no longer retain their solidity, and colour returns with a decorative rather than descriptive function. Here the shapes we associate with various everyday objects are fragmented and dispersed flatly across the picture surface in an assembly of geometric shapes which still cohere to a single unified whole. The strings of a violin bent over its bridge, the curving bulge of its body, the silhouette of a table-leg, bunches of grapes, the corner of a newspaper, perhaps LE JOURNAL, the fringes of a white table cloth, are allusions to objects rather than the direct statements of objects themselves. Nor does colour help the eye to assemble the scattered shapes. Rather, it is deliberately used to push them apart, so that the dominant bold outline of a fruit-dish is clearly discernible in broad flat silhouettes of plain green, white, black and salmon pink, and a small area of bright blue which emphasises the curve of the bowl. It represents an extreme reaction against the atmospheric and painterly approach of the Impressionists. The brown surfaces are not paint at all but hard dull grains of sand which seem to assert that even an arrangement of flat decorative patterns on a flat canvas has the objective reality of a three-dimensional object.

Picasso's still-life brings us full circle. In Duccio's *Annunciation* (*see* p.21) the painter was struggling against the flatness of a painted surface to create the illusion of three-dimensional space without the theoretical knowledge to do so. Here the painter knows all the rules and deliberately breaks them. He can afford to concede, even to emphasise, the flatness of the canvas. He is no longer interested in an illusionistic reality, but in a decorative statement utilising everyday objects. With the move towards abstraction began a new era of painting.

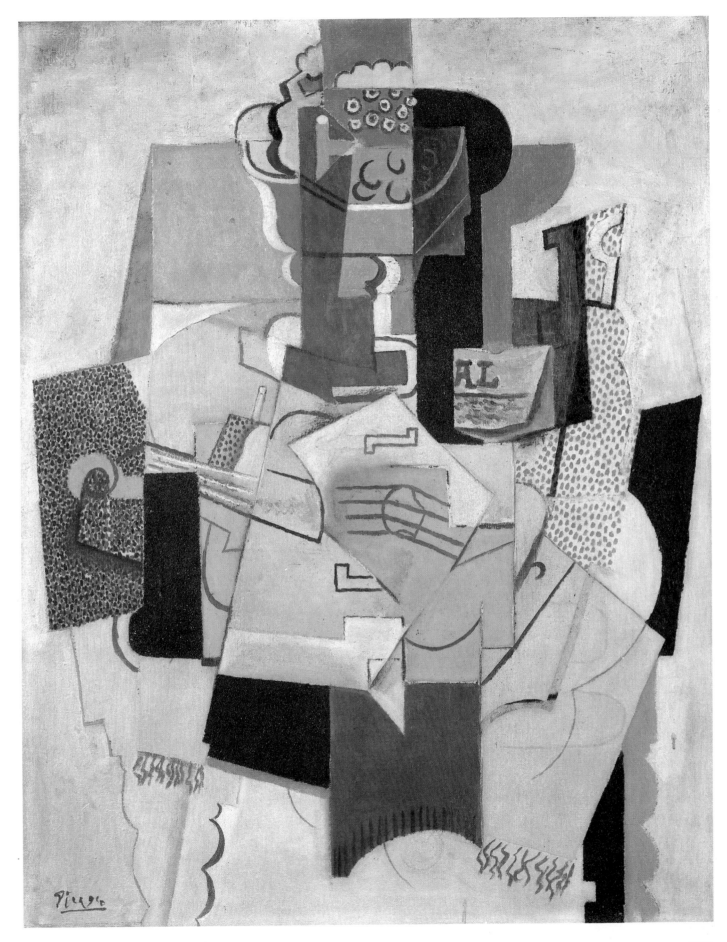